MW00755321

I Came
All This
Way
to Meet
You

ALSO BY JAMI ATTENBERG

Instant Love

The Kept Man

The Melting Season

The Middlesteins

Saint Mazie

All Grown Up

All This Could Be Yours

I Came All This Way to Meet You

Writing Myself Home

Jami Attenberg

ecco

An Imprint of HarperCollins*Publishers*

Some names and details have been changed, some conversations have been compressed, and some memories are faint due to age, drugs, alcohol, and general good times.

I CAME ALL THIS WAY TO MEET YOU. Copyright © 2022 by Jami Attenberg. All rights reserved. Printed in Canada. No part of this book may be used or reproduced in any manner whatsoever without written permission except in the case of brief quotations embodied in critical articles and reviews. For information, address HarperCollins Publishers, 195 Broadway, New York, NY 10007.

HarperCollins books may be purchased for educational, business, or sales promotional use. For information, please email the Special Markets Department at SPsales@harpercollins.com.

Ecco® and HarperCollins® are trademarks of HarperCollins Publishers.

FIRST EDITION

Poems "VII" and "XXX" from *Absolute Solitude* by Dulce María Loynaz, translated by James O'Connor, appear courtesy of Archipelago Books.

"California Stars" Words by Woody Guthrie, Music by Jay Bennett & Jeff Tweedy. Words © Copyright Woody Guthrie Publications, Inc. All rights reserved. Used by Permission.

Designed by Paula Russell Szafranski

Library of Congress Cataloging-in-Publication Data has been applied for.

ISBN 978-0-06-303979-7

22 23 24 25 26 FB 10 9 8 7 6 5 4 3 2 1

I Came
All This
Way
to Meet
You

For a long time, I worked day jobs that were different from the one I have now.

For twenty years, I hustled. I ran the cash register at a pharmacy. I counted pills. I sold lottery tickets. I squatted on the ground and counted boxes of enemas during monthly inventory. I shelved books in a college library. I waitressed. I wiped countertops. I took out the trash when my shift was over, and married the ketchup bottles, too, cleaning off the dried, red crust from the tops, which led to a loathing of ketchup, the scent of it, the taste, the texture, for the rest of my life. I flirted for tips. I did shots with strangers. I counted out my money at the end of the night. I worked in a pool hall. I worked in a beach bar. I worked the door at warehouse parties. I checked lists. I did drugs in the bathroom. I sent people on their way.

I temped. I filed. I answered phones. I typed up letters,

and then I faxed them across town. I pointed people in the right direction. Down the hall. One flight up. You just missed him. I worked in fifty different offices. All these lives. I took food from the conference room without asking. I replaced women on maternity leave. (Never men.) I lent a hand when they were short-staffed. There was a big mailing. Me, alone, in an empty room, stuffing envelopes. Fingers stung with paper cuts at the end of each day. I worked temp-to-perm and was supposed to feel grateful. If you play your cards right, kid. I never made it to perm.

I worked in an assisted-living facility where every day a resident named George came into my office, often introducing himself to me as if we were meeting for just the first time. He carried a hoe with him, which had belonged to his grandfather, who had brought it with him from Norway decades ago, and George would use it to tend the roses in the garden outside the facility. Sometimes he would tell me the same story about the hoe, too. George was sweet, and he was a gentleman.

I learned a lot about people, and how to be in the world.

I worked for a start-up, where my job was, essentially, to type really fast all day long; I talked to no one for months, I just typed. The next job, I signed people into conference rooms and assisted with their meetings and listened to them talk about their important jobs while they ignored my existence. I smiled when I didn't feel like it. I tried another job and another job and another job, always searching for a place I could call home. I was creative and I was curious and there was a propulsiveness to my life—I was completely engaged in forward motion—yet I had no specific direction. A problem I had. Figuring out the direction.

I spell-checked. I sent emails. I did math. I copyedited. They would find out I could write and then ask me to write something and it would only be a paragraph or two but it made me feel important and special and necessary and like I wasn't totally wasting my life, even if I was writing something that wasn't interesting at all, a forgettable arrangement of words, a decoration on a page, the baby's breath of corporate America.

I found a way into working on the internet, which was then the new frontier. I wrote, I produced, plenty of it garbage. I learned what code was. I learned what keywords were. I learned how to structure a website. Information architecture. I liked the idea of that: organizing information. I learned how to write short and snappy things. I worked for advertising agencies, lots of them—it felt like every agency in town. I watched things I wrote finally exist in the world, with the recognition that no one would ever know it came from me. I was detached from the thing I was making. I had no ownership of it.

On the side, I started writing personal things on the internet. Blog posts, little essays here and there. I began to tune the sound of my voice.

I argued with my coworkers about things that seemed important at the time. I asked for raises and got them. I quit. I got fired. A few times I didn't get jobs because people read something I had written on the internet. I had jobs where I was taken less seriously or my opinions dismissed entirely for being a woman. I have been told I am difficult. I am difficult in the sense that I am not easy, but fuck easy.

I have been harassed at work, but seriously, who hasn't?

I worked for a cable network on websites for critically

acclaimed television shows, all of which were created by men. It was the best job I ever had besides the one I have now. I watched how everyone ran around making these shows happen—what a massive amount of work went into their production; such brilliant people worked on them!—but all of the credit was given to the show's creators, their creativity, their genius. They had come up with the ideas. They had ownership. The rest of us were there to make their vision come to life. We served their ideas.

Eventually I thought: What about my ideas? When do I own them?

And once I realized that, I couldn't stop thinking about it. I could not stay where I was any longer.

The solution was to write my way out of the problem. That meant writing early in the morning, late at night, and on weekends. It meant carving out time, claiming it for myself. I thought: I will write this first book, and then maybe another after that. This is the thing I want to do.

This desire informed life choices I made, paths I took, and paths I rejected. Everything got easier, in a way, once I realized this was what I wanted, even as things got much, much harder. I had decided to operate in service of my ideas.

There are plenty of reasons why I write. This is just one of them. The sense that I want to own something, own my work, own my creativity, own my name. It is perhaps not the purest reason, not truest of heart, for there is some ego attached to it. But it is real.

I own these words. I own these ideas. Here is my book.

PART I

The Long and Winding Runway

1

Ingredients

1.

I am the daughter of a motherless mother. That sounds more dramatic than it actually is, though I suppose it had a gothic romantic quality to me when I was a child. It was sad, that my mother's mother had died so young, but it was also a mystery, and mysteries were interesting. I knew so little about the woman who would have been my grandmother; she passed away when my mother was eleven, and had been sick for five years before her death, so my mother had only known her in a certain way, and only up to a certain point. There was a palpable absence that existed in our lives, the not knowing of this person, having so few stories to pass around fondly. She was mentioned, she was discussed on occasion, certainly, but mainly the faint idea of her existed in the background.

Even when sadness is not stated, of course it can be deeply

felt. "A shroud of sadness" was how I had thought of it, described it to people as I got older. My mother was not an outwardly unhappy person: to this day she is cheerful, energetic, and congenial. She has a crisp sense of humor. Big brown eyes, a wry smile. She likes to play team sports, even in retirement. You have to drag her off that pickleball court. People like her. I get asked all the time how I can write about such fucked-up families when my mother is so obviously a nice person.

And yet, I always had an awareness of tragedy and loss in my youth—even though I had lost nothing myself. An attraction to that which was absent. A sketch, an outline, never fully formed, but still, it existed as an idea. Filling in the imaginary blanks with information I did not have but found I could invent quite easily. A thing we do as writers. If we just give ourselves permission. But also, there was something about simply feeling the sense of the void. It wasn't just one less nana to tell me they loved me, although wouldn't that have been pleasant to hear? The tragedy and loss had nothing to do with me: it was explicitly the absence of her in my mother's life. A woman, missed. And with that, the things she never had a chance to learn from her mother.

Many of those things revolved around being a girl. I am speaking of the traditional, old-fashioned sense of girlhood and femininity, one that still thrived in the 1950s and 1960s and even still through the 1980s when I was growing up in the northwest suburbs of Chicago. What it means to be a girl now is different, more flexible, full of new possibilities, and for whom that girlhood is available has changed as well. But I'm thinking of a time when girls were supposed to wear makeup and dresses, eventually get married and have babies.

Cook and clean, that sort of thing. It seems like eons ago. I know all these expectations still exist in our culture, but there is room for more now—much more than this laundry list of expected feminine characteristics.

My mother never learned these things, though, not in a way a mother hands them down to her daughter, and thus I never learned about them either as a child. (And anyway, why should it have been up to her alone to teach me?) I was a tomboy, until I wasn't. But there was no bridge to the other side.

However, there was capitalism. When I was twelve years old my mother took me to the mall to find out about makeup. Madonna's first album had just come out and everyone wanted to look like her, especially, apparently, the young woman at the makeup counter. Her hair fell in neat waves against her head, curled, certainly, that morning, patiently in the mirror. She was patient with my face, too, disciplined, focused on a vision: an elaborate, geometric display on my eyes of hot pink and lavender triangles, heavy mascara, and eyeliner. I experienced a rivet of panic with each new layer. It was a look for a much older girl, and also, there was no way I could have re-created it on my own. I was never any good at coloring between the lines, let alone eyelids. I can't do this, I thought. I can't be this.

During the car ride home from the mall I looked at myself in the passenger-side mirror, then burst into tears. "I look like a prostitute," I said, not having ever met or seen a sex worker, or having any understanding of their experience. "Well, you don't have to wear it again," my mother said, in a tone that suggested makeup was unnecessary anyway.

What was makeup after all? A way to alter the perception, when my face was already young and clear and healthy.

Lipstick did this, mascara did that. It was a concoction, a rec-ipe. At the time it felt false to me. The objects that dispensed the makeup I had seen before, in the bathroom I shared with my brother and my parents, often gathering dust in a drawer. Bonus gifts from the Clinique counter when she bought some hand cream or face moisturizer. Trial sizes of eye shadow, soon forgotten.

Makeup seemed an obligation, a task to apply it. It was what I was supposed to do to present as normal, whatever "normal" means, whatever "being a girl" means, whatever it all means. The rules had been constructed long before I was born, and I did not know yet I was allowed to break them or redefine them or ignore them entirely. After all, I went to the mall to learn how to be a girl. And, at that age, I wasn't even sure what I liked about myself, what I wanted to show off or accentuate—if that was a thing I even wanted to do at all. Couldn't we just talk instead? I loved ideas. Couldn't I just daydream all day? But no: it was time to look differently, feel differently, grow up into the next version of yourself.

Makeup made me realize there was a clock ticking that I hadn't even been aware of before then.

When I ask my mother about that disastrous foray into womanhood at the mall now over email she only says, "I remember it not being a good experience! It's tough being a mother." I tell her I'm writing about makeup. "It's just not your thing, huh," I say. "I think I look quite beautiful with-out it," she says. I agree.

One lesson unlearned, but another learned, even if by accident. Who cares about the superficial? And my mother impressed upon me instead the joys of reading and creativ-ity and also respect for my education and the belief that I

could accomplish anything I wanted no matter my gender, all of which I would gladly take in place of conquering the challenge of liquid eyeliner. (Still not conquered at the age of forty-nine, if I am being honest here.)

The only kind of makeup I have ever really loved is lipstick. I love all the bright colors, wild, hysterical pinks that turn a dull outfit up, poke a hole in a gray day, or bright, sexy, sultry reds that stain my lips for hours, marked in some way. I like the way lipstick can interact with my eyes, which I feel most of the time are happier on their own, undressed. I like thinking about my mouth, after many years of not thinking about it at all. A thing I like on my face, I can confirm it. My mouth. I will decorate that. It took me many years to arrive at that place. To find a thing I wanted to paint.

2.

Another unlearned life lesson from my mother: cooking. Certainly, she had cousins and aunts who passed on bits of knowledge here and there, and she was taught to cook as part of her public education. Water, she could boil. Instructions, she could follow. A box of recipes handwritten on index cards, stored in a kitchen cabinet. Honey cake for the High Holidays. But with a single father raising two young girls, my mother missed some skills along the way. And so, I never learned much beyond the basics either.

Instead, I have become a superior dinner guest. I am wonderful to have at your side while you cook, particularly if you give me a glass of wine, and also to have sit at your table, because I will appreciate your food in a deep, emotional, and

highly verbal way, perhaps, in small part, because I did not get to experience that kind of cooking growing up. I'm just always so appreciative of being fed a delicious, home-cooked meal; genuinely, puppy-dog-eyes astonished by the food put before me. Invite me over and feed me. I will be your best companion.

Still, my mother tends to me with food in her way. Once, she flew from Chicago to New York to care for me while I recovered from a minor operation. The surgery went smoothly, the painkillers a delight. Later, at my apartment, I handed her a grocery list of comfort foods. Included on that list was Campbell's Chicken Noodle Soup.

"I should make you some chicken noodle soup instead," she said.

"Mom, you have never made me chicken noodle soup in your life—except from a can," I said.

"That's not true," she said.

"It is absolutely true," I said.

We discussed this a moment longer. Soon, a cell phone surfaced from a purse, and my father's voice came through on the other end of the line.

"Didn't I make chicken noodle soup when they were kids?" my mother asked.

"Let me talk to him," I said.

"Your mother did many wonderful things for you," my father said. "She encouraged your love of books; she taught you to believe you could be anything you wanted in life."

"I know she did!" I said. "I'm not saying she wasn't a great mom. But there was no chicken noodle soup, right?"

"I do not recall any chicken noodle soup," my father said.

I shook my head at my mother. "Dad says no."

"Well, now I'm definitely going to make you some soup," said my mother, who loves a well-thrown gauntlet.

"Tell her to be sure to ask for help at the grocery store," my father said.

I emailed a friend who was a wonderful chef. I wrote that my mom was going to make some chicken noodle soup and that perhaps this was dangerous terrain. "Send us a recipe," I said. "But make it airtight."

She sent a recipe, and off my mother went to the grocery store in search of decent chicken thighs. Meanwhile, the painkillers were wearing off. That soup better be good, I thought.

Three hours and a dozen emails with my friend later, my mother had successfully made the chicken broth.

There were some arguments along the way. She bought low-sodium stock, for example, and I forced her to salt it. "I'm recovering from surgery," I said. "Let me have my salt!" But it looked good, and it smelled good. It was definitely chicken soup, and it was made with love.

All we needed were the noodles.

I watched as my mother emptied an entire one-pound bag of noodles into the soup. Something clicked in my head. At that exact moment, my friend sent me an email. Subject line: Noodles. "I forgot to say how many," she wrote. "Did she put in the whole package? Really, it should be like . . . a cup."

"She put them all in," I wrote back.

"But the noodles are the best part," my mother said.

"The broth is just an excuse for the noodles," my friend agreed. "But still . . ."

We watched in horror as the noodles sucked up all the

soup. We tried to add more water, but it was too late. My mother and I stood in the kitchen, frantically spooning the remaining broth into our bowls.

"It's my fault!" wrote my friend.

"It's my fault!" said my mother.

Aha, the final ingredient: Guilt.

But let me tell you, that one bowl of chicken noodle soup was delicious. We did not think about the vat of soup-soaked noodles sitting in the kitchen while we ate, nor did we think about the imperfections of life. I was my mother's best dinner guest, and she was my favorite chef. It did not matter what she had or hadn't taught me, only that she was there then, for me, in Brooklyn, in a concrete loft, making sure I survived.

<p style="text-align: center;">3.</p>

But what of this woman, the missing mother of my mother. I didn't know much about her, but I couldn't tell if it was because I had never learned about her in the first place or I'd just done too many drugs in the '90s, so I called my mother for more information.

"Oh dear, is this going to be a therapy session?" My mother sighed. Discussing her feelings about her past was not her favorite hobby. She thought about it for a while. "I blocked out a lot," she said. "I remember not wanting to talk about her at school. I didn't want anyone to know she was sick. There was certainly a gaping hole in my life, during those formative years. Do you remember having happy birthdays?" she said.

"I mean I don't know how happy they were." I laughed. "But that's probably my problem."

"Well, I don't remember any birthdays at all," she said.

Grief can be forever. We are taught to seek closure in this country, we are encouraged to move on quickly. We are judged, possibly, for not getting over things fast enough. But grief can be for your whole life.

Currently wedged between a lamp with a faux brass pineapple-shaped base and a copy of Laura van den Berg's *I Hold a Wolf by the Ears,* and behind a dish that holds throws from Mardi Gras parades, on a beautiful built-in bookshelf made of cypress in my living room, there is a picture of my mother's mother.

She is lovely, my grandmother, and feminine; put together, smiling, womanly. She seems small in this picture, petite shoulders, narrow arms, which are crossed against her chest. Her smile looks genuine, easy, and she looks happy and relaxed, but the portrait is clearly posed, she's standing at an angle, she's staring at the camera, there's a white backdrop. Someone said, stand this way, look here, smile. I do not think she was vain. I bet she was easy to love. Her eyebrows are neat, not too thin, but not bushy in the slightest, and her eyes are dark and direct and looking into the camera. She does not seem to be wearing much eye makeup. Her hair is thick and brown and curly. It looks tied back on the sides, as if she has pulled the hair back to be embraced by a clasp. Her

hair is mainly neat, but there is a wildness in parts. It is the least tidy thing about this photo, the hair. When I study it, I can see bits of frizz here and there. Same, I thought. Same.

She's put together for the occasion, though, otherwise. The sleeves of her blouse—or possibly it's a dress—are puffy, with small shoulder pads, and there appears to be some sort of embroidery on it. The style of the top, along with the hairstyle, indicates the photo was taken sometime in the 1940s, which would have put her in her late twenties or early thirties. Her nails are painted mahogany, skewing slightly on the red side. She is wearing a slim, elegant watch, and a wedding ring, a band that could be either of diamonds or gold, it's hard to tell. I can see one big diamond in the center.

The star of this show is not the diamond, though. It's her mouth. There's a big smile on her face: all her top teeth are showing, and most of her bottom teeth, too. They are straight and white. It's a healthy-looking smile. Her lips are red, a bright red, cheery. The top bow of her lips is a bit crooked, one side is lower than the other, and I can't tell if she's just applied the lipstick incorrectly, or if this is the natural shape of her lips. It looks familiar to me, this crookedness.

My mother doesn't look like her exactly, but this is clearly my mother's mother.

Is it strange to have a photo of a woman I've never met and know so little about take such prominence in my home? The photo lives at eye level, so when I sit on the couch, she's right there, watching over me. She is not a historical figure, although she is a figure in my life. Certainly, someday I will pass away, and this photo could end up in the garbage. I know this. There may be no one around to pick through my goods. I am the youngest of two children and childfree, my-

self. The photo will have meaning to no one but me. The grandmother stops here. So now I sit with the meaning it does have. I sit with her face, and the stories I have imagined about her.

So what do I know about her? What kind of stories? Faye Sudack Schwartz was born in Fall River, Massachusetts, the child of Ukrainian immigrants. She passed away in 1957. She was thirty-nine years old, too young. "I remember my father telling us, that whenever there's a full moon, we should think of her as watching over us," said my mother.

My favorite detail about her, the one that I cling to when I am wondering where I came from and why I am the way I am, is this: she was reportedly a great letter writer. That's where I get it from, I always thought. I wondered what would have happened if she had lived, what kind of letters I would have gotten from her, what wisdom she would have imparted. Maybe she would have told me to always be an appreciative and gracious guest. Maybe she would have said that I should always push myself a little harder to accomplish my dreams. Maybe she would have told me, just as my mother had, that a woman's appearance isn't as important as what she achieves with her brains and guts. But maybe she would have told me: You know what though? A little lipstick wouldn't kill you.

At the bathroom mirror, I examine my own face. In a way, it is safer to reflect on my physical appearance through the filter of an ancestor than it is to examine my current reality. A desire to create another narrative than just me, just this face. It's part of the process, as a human but also as a writer, part of being an artist, this continued assessment, of breaking things down into their original parts and then putting them back together in a new way. These details we inherit,

can we claim them, can we recognize them? It doesn't always feel comfortable. But if we can do it with love or humor or forgiveness or at least some generosity, some understanding of the other, it only strengthens the work. Only strengthens the self.

I think about how her lipstick lays on her lips is how my lipstick lays on my lips, too; one side is a little bigger than the other. And my face is the same shape as hers, slightly off on the right side, a bit rounder on that cheekbone, and up next to the eye. The ingredients of her face, her genes, her cells, present in mine, directly, it feels. Her not being there, how that affected my mother, it is an ingredient in the makeup of me. This mystery, this sadness, this unknown woman, all ingredients in where my gaze goes, my desire to tell stories, to uncover truths about families. As if I could solve the mystery of myself through understanding someone else.

A lost mother, red lips, the letters we write.

2

Get in the Van

Early days, I did most of my touring by myself, driving cross-country. Everyone thought I was nuts. Out there on the road, in my station wagon, the one with two hundred thousand miles on it, which rattled when I sped along the highway. After I hit sixty, I couldn't hear the speakers, just an unceasing vroom from state to state. Friends and family told me they worried about me every time I set out on another trip.

But I am the daughter of a traveling salesman, generations of salespeople preceded me in fact. My great-grandparents were Russian immigrants, and they built a life for themselves here in America. Papa Joe, and his grocery store in Massachusetts. You quit never. You sold and sold. And I was raised in the Midwest, a place where people work, in a town that was built out from scratch just a few years before I was born. I was surrounded by drive.

I was thirty-eight when I went on tour for my third book, the one that nearly killed my career. It was 2010. I was so full of hope about books and literature and life and completely in denial that the handful of reviews I'd received thus far for the book were only adequate, certainly not great, and there weren't a lot more coming, and in fact what little press in general I'd gotten was petering out entirely and the book had been out for only a week.

Had I paused for a moment and thought things through I might have seen how the weight of this particular silence was grinding my ego into a sullen, yellow, fibrous dust, the grit from which would surely stick in my throat should anyone innocently ask, "How is the book doing?" But no one asked. And I did not pause.

Instead, I thought to myself: If I just hit the road, everything will be fine, this book will do well, I will be living a life that interests me, and I will be working as hard as I possibly can on my career, supporting a book in which I believe. Who cares if no one was talking about it? They weren't talking about it *yet,* I thought. So what if my publisher wasn't investing in any advertising for the book? I would make my own advertising. I would be my advertising. I would stop only when they made me. I would keep driving all over America until someone bought my goddamn book. I was living off money earned from freelance advertising work, writing copy about servers or flashy new cell phones, technical things out of my price range. My bank account would be nearly empty by the other side. But I would drive from New York City, across the heartland, and all the way to California, with readings wherever people would have me along the way. By the

end of the trip, I was certain, I would have made a kind of magic happen. If I sold enough books, they would let me write another one.

I am sorry to report: No one was buying my book.

It was winter, and the trip was cold and wet. Scraping off snow from the car in the morning. Stomping my boots on the ground. I still smoked then, and I'd catch a drag outside the hotels where I stayed before I went to sleep. Whiskey night-caps to warm my bones. In Portsmouth, only eight people came to my reading. A few more than that in Boston the next day. I stopped in Buffalo the following night, where I knew no one, just a place to rest my bones, and I felt good and lonely in that hotel room, in a way where the pain stung so beautifully it was like it was trying to make a point, and then I drove through to Oberlin in the morning to speak to a group of creative writing students.

To them, I was just a random woman who had shown up in their classroom, one they had never heard of before. Ask me about writing, anything you want. Writing *what*? I was not disheartened. It was all part of the strategy. Just keep meeting people, spreading the word about my books, and it would all work out. Good strategy. Smart.

Later I met a few of the students in the parking lot of the restaurant where I was having dinner and traded them copies of paperback versions of my earlier books for mix CDs they burned for me in their dorm rooms. My ancient car, still only playing CDs. For the rest of the tour, I listened to their mixes, writing stories about the kids in my head based on their taste in music. I wondered if any of them would become writers someday—or if I had scared them off from the idea entirely.

This woman out there on the road alone, driving from state to state. Bye-bye, I waved to no one, every day.

Oberlin to Chicago, Chicago to Davenport, where I was to speak in a student center of a small university, another event that wasn't a big deal—none of them were—but I liked the idea of talking to students as much as I could, and also, I liked the idea of Davenport.

I grew up in a town about a half hour away from downtown Chicago when I was younger, and then, as the suburban population exploded over a few decades, and traffic heightened, the drive became closer to an hour. I loved a small midwestern town. I loved a place with two pizza parlors and one Chinese restaurant and one burger place and one steak place and one small department store and a park with walking trails and grills for barbecues and a town swimming pool and a town hall and three taverns that all serve Old Style on tap and two grammar schools and one junior high school and one high school and a Weight Watchers franchise and a public library and several religious institutions and a temp agency and a nearby body of water and flat, flat land and icy cold winters and tornado warnings and a dusty liquor store that sold out of kegs on Friday nights and maybe, on the edge of town, a terrible motel, ignored by all, but still somehow in business. I liked houses that were built irregularly, over time, instead of housing developments that came through and dug up land and built the same house again and again, with slight variations on a theme. I liked towns that came into existence sometime after 1900. I liked steel mills in the distance. I liked the idea of a functioning America, one that sprouted up from

honest, hard work and consistent traditions, even though as an adult I now know so much of it was either stolen or built on the backs of others, that racism flourished in every corner of this country, and some of what I was taught by the American educational system about this country's history was either misleading or incorrect. But on occasion I still liked to play make-believe in my youthful idea of America, to whisper to a town, "Aren't you cute?" And when I could visit a midwestern city on book tour, if I squinted, I could pretend like that version existed.

The problem, of course, is not in the fantasy. No fantasy is wrong. As long as we recognize it is just that. For it is a half-true version of America I am talking about here. It only works for some of the people.

But I'd looked forward to Davenport then, this small city in Iowa, with its gorgeous old downtown, an original Quad City, even though there were five in total: Bettendorf, also in Iowa, and the Illinois cities of Rock Island, Moline, and East Moline. It had snowed, but days before I arrived, so the snow had just settled on the ground, slightly icy, and the light was dimming, and there was smoke coming out of chimneys around town. I arrived at the house where I was staying, greenish-brown, narrow, two stories, on a block much smaller than the others around it, so it felt more like an island than a street. There was only one other house on the block, and together they seemed like comrades holding down a small kingdom of their own.

The way I felt about America when I arrived at that street in Davenport that night is the way I feel about America now. It is big and beautiful and mismatched blocks can still exist and it is still untouched entirely in enough places, and we can

drive across it and witness it, and all of this gives me hope that we haven't fucked it all up yet. I worry that what was stolen once will be stolen again and again, but I still hold on to this feeling. I try to live in hope when I think of America. Things are terrible everywhere, all the time, I know, but let me have my hope anyway. It does not alter how I walk through the world and what I know to be true. Yet I take comfort in the burning embers. There are still embers! With enough life left to burn.

I parked my car on the half block and got my suitcase from the trunk. I wasn't wearing the right shoes for the snow. I trudged through the inches of remaining drift toward the house, half-assedly dragging my bag, and the friend I was staying with met me outside, greeting me with a back pat and a handshake. He was an art professor in Davenport, a tall, bearded, friendly man with a nice head of hair; it was he who had arranged for me to speak at the college there. I didn't know him well, but I was fond of him, and his wife, a therapist. They were soft-spoken and even-toned and thoughtful people, maybe ten years younger than me. They read a lot. I felt embraced by them immediately. They had moved from Chicago and seemed happy to have big-city company in a smaller town. We had met two years before, briefly, after a literary festival in Chicago, and here we were again. The kindness of near-strangers. I was doing this all the time then. Meeting people briefly, bonding with them, and then showing up at their houses, invited, but still, in a way, just . . . showing up. Was it strange that I did this? That I befriended people so quickly and then showed up in their homes? In truth, I had been doing it for years.

He took my suitcase from me and carried it the rest of the

way, hefting it easily. The relief I felt from him helping me with my bag. After carrying it myself for so long.

The next time I would see the art professor and his wife they would have a child, and then they would have another after that. I was still just a person crashing at their home. They would move to a new house. He would get a promotion. Their lives would look different. They started in one place and ended in another. I was still the same. On the road.

I did some events in Nebraska, where the air was clear and lovely, crisp winter blue skies, even as the land was still dry and level and barren, impossible to conceive it would soon enough be covered with growth. Two days later, I left for Laramie. Somewhere around Cheyenne it began to snow, and it thickened immediately, turning into a whiteout. It could have been any time of day or night. I talked myself through it. "You're OK, you're all right," I said. A car in front of me spun out: this happened a few more times, and I kept dodging them. I saw a jackknifed truck, and then, a few miles later, another. There was nowhere safe; I did not trust pulling over, and who knew when the snow would stop? Was this how I would go? I thought. A snowstorm in Wyoming. "She died on the road," I wrote, in my head. "And no one had even bought her book." But I somehow made my way safely to Laramie.

In the city the snow had slowed. I found a cheap hotel with a few rooms open. The elevation in Laramie is 7,165 feet above sea level. My adrenaline rush from the stress of driving finally crashed. I felt dazed as I walked through the streets. I remember ordering the biggest, juiciest cheeseburger I could

find in town, with grilled onions, and a huge slab of bacon. I sat at the bar of the restaurant while I ate. I had a beer and a whiskey, and then another beer, and then another whiskey. I crunched around town on the icy streets, from one bar to another, grateful to be alive, and drunk, in Laramie, though still rattled.

I hit a slippery stretch of ice. I made my way carefully down it. The city streets empty and quiet and cold to the bone. The opposite of an embrace.

And then suddenly, I could see my life from a whole different direction: What was I doing in Laramie? Was there a home that existed somewhere else for me? Somewhere cozy. I could have a job in an office, a home in the suburbs. (Not that I wanted to live in the suburbs, but still, they existed and seemed safe.) A stable existence instead of fearing for my life, alone on the road.

But I knew home was in the books for me. All these things I did for books. In Laramie, in the bitter air of the evening, I laughed at myself. I was cursed, doomed. But I was still alive. I made my way to a sidewalk dug free from ice and snow. Forward, I thought. Forward. For the books.

I hit the West Coast at last. It was not the end of the tour, but my memory goes no farther than Big Sur. I stopped there for two nights off, at an inn you might know if you've driven up or down the West Coast of California before in a leisurely fashion, the drive the vacation, rather than the destination itself. Compact cabins, quiet, rustic, no internet, just peace.

At the time of my book tour, the only way to make reservations at the inn was to call them on the phone. I told the

front desk clerk I would be traveling by myself, on a road trip. "Ah, the solo traveler," she said. Recognized from a distance. She said it matter-of-factly, as if my identity had been confirmed. I had no emotional response at that moment to being labeled as such. That time would come in the future, though.

The room was small and snug. A sign on the door named it: LA PETITE CUISINE. And in the tranquility of the room, there was still noise: car tires popping on gravel, the chirping of bugs at night, the wind rustling through the trees. The air drifted from the Pacific Ocean just across the road, landing in my lungs, giving it a crisp, healthy sting. It reminded me of a campground from my youth: there, time stopped, the outside world disappeared behind the curtain of distance. No one knew what was happening anywhere else. The only thing that mattered was where you were right now. All the elements of nature were available. And nearby, a bed on which to sleep.

I have been to Northern California maybe a dozen times, mostly to San Francisco, back when you could still be a young dirtbag and live there cheaply, when it still seemed a viable, reasonable place to get away for a few days. It was also where I had written my first book, in Napa.

I had ended up there because a friend of mine had fallen in love with a man named John, a writer for television. She had met him on the internet and moved to the West Coast to be with him, first in the Los Angeles area, and then to Napa, where he owned a compound of houses, a small vineyard, and some acres of land. The previous summer I had driven my friend and her daughter to start their new life with this man. The next summer I had been invited back. I had published a small chapbook and some zines and a few essays here and there, and my friend had said to me: "What are you waiting

for? It's time for you to write a book already." How lucky I was to have a friend like that. She told me to come for a few months, and John, who barely knew me, generously agreed. She was right, I decided. It was time. This was in 2004.

In Napa, there was a big house, where my friend and her daughter lived, a mother-in-law house, where John's mother, Hesper, an irascible former screenwriter and memoirist, stayed, and the tiny two-story cottage where I would spend the summer. The cottage felt like a mansion simply because I wasn't sharing walls with anyone, as I had for so long in New York. To not have to hear my next-door neighbor's alarm clock going off in the morning: Was I suddenly a millionaire? There was land all around, a garden of fresh vegetables, a swimming pool, that vineyard I meandered through sometimes at sunset. I was allowed to stay there for free as long as I walked the dog, an enormous Tibetan mastiff, which I did, diligently, even though the dog didn't like me all that much and sometimes snapped at me. I felt a little bit like I was the help, there to accomplish a designated task, even though no one actually made me feel that way. I have always slipped into discomfort around affluence, even then. Any success I'd had I'd stumbled into. I was a happy-hour girl, free snacks with your cocktail. I wore cutoff jean shorts and too much mascara, flakes of it pooling under my eyes. I had gone to a fancy college but had attended with grants and scholarships and graduated in debt, and I had always felt like an outsider because I had gone to public school in a small midwestern town as opposed to my peers, who had gone to places with names like Choate and Deerfield and had parents who were investment bankers or worked in embassies. I was ill-mannered and poorly manicured and boozy and awkward.

(Still am! she screams from deep inside the prison walls.) I carried those insecurities with me well into my adult life. I was nobody special. And now here I was, someone's friend-in-waiting, there to watch a dog, while doing something that felt as simultaneously bold and ridiculous as writing a book.

But I loved writing it. Every day that I woke up and did the work was another day that had meaning for me. I was certain nothing I had done before then had held any purpose, had any real significance. My name hadn't existed before that moment, but now there it was, typed on a title page, and who knew what would happen next. I didn't know if I could actually sell the damn thing but I could see those words were piling up. It was a bunch of stories, but characters kept showing up throughout, so it felt connected. Once I realized I could make it funny or dirty or sad or whatever I wanted, I felt wild. This is what making art does to a person. When else do we feel so free as when we invent? Is there any sensation as free as that? The characters were complicated, like everyone I knew, but also they were their own people, familiar, but brand-new to me. Putting words in their mouth felt so natural. I liked thinking about the stories on a big scale. It was more than just the voice of an individual story (although those were hard enough to write on their own) but in fact a whole universe of them acting in cooperation with each other. There was a partnership emerging from the words. Wildness, yes, but I was taming it, claiming it for myself.

In the mornings I would pad downstairs to the small living area, make some coffee, and read from a stack of books I had brought with me or that I had borrowed from the big house. I would do this until my brain felt open and my heart felt light and limber. I wrote in notebooks filled with quadrille-lined

paper. I wrote with great delight. I cracked open the book not with ease—for writing a book is never easy—but with something like steadiness. I didn't know if I was any good at it, but I could see with my own eyes that I had certain kinds of skills necessary for the job: diligence, and determination, and focus. I loved feeling like I *could*.

At night I ate store-bought fresh pasta, the kind that comes refrigerated and soft and takes three minutes to prepare, and garlic and butter and olive oil and whatever vegetables I could scrounge from the garden near the big house and I would drink two or three (or four) glasses of wine and sometimes I would sob quietly by myself. I was a joke, but on the other hand, it felt great. The writing filled me like nothing else had. But it also poked holes in me, and that was where the sadness came out. I accepted it all as part of the process.

Now, nearly twenty years later, I fully understand what the words do for me: when I write, it's a place I can go to feel safe. It has always worked that way for me, ever since I was a child. The safety of a sentence. The sensation when I push and play with the words is the most pure I will ever feel. The calm space of my mind. I curl up in it. I love when sentences nudge up against each other, when I notice a word out of order and then put it in its correct spot. I can nearly hear a click when I slot it into place. I love making a sentence more powerful, more dramatic or moving or sad. Or when I make a sentence quiet enough that I can almost hear the sound of my own breath. More than anything, I love when a sentence makes me laugh. The words light up for me on the page, showing me what to do, where they want to go. They have always been my best friends in the world. All I need is for a few of them to show up. To soothe me.

Nine months after my time in Napa, an agent sent my book out on submission. I learned I had sold it while standing outside Dulles Airport, where a flight I had been on had been rerouted from New York. My fellow hapless passengers and I had been held hostage by the airline for hours at the baggage carousel, where my cell phone didn't receive service. Eventually they hired a bus to take us to Port Authority, and, at 1 A.M., as I waited in line, I was at last able to access my voicemail, and a message from my agent. I looked around for someone to tell, but it was all strangers. On the bus I ended up being wedged between the window and an ophthalmologist who had flown in for a convention in New York. He did not care that I had sold my first book.

No matter, I cared. I could feel it physically, in my shoulders. I remember it so vividly, as if something had been lifted off of me, an actual weight removed from my shoulders. As exhausted as I was at that time: the flight, the stress of the landing, the waiting to see what would happen with my agent, the forced closeness I was now sharing with a stranger, our limbs touching, no escape for me, just him and the window for the next few hours, all of that, together, I could still feel the release of this weight I had carried for so long—forever? No. Not forever. Years, though. But I would be someone else now.

Four hours later the bus dumped us out at Port Authority, where we all scrambled to find a taxicab in the early morning hours. But now it was a new city to me, and I was new to it. Here I was, showing up, a writer.

Six years later, I was still a writer, now staying in Big Sur at this inn on the highway.

In the afternoon, I went to the ocean.

I walked down through the property to a small path that led in one direction to a waterfall, and in another direction toward a beautiful cove at the Pacific, damp, sticky sand, shells shattered in bits, surrounded by high cliffs, pulsing with an energy that made them seem like they could tumble at any moment. At the edge of the cove, I saw a couple, the man pointing at something, a woman hugging herself to keep warm. I wondered if she wanted to be here. I wondered if she'd had a rough week at work. They were both wearing matching fleece vests, and they both seem occupied, by each other, and by the sky and the ocean and the cliffs.

I sat by myself for a while, pulled out my journal, and also the book I was reading: *Just Kids*, which had been published the month before. Smith's vibrant memoir of her life as an aspiring poet in New York City came along at the right time for me. She and Robert Mapplethorpe scrounged and hustled to pay the bills, but they knew no other way to live but to pursue their art. I always loan my copy to people when they're at the crossroads in their life, and the book always comes back to me so I can hand it on to the next person. A few months after I returned from this tour, I started working part-time at WORD Bookstore in Greenpoint, a jewel box of a shop, and I hand-sold that book as often as I could, pressing it enthusiastically into the hands of what was then a burgeoning youthful creative population of the neighborhood. I thought it was a guidebook on how to grow up in New York, even though that way of life seems impossible now. Patti Smith came by the bookstore and signed some copies for the holiday season, and I stashed one of the copies behind the counter at the beginning of my shift on the day before

Christmas; the shelves nearly empty because all of the cus-
tomers had made their last-minute purchases, no cookbooks
left, no art books, no collected children's series, no copies of
the new Jonathan Franzen novel left either, or that quirky
linked-story collection everyone was talking about by Jen-
nifer Egan. I was waiting for the right person to sell it to, and
then just before closing, in dashed my favorite barista from
Café Grumpy. He needed something for his mother, a social
worker. He described her as a great and special person. "I
have just the thing," I said and handed him the book. "She's
going to love this," he said.

What is that thrill, when you give the right book to the
right person? What psychological button does it press? I can
only tell you I felt giddy at that moment. Someone was going
to be happy for all the right reasons.

After I savored a few more pages of Smith's youth, I wrote
in my journal for a while. I was on my own and had arrived
at this beautiful place. The ocean was ceaseless and crash-
ing. My brain was clear and unfettered with the concerns of
others. I didn't expect to live a fantastic life as an artist. To
pay the bills seemed fantastic enough. I just wanted to be in a
better place than I was when I wasn't writing. If I just looked
at everything a little differently, if I fully accepted the artist
within me, if I leaned into my eccentricities, if I saw all the
colors in their most vivid fashion, if I embraced the kaleido-
scope at last, I could be there. It meant taking a step away
from a normal life, but hadn't I already moved too far away
from it? Where was I anyway? I was all alone on this beach,
far away from home, watching strangers, making up stories
about them. Wasn't I already there?

Farther down the cove, the woman was ready to leave.

This trip was for him, not her, I thought. He was studying the cliffs. I wouldn't want that, I thought. To be freezing, and ignored. I was still writing when they passed me. They stopped and asked me to take a picture of them.

I looked up, distracted. It was nearly the end of the tour. How was the book doing? Badly. Still only a handful of reviews. A nice one in the *Chicago Tribune* had shown up, I remembered, my hometown paper looking out for me, but mostly it was crickets, chirping their sad, lonely song. I had probably sold fewer than a thousand copies at the time. On the cover of the book, a woman in a black turtleneck, her back to the camera, stood in a field of wheat, wondering what the fuck she was doing there when there was clearly another book cover somewhere else that would be a better use of her time.

In a year I would send my fourth book to my agent and he would read it and enjoy it and send it to my editor and she would read it and then she and her coworkers and her boss or whoever—I wasn't there, in the meetings, but I will guess her boss—would look at the book but more importantly look at my last two books with their company, and their sales, which were terrible, and how much money I had lost for the company, and even if I imagine they liked the book (though I heard they did not), they would not buy it, and in fact they severed their relationship with me entirely. This is the end, my beautiful friend.

But I didn't know any of this was coming yet.

I took the camera.

People still used digital cameras regularly then to capture moments, instead of phones like we do now. There would be no instant gratification, no immediate upload to the internet.

This was just for them, for now. Maybe later the woman or the man would plug the camera into the computer and meticulously crop and adjust the photograph, eventually posting it to Facebook or sending it to someone's parent or friend, to show how happy they were, together on the coast. Maybe they'd curse me then, for getting them at an angle they didn't like, but we weren't as attuned to all our angles, as we are now. Maybe they were simpler people than me, happier, more content with their existence. An ocean, a romance. Congratulations to us, we're in love. It was enough that there was a photo of the two of them, enough that they had had their morning at the beach. Maybe they would look at it again sometime and think: oh, that was a nice day. Or: That was the day we fought all the way home. Maybe they would take a better vacation together someday, more than a few, and they wouldn't even think about this trip at all. The forgotten drive down the coast.

"Smile," I said, without actually smiling myself.

Her hair was brown with blond highlights, naturally, from the sun, I thought, not dyed, and it blew about her in the wind. Her lips arched tentatively. He was already smiling, beaming, had been this whole time; he had needed no suggestion. They were a few years younger than me. I studied her again. She leaned into him, rested her head against his chest. He was taller than she was. I decided she was happy, too, after all. She was just a little cold, that's it.

I looked through the lens at the couple.

Wasn't I already there?

3

Other People's Beds

I slept around a lot. Not like that. (But also like that.) I crashed in people's houses, in their guest rooms and on their couches. I house-sat, I pet-watched. I showed up. My own bed, ignored. I didn't even own a bed frame until I was forty-five years old. Just a mattress on the floor, forever. Let's say I'm a minimalist instead of some odd bird flapping her wings all over the country. *Peripatetic* was a word I learned in my early twenties. I remember looking it up after reading it somewhere and I thought: That sounds familiar.

Before college, I had sought permission my entire life to make choices; I had been well behaved and studious as a youth, jumped through all the required hoops, academic, extracurricular, and otherwise. But college was rough for me: conservative, snobbish, unwelcoming. I thought about transferring. Instead, I fled to England my junior year. I fell in with a crowd of creative people, boozy, eccentric, friendly. We

smoked hash and listened to Velvet Underground in dimly lit rooms. I got invited to people's homes for the holidays where I was fed fish sticks and peas and introduced to a number of cheeses I had never even heard of before. Where were you the first time you learned the word *Gorgonzola*? People laughed at my American accent, but I didn't mind. After the New Year, I backpacked by myself. On the Continent, as they said; the most pretentious thing I had ever heard. Soon enough I was saying it myself.

There, I was always getting into trouble. I slept upright on overnight trains, I snuck into grimy youth hostels to sleep when I had no money. I shared food and drugs with strangers. That was the year I started smoking, and I bummed cigarettes everywhere I went. I listened to the tape of *Nevermind* in my Walkman all over Europe. I saw so much art that year. Every museum in Europe has Warhols in its collection—did you know that? They did that year, anyway. By the end of it, I knew more, I was smarter, I was wiser: I was absolutely certain of all of this. I had decided freedom was to be explored and exploited. Bed after bed after bed. I had never been to so many places at once. And no one was there to stop me.

These travels taught me that moving around wherever I liked was possible. The stabilizing force was this: my friendships, the people I met, the relationships I built. And that I was always at home as long as I had a few necessary items: a journal, a pair of blue jeans, a few ducats, and most of all a sharp mind. Most people who spent their junior year abroad acquired a faintly European accent, drank, ate, screwed, smoked hash, wandered around museums gaping, and then went back to America, let that part of their lives fade, finished college, got a job, went to law school, resumed regularly

scheduled programming, marriage, kids, whatever people did, barely even remembering that wild year away after a while. But I had only gotten a taste of the life without restraint. Ruined by freedom and choice and opportunity. Ruined forever.

If it hadn't been that year, though, it would have been something else. I was just waiting for the trigger. Once I graduated from college, I was on the run across America, as if someone were chasing me, or as if I were running toward something, though I couldn't have told you what at the time. I couch-surfed in Northern Virginia for a few months, then shared an apartment with my college roommate Sunil, who had noticed I had been floating around for a while and gave me a place to land for six months in Tampa. And then I spent a year and a half back up north in Washington, DC, where I had several apartments. The first had a hole in the floor of my bedroom, which I nimbly stepped over each night, onto the ancient mattress I had inherited with the room. It was so cheap, I kept telling myself. It was a group house, run by a couple who worked on a farm in Maryland and left at the crack of dawn every day, letting the house do as it would while they were gone. It was filled with a rotating roster of roommates who worked in the service industry and a few gentle hippies focused entirely too much on being nonjudgmental. Drugs running through the house, a chore board in the kitchen. One roommate from London, who worked in fine dining, stumbled home one night with a bloody, swollen face, and was now curiously speaking with a New Jersey accent. There were gunshots all the time out on the streets. It was a house, but it did not feel like anyone's idea of home. One day I drove my car to park behind the house and someone had lit

a fire in the back alley. I cruised past it, dodging the flames, and thought: OK, it's cheap, but couldn't I do at least a little better?

All told, I lived in eight homes during that three-year span, acquiring virtually nothing but more scribbled-in notebooks, which I carted around with me with great care. When you move from rental to rental, rooms often come furnished. Or I acquired things cheaply. Sometimes I would sell what I had to the next person who was taking my place, or I would give it away to a friend. Other times it just got left, depending on its state. Nothing I owned was of any particular monetary worth, either made of particleboard, or purchased at thrift shops—"used" rather than "vintage"—and anyway I never owned any of it for too long, so there was no sentimental value. I lived in a perennial state of either garbage picking or leaving my junk for others.

Eventually I tired of DC. There was nothing for me there, I decided, a refrain that would become common enough in my life. I walked away so quickly from everything. A résumé littered with jobs lasting twelve months or less. (*Capricious* was a word a high school French teacher had told me I was when I dropped her class after one year of study. I had to look that one up, too.) Which risks were worth it? I wondered. What could I possibly gain by settling down somewhere? Brief stints in Chicago and Atlanta followed. There was a month in New Orleans, crashing on the couch of two members of a band then called Galactic Prophylactic, and I remember waking up on the thirtieth day in a row of being hungover and thinking, I like to have fun, but not *this* much fun. It was 1995.

Onward, west, to Seattle, after a month on the road. When

I arrived there I thought: I guess I'll stay here for a while, because I can't drive straight into the water, now can I? (I stayed for three years.) A recovering junkie friend there suggested I was "doing a geographic," a term popularized by Alcoholics Anonymous adherents, which means moving to a new city or state instead of facing one's problems. But I wasn't an addict, not specifically, except perhaps heading on to whatever place was next.

In Seattle, I lived first on a couch in a houseboat on Puget Sound, then a house rental with two roommates, and, finally, a studio apartment. This last place was the most precious to me: the mattress pushed up in the corner of the small room, bay windows filled with sunlight when it wasn't raining, fixtures from the 1950s, walls painted lemon yellow, a park across the street where children played soccer in the afternoon, the mixture of their chatter and cheers a pleasant, warming white noise as I stretched out on the mattress, stoned and thoughtful. Most special was that it was all my own. Even if I eventually tired of it.

Now in New York, Sunil, better employed than myself, decided to treat me to something special. He flew me to Manhattan for my twenty-seventh birthday, and after a high-charged weekend, elaborate dinners, nights out clubbing, men who worked in finance or was it film crews or was it both, I woke up and thought: "There's nothing for me in Seattle!" Within two months, I made my way back east, landing on East Thirteenth Street between Second and Third Avenues, in Sunil's spare room. I lived in seven apartments during the eighteen years I lived in New York—although three of them were within the same apartment building, which felt strangely like progress. In that building each apartment had a loft bed,

up a series of steps to a platform about six feet below the ceiling—no bed frame required.

I wasn't paying attention to what was happening. Time passed and I could only see a month or two ahead in my personal timeline, if that. The future, or planning for it anyway, didn't make sense. The future was for people who knew what to do with it. I saw how it worked for others in my life. My brother and his wife had met early in their college careers and fallen in love, and that was it, they operated as a team, a unit, for eternity. They made purchases together, a couch, a dining room table, a house. They cooked side by side in the kitchen, talked about which vacation they would take next summer versus the summer after that, nodded at each other's opinions. Even if they disagreed, they were paying attention to each other.

I tried it on for size. I lived with someone for a while, a boyfriend, Michael. The one with the gentlest heart. I admired the way he saw the world through such a forgiving lens. Everything had the potential to be beautiful. We bought a bed, with a box spring. (Still no frame.) We moved from one apartment to another, and then we broke up and I don't even know what happened to the bed after that. I can't even visualize where it went. Did I throw it away? Did he take it with him? It was just an object, and I cared so little then about the things that I had, except for books and art, that's it. What are our possessions but an extension of our aesthetics? Comfort, ease, safety. Those were not part of my aesthetics. No bed for me.

I loved. I had lovers. I was loved by others. I knew it, that

feeling. But I didn't have true partners. I had collaborators. I had people I made shit with. I had people to talk to. I had people in my life who understood me as much as I could be understood. A few mentors. More substantial than romantic love, I had friendship. That I knew best of all. I was nurtured more thoroughly by friends. These relationships are about a much more equal exchange. We looked out for each other. Swapping cigarettes on the street outside a bar. Splitting a cab home. How many times did I sleep in Stefan's spare room? How many meals did Rosie feed me? How many drinks did Emily and I buy each other? How many dinners did Vannesa and I split? No one kept track of anything; we'd never catch up anyway.

When I was in my mid-thirties, a mentor told me I would never be able to have a house of my own. No bank would loan me money, they told me. Not on an artist's income. Don't even bother thinking about that. Give up on that dream. If you choose this life, if you choose to be this way, you will get the bare minimum. An implication that I deserved only that. Ah, the impregnability of capitalism. I don't blame them though. I'm the one who chose to believe them. A great lesson: When someone tells you not to bother dreaming, they're not on your side.

I kept bouncing around. For fifteen years. Especially after I moved to Brooklyn. I had an apartment I couldn't afford, even if it was cheap for the neighborhood, but actually it wasn't the apartment I couldn't afford: it was New York. And

paying for my own health care. But I couldn't give it up. I couldn't walk away from the city entirely. I rented out my apartment a few times a year, found other places to stay, always to return to my life there. The place I thought I was supposed to be for so long, as a writer, as a human.

One year I slept in twenty-six locations in seven months. This started just after I turned forty, in 2011. I left town in December. From Chapel Hill to Savannah to Gainesville, where I stayed with Lauren, her husband, and their two young sons. Her husband made lasagna for dinner, and I drank wine, and after dinner Lauren and I talked about books, and she had an electricity and ambition I admired, and then I fell asleep in their guest room, hard and fast, feeling as if I was at last far enough away from New York.

Then it was on to New Orleans, where I stayed for a few months, in one half of a shotgun in Mid-City I shared with my landlords, two doctors, and their two children and dogs. It was a bi-level apartment, the bedroom and bathroom upstairs, a living room and dining room and kitchen downstairs, fully furnished, big windows, ceiling fans to keep the room cool. There was a long dining room table on which to spread out and write, which I did religiously, daily, with a firm discipline. My rent was one-third of my rent in New York. I could breathe for a moment. But then I found out about all the money I owed in taxes. I realized I had to sublet my apartment in New York until the next summer. Six months till home again.

From there I went to Austin then Memphis to Charleston, where for the first time in person I met my internet friend Roxane, who was a professor at the university there, and I was impressed by how clean her house was, and all her books,

how stable and organized her shelving was—the things book people notice about each other—and the next morning I bought her lunch at a nearby diner and it was then I realized how gorgeous her smile was, too. Then I was off to Chicago, to my hometown, where I spent an evening with my parents in my childhood home, in my childhood bed, where I always slept like a rock, because it was quiet there, and the room was small and compact and womb-like. When I said goodbye to my father in the morning, he seemed sad, though at the time I didn't think it had anything to do with me.

In Evanston, I stayed with my old college roommate Mara, and her husband and two children in their beautiful home. We ate pot roast and drank wine. I slept in their basement on an air mattress, a trunk of children's toys nearby. I felt extremely close to the ground. Rilke was notorious for always being someone's houseguest, and I read somewhere once that he had fifty addresses in four years, although I suspect he wasn't sleeping on air mattresses in basements.

In the morning, their daughter twirled around for me in her skirt, delighting at how it moved in the air. When I grabbed something from their well-stocked refrigerator I stopped myself for a moment and briefly tracked the feeling. It was envy. The six-packs of yogurt, all different flavors, the fresh-squeezed orange juice, an entire drawer just for cheese. I did not want this life, the husband, the kids. But I did want that refrigerator full of food.

I arrived in New York City at the beginning of May. I had two more months to go until I could return to my apartment. A migraine kicked in as I was passing Bryant Park on my way to Greenpoint, where I would stay for two nights with Gabrielle. I immediately blamed New York for my migraine.

I was flattened for two days. Gabrielle sketched me while I lay on her couch and we talked about money and art. What else would we talk about? What else was left?

In Queens, I crashed with my brother, his wife, and my seven-year-old niece, an already funny, sharp little girl. An air mattress, again, this time in the attic. I babysat my niece for a few hours and when I told her that soon I would be back in New York for good she slid down to the floor and made a small squeak of happiness. "Did you think I was never coming back?" I said, and she said, shyly, "Yes." It hadn't occurred to me that anyone was even waiting for me to come home again.

I moved to South Brooklyn for a few nights and joined Rosie in her tiny three-room apartment. I loved it there, her colorful home, where she'd lived for more than a decade by then. She had invested in it, even though it was a rental, making it hers. Pots and pans hanging high from a rack in her kitchen, which was painted creamy white with a barn-red trim. A chandelier made by a Swedish designer. Books and art everywhere, a velvet-covered couch she made up for me after we drank wine and caught up. She fed me, tended to me. I got up at 7:00 A.M. and found a café so she could have her morning to herself. At the table, I stuffed a napkin under one of its legs to balance it, then bumped my head on the way back up. I realized I had fully rescinded control of my life. I had left her house so she could do her work. I was fine in this small café on Fifth Avenue—I could work anywhere; it was one of my skills—but what would it have been like to have risen that morning and sat at my own kitchen table and taken pen to paper there?

I was forty years old. It wasn't cute or charming anymore

and maybe it never was. Whatever I had been doing for the last ten years of my life was no longer working. What does housing instability do to a person? How does it alter them? For me, I felt shame. Not having a regular place to live for so long. Relying on the help of others. I told people I was doing fine, that I had things under control, that there was a plan in play, but I was nervous and edgy and difficult to be around. I felt like I didn't deserve anything. No one judged me more harshly than myself. I accepted who I was, but I didn't always like it. I was lucky I wasn't on the streets; I knew that. So goddamn lucky. America does not look kindly upon the unhoused. I have always felt like I was two wrong turns away from complete destruction. We all are, and we're fooling ourselves if we think we're not.

Up north, to Maine and New Hampshire, and then back to Gabrielle's for three weeks, renting her spare room so that she could afford a plane ticket to Chicago. We were all trading off. The heat wave started. There was no air-conditioning. At night, I drank and sweat. During the day, I hid in cafés, tackling freelance assignments when I could get them. I wondered if everyone else nursing their dollar-refills all afternoon was crashing on someone's couch, or was it just me? All I wanted was to return home. But the deal I had made with myself in New Orleans in the winter was still in effect: my apartment was sublet until the end of July.

I was still broke. I had already borrowed money from my literary agency. My credit cards were maxed out. All my freelance gigs were way behind their payment schedule, as freelance gigs in New York City often are, no matter how many emails you send or spells you cast. Right then, Sunil wrote me a check to cover exactly one month of my life in New York

City. Still looking out for me after all these years. I wanted to say no, but I couldn't. Then another freelance project arrived, one that paid promptly. It would be enough to get me through until the fall, when my fourth book would be published. Enough to give me a moment to breathe. My subletters moved out, and then I returned home, paid my rent, and wanted to wrap my hands around my apartment and never let it go.

Sometimes it rocked me to be in a sturdy bed. Not a nice hotel bed—although I enjoyed that experience, too—but a big bed in someone's home, where the sheets were worn in so softly it was like they were holding you, and the blanket had been chosen with care, a hand run across its surface in a quaint boutique; a big brass bed frame, maybe, and a king-size mattress with a box spring underneath, all together a firm bed; and sheets pulled tight, with matching pillow covers, or maybe mismatched, but on purpose, stripes with polka dots, or neutrals with bright flashes of color; and a bedroom with a window, too, and a solid set of drawers made of pine, and a full-length mirror leaning up against the wall, and a table lamp that makes a satisfying click when I turn it off at bedtime. The bedroom faces a garden; no street noise to wake me. I can see the moon through the window. Imagine me in a guest bedroom, quietly marveling at all this. A bed above ground. Grateful to know a person with a guest room. What power they had. Imagine me thinking, I will never have this, right before I pass out for the night, the shame disappeared for the moment, consumed by collapse. Imagine me sleeping soundly through the night, and in the morning, the host asks

me how the room was, how the bed felt, was the mattress too hard or too soft? Did I like the new comforter? I am well rested, I say. My host tells me I look tired, a note of concern in their voice: They want me to sleep well in their home; they want me to leave their house feeling better than when I arrived. No, no, I assure them. It was the best night's sleep of my life.

4

Scars

Once a writer I did not know asked me to meet her for a drink at a bar in Brooklyn. Writers meet for drinks for different reasons, perhaps even more kinds of reasons in New York City, because the publishing and media industries live there—books, magazines, newspapers—and in general, there are more opportunities—teaching jobs, some television and film, too. Sometimes we need something from each other. Sometimes we desire each other. Sometimes we meet because we have read each other's work and we believe we share a similar sensibility. It could be good for a laugh. Sometimes we meet just because we are lonely. Because we could use a friend.

I had read this particular writer for years, her sexy, funny, charmingly narcissistic essays, less so her fiction, and watched her during her occasional guest appearances on morning talk shows—and I thought there was nothing I could offer her

but friendship. But friendship means a lot to me. When I was young, I had no friends. I was a daydreamer, a reader, a little lost socially, perhaps with the sense of humor of someone older than myself because I consumed books beyond my years, but I had not quite figured that out yet, that my peers would not find the contents of my brain funny. I was aware I lived on another planet, but I wasn't quite sure why. I had acquaintances in the neighborhood who invited me around just to tease me, poke fun at me for being nerdy, call me "husky," and laugh. I didn't have close friends until I was well into my teens, and truly it wasn't until college that I held anyone close to my heart and kept them there. I am still flattered when people want to be my friend. The chubby child wonders why anyone would want to have her over after school, is grateful to be invited. If someone asks me to meet them for a drink and it feels like something good might come out of it, some sort of future relationship, I enter into it with an open heart.

Soon enough her real reason for inviting me out became apparent. A book of mine had, at last, done well. Mere months before the book had come out, I had been a middle-aged writer couch-surfing across America. Now I had a hit. Jonathan Franzen had plucked my book from a stack of galleys he had brought with him on a flight to a speaking engagement in New Orleans, and a few days later he sent my editor a blurb. The editorial director of the books section at Amazon decided to champion the book. Molly Ringwald narrated the audiobook version. A copy of it showed up on the bedside table of a character on the TV show *Girls*—or at least that's what the hazy screenshots friends sent me seemed to indicate. Jews, in general, really seemed to like it, unless they hated it, but I learned it didn't matter how people exactly felt

about my book as long as they talked about it. The book was published in a dozen other countries, and went on to spend exactly one week on the *New York Times* bestseller list. A rave review of the book appeared on the cover of the *New York Times Book Review*—although a full two months after it had come out—an apology, it felt like, for ignoring me for the first seven years of my career, but that was just the story I wrote about it in my head. The book was not a massive bestseller or a smash hit, but it was a nice success. It made money. It made people happy.

People were reading it, and it continued to sell, and this writer at a bar in Brooklyn, she had questions. She wanted information she could perhaps apply to herself and her own writing career. It was a "brain picking" session, as it turned out, as if my brain were a carryout salad and she intended to eat only the good parts, the chunks of blue cheese, the avocado slices, the online marketing tips. Why this book? she wanted to know. Why now? I didn't know how to answer her much beyond "Well it's a good book," but I know that's not what she sought. What did I do, she was asking, so she could do it herself. That was the point of this conversation. What did I know, so she could know it. She wanted the math of it.

Sometimes there is at least a little math to it. A book is written that is hooky or topical or suspenseful or funny or heartwarming or stylishly executed and the publisher pays enough to purchase it so that they have to put dollars toward advertising and marketing otherwise they will lose on their big investment. They put their weight behind it because they have to, because they love the book (hopefully), but also because it is about the money. Most of the time these authors are white. I have certainly benefited from my whiteness in my

career, even if I didn't realize it at the time. But I was paid fifty thousand dollars for this book—an unremarkable sum for several years' worth of work, especially after my agent's cut and taxes—and was considered a loser walking in the door, having been dropped by my previously publisher for my terrible sales. So, this is not one of those million-dollar-deal stories. This is another kind of story.

In 2008, I broke up with my boyfriend, Michael. This was right before I went to Portland, Oregon, for the summer to house-sit for a novelist I knew. I had just sold my third book, the one that almost killed my career. I thought I was on fire, newly single, with a book deal. At the same time, I was deeply sad: I had loved someone, moved in with him with the idea that it would be for a long time, if not forever. We hadn't planned on being terrible communicators with each other, it just happened. I had looked forward to having someone to eat dinner with every night once we lived together, but instead we ate silently, afraid to say what was really on our minds. It was like I had stumbled into just another bad roommate situation—something I had promised myself would never happen again. I felt a desperate need to flee the scene. I couldn't bear to stay any longer in that apartment with that man I no longer loved, or at least could no longer tolerate. I just wanted to be somewhere else. I drove, fast, out west, lingering nowhere along the way.

That summer I started writing a novel called *Stumptown,* which was set in Portland. I also had two ill-advised affairs, one which does not merit discussion, because some people are worth writing about and some people aren't. The other

was Peter, a drummer who had been in a 1990s indie rock band from which he had never fully been able to move beyond. Instead, he survived beautifully off reunion tours and reissues and the like. He was actually a business inspiration to me: how to make a living as an artist all that time. (I had liked his band, too.) He was divorced, childless, a few years older than me, living in an outlying suburb of Portland. We'd had some text banter while I was still back in New York as my ex and I were breaking up, and I sought the comfort of a new flirtation. He wasn't a reason for my breakup, but perhaps he would provide a soft landing. It was pathetic, but it was human: I thought sleeping with him would cheer me up. And perhaps it would do the same for him. A chipper roll in the hay.

In Portland, Peter took me out for a steak dinner, and I wore a short dress, and he commented approvingly on its length, and I couldn't figure out if we were being sleazy or what. Then he brought me home to his hospital-level-clean house and excused himself to take a shower. Framed posters promoting shows he had played, expensive-looking modern furniture, floorboards painted white, worn woven Turkish rugs. He reappeared, dressed differently, freshly washed. I was covered in the humidity of summer. Should I have showered also? Too late.

We made our way toward nudity. In bed, he pulled out a brown paper bag. I thought for a moment he had packed a lunch for me. Perhaps there was a sandwich in it. Instead, it was a sex toy, one with a squiggly shape, not previously discussed, very much an off-the-menu item, sex toys, in this particular circumstance. I raced in my mind through all the texts we had sent: Had I agreed to that? Had I said I wanted that

and forgotten? It was hard for me to imagine that had been the case. But I hadn't dated in a few years. Was this what people did now? Go straight to the sex toy? I knew the sexual world was now accelerated by the internet, with access to all new kinds of visual stimuli, and of course the West Coast was its own hippie-dippie easy-loving deal, and also he was, eternally, a guy in a band, but even knowing all of that, in no way was I prepared for the revelations of that paper bag. Why couldn't it have been a peanut butter and jelly sandwich instead? Here, I brought you a snack! Mercifully, he recognized the discomfort on my face, and relented. How grateful women are sometimes when men simply back the hell off.

At the end of the summer, I flew back to New York and cast a wary glance at my options. Brooklyn held an apartment I couldn't afford on my own and an ex-boyfriend in pain who wanted to see me and talk. For all the words I have put out in the world, it turns out I am terrible at "talking." I swung into a self-protective zone. We had a bad argument outside a café once on Bedford Avenue, and then we never saw each other again after that—ever. But I didn't know that we would disappear from each other's lives. I only thought there might be more arguing. Through a friend of a friend, I found a cheap sublet in Los Angeles; sure, why not Los Angeles? I picked up some freelance work I could do from home, copy writing and the like, then rented my Brooklyn apartment to a woman who had recently left her husband. Everybody was leaving everyone, it seemed. I flew back to the West Coast.

Three months in a one-bedroom Silver Lake apartment up the side of a rickety stone-pathed hill, which charmed me in the sunshine, even as I dragged my luggage awkwardly

up the jagged walkway. I settled into Los Angeles, writing, thinking, walking the hills of Silver Lake, feeling my legs again, getting strong, breathing fresh air regularly, staying in instead of going out every night, picking through the apartment owner's design and philosophy books and graphic novels, marveling at his enormous television set, doing the first-class-free at a series of yoga studios in the neighborhood. My clothes grew looser, my hair shinier, and there was a glow to my skin. Fresh fruit every day. Cut back on my cigarettes. "I'd like to dream my troubles all away / On a bed of California stars" wrote Woody Guthrie in his song "California Stars," although it was sung by Jeff Tweedy of Wilco after the thirty-year-old unrecorded lyrics were discovered by Guthrie's daughter after his death. Ghost words, resurrected, and speaking directly to my soul.

Who says you can't run away from your problems? I had done it. We were a month away from electing Barack Obama, and it felt like the world was going to change forever, although I would believe it when I saw it, of course. I voted absentee. On my birthday, two old friends from New York who had moved out to Los Angeles took me out for the night. Expensive drinks in a hotel bar, I loved it. Six nights later we had our first Black president. From where I sat in my cozy apartment, I could hear the fireworks going off around Los Angeles. Hope had arrived, I thought.

After a month of recovery, I felt ready to surface again. I reached out to Portia, a smart, good writer who had moved to town after finishing an MFA out east, where I had been introduced to her once on a street corner. One night we met at a dive bar in downtown Los Angeles. She had just gotten off a freelance gig for a science journal and seemed jittery.

We got drunk very quickly, perhaps she more than me, but I didn't know her well enough to be able to tell, and then a few of her friends showed up, two men, and we drank a little more, and we decided to drive around town with them. Everyone was kind of a mess except for the driver, who I was trying to flirt with because I was free and in a new city I hadn't ruined for myself yet.

And then we stopped at someone's house for a moment in the neighborhood of Frogtown, and as we pulled up I said, "Why do they call it Frogtown?" and before anyone could answer me, Portia said that she thought she was going to be sick, so we all got out of the car immediately, doors burst open at once, and she stood in the street, and we all scattered in different directions, me running toward the house to get her a towel, something to clean herself up with, a bottle of water, something, and as I ran I thought, I'm glad it isn't me that's a mess right now, and whatever force that exists in the heavens decided I should be punished for my hubris, like, Fuck you, little girl, you think you're not a mess? Try again, so as I ran the heel of my vintage shoe broke and my ankle turned and I fell and I howled in pain and now I was crying and the two men helped me inside to deposit me on a couch and someone's wife came out, pissed off that there was a drunk, crying woman, a stranger, in her living room, and by then Portia had cleaned herself off, and someone handed me a bag of ice and we discussed whether or not I should go to urgent care or the hospital, and I said, hopefully, knowledgeably, confidently, "I'll be fine, it's probably a sprain," and I never found out why they called it Frogtown.

It was not a sprain. It was a break, a bad break, a bad, tough break. Although I refused to admit it at first. I hobbled

around on it for a few days until one morning I passed out from the pain. At the emergency room, the X-ray technician snorted at how bad my break was. I would need surgery to re-set and put a pin in my ankle. My mom flew in to take care of me for the week, skipping Thanksgiving with my father and their friends to be with me. On the day of the surgery, a nurse gave me Dilaudid, which I loved, and I considered briefly the life of an addict as the nurse flirted with both me and my mother, seeming impressed I had written a few books. If only he knew how they sold.

My mother stayed with me for five days, helping me up that rocky path to my apartment, high, high, high, in a cast, butt cheek by butt cheek. We saw the doom immediately. That I would not be able to leave the apartment by myself in the cast. My mother's eyes glittering and scared and sad, trying to assess how I would do this on my own for the next two months. She went shopping at Costco and bought meals in bulk that would be easy to prepare on crutches, assessed the living space, talked to me about not abusing the painkill-ers I had been given, tried to stay calm for the two of us. No mother wants to leave their child in an uncomfortable posi-tion, but she had a job, and she couldn't take off months of her life to take care of me. I would be on my own, in a cast, alone, high up on a hill.

On Thanksgiving Day my friends came over and cooked dinner. They were chatty, wry, funny, chain-smoking, boozy broads, not terribly different from myself, how I had been for years, in fact, but in contrast to the ailing me, and after the quietly disastrous past few days, it shocked my mother, who was never much of a drinker and certainly not a smoker. She hated that day, hated that she was missing Thanksgiving

with my father, hated that she was going to leave me there on my own, hated that I was checked out on drugs while she had to play hostess to these smart, tough-talking, tough-acting women she barely knew. The whole unspoken story of why I was even in that circumstance in the first place—I had been drinking, after all, and rushing to help someone who was even drunker than me—hovered over the event as my friends became more intoxicated. They were having a Friendsgiving; my mother was having an emergency. She was not their mother; she was my mother. And she didn't have to like any of it. At some point, I wandered off from the living room on my crutches to the bedroom and my mother came in a few minutes later with tears in her eyes. "Don't leave me out there with them," she said.

That was a decade ago. None of us live those lives anymore, because if we did, we'd probably be dead by now.

My mother returned to Chicago. I had six more weeks on my own. I had secured some vague freelance work, writing city guides, reviews of restaurants I had never visited for a sympathetic editor friend in New York. I'm a fiction writer, I can do this, I thought, so I just made up every single review while high on painkillers. My surgery would cost thousands and thousands, even with health insurance, but I didn't know that yet. Effortlessly, I drained my bank account.

After a week, the nerves in my ankle came back to life spontaneously, and it felt as if there were fireworks going off in my foot. What an incredible, terrible new pain to endure. And yet, it was the loneliness that got me the most. This was the first time this had ever happened to me, loneliness as a trauma. The few friends I had in Los Angeles visited when they could, but they also had work, social lives, in some in-

stances families, and if they lived more than a few neighbor-
hoods away, I learned it was difficult for them to drive to me
after they got off work. One of my friends wasn't particularly
employed, and so I paid her to clean my house for me a few
times, but really, I was paying her to talk to me. I hadn't
realized the complicated nature of scheduling in Los Angeles
when I had all the free time and was still mobile. I had just
gone where people told me to go; I was happy to be the flex-
ible one. It had all been an adventure then.

I talked to the pizza delivery guys for too long. I identified
the cycle of the sun in the apartment so I could position my-
self to catch as much vitamin D as I could to stave off depres-
sion. I would splay myself awkwardly at a small café-style
table in one room, a wider dining table in the next, grasping
at sun. Some days I hobbled over to the front of the house
and opened the door and stood on my crutches for as long as
I could stand it. Out there, it was California.

I was sitting there in that house every day thinking: This
is no one's fault but yours. Everything bad that has happened
to you, you have done it to yourself. I took another painkiller.
You are a grown human and this is what you do to yourself.
My wings were clipped so intensely I could feel the blood
dripping right off them. Days would go by where I wouldn't
see anyone at all. I was certain I was bothering people to
ask them to come to my apartment. Everyone was so busy.
I didn't live there. I was a visitor. Everything started to feel
transactional. My ex-boyfriend left me sad voicemail mes-
sages. I lost twenty pounds. I waited to heal. I was the loneli-
est I had ever been in my entire life.

In the middle of all this, a woman I knew who worked in
sales in publishing, Rebecca, reached out to me and told me

she would send me a few things to read to keep me company. The act of a real booklover. (Soon after, Rebecca would go on to cofound one of the finest bookstores in New York, Greenlight Books.) A few days later a box showed up, inside a half dozen paperbacks; an interaction with another human being—the UPS man—was an unexpected perk. One of those books was *Olive Kitteridge,* which had not yet won the Pulitzer Prize. My scattered travels had distracted me from it before that moment. I read it in a day, following the sunlight from room to room, clutching it in my hands. Shuffling on my crutches. Trying to reduce my pill count for the day. Thinking about structure, thinking about character, thinking about landing every single emotional moment no matter how small. It was the first time I had felt my brain working properly in weeks. As if I had forgotten who I was entirely and then there was a book to remind me. I had received the message.

In fact, we receive so much from other writers when they show us how it's done. When they position a character's heart directly on the page for us, when they're inventive in form or structure, or emotionally true in a way that feels radical in its familiarity. Or when their sentences are so crisp as to be nearly audible, like a piece of paper torn in two—all of this shows us how to do it ourselves, how it's possible, but also it emboldens us, releases us from our fears about our own work. An encouragement by example. We learn from them, but also, they tell us we can. Without even knowing it. Enter here. Start here. Begin now. This is why it's always important to be reading. This is why we must always chew on the words of others. It's nutrition. Eat your dinner.

When I was done with *Olive Kitteridge*, I thought: Oh,

this is how I can write a book about where I grew up. A tiny, boring suburb interesting to no one. Except it's all interesting if the emotions are real. It's not about the place (although it is about the place), it's about who lives there, and it's about family. It's about America, but if you do it right, it can be about anywhere. And all the chapters could feel separate from each other and yet connected at the same time until they build up into one complete feeling. I could write that, I thought.

I picture her on her barstool now, this writer in Brooklyn. She is slightly older than me, but much better kept. Someone who has been found sexy her entire life. A more accessible type. Taller, more lithe, softer curls on her head, more specific lips, lips with a wry, saucy point of view, pursed, it seems, always. She rounds the corner with her question: Why this book? She is a journalist in her conversation, in her thinking. This may be why she is better at essays than writing fiction. I don't want to tell her to give up her fiction writing (I would never tell anyone to give up anything anyway, even if I think it), but sometimes it is obvious where people's skills lie. You're already good at one thing, I think, and maybe I'm thinking this for myself, too. Do you have to be good at everything? Do you need to be greedy?

After I got the cast off, I was still limping around on crutches, and I couldn't drive. My friend Pat, who I've known since we were in *Of Mice and Men* together in high school, picked me up one afternoon. That day he offered to take me to see Mike Leigh's newest film, *Happy-Go-Lucky*. I slid down the

side of the hill on my behind while Pat gallantly carried my crutches for me, then helped me to his car. It was the first time I'd been outside socializing in months. He had the sunroof open, and I felt the warmth in every cell. Los Angeles, the city, the streets, the speed, the traffic, I was feeling something big and emotional. We were just going to a movie, but it felt as if he had broken me out of prison. It was my first day feeling free. I wasn't going to a doctor's appointment, I wasn't going to a hospital, I wasn't experiencing a life-changing moment. I was just going to a movie with a friend.

Happy-Go-Lucky tells the story of Poppy Cross (played by Sally Hawkins), a thirty-year-old British schoolteacher who is whimsical, curious, sincere, and, at times, a bit naive. Her fashion sense is vibrant and eccentric—colorful dresses, a distinctive pair of bright red patterned tights and enormous red hoop earrings—and she goes around town with a group of loud, hilarious, edgy girlfriends, drinking and having a laugh. I found myself hungry for what she had, her physicality and spryness and youth. She is also good at her job, protective of her children, and kind to her peers. The main dramatic crisis of the film is her relationship with an angry, aggressive driving instructor who has an unrequited crush on her, and who ultimately is abusive toward her in a confrontation one night. She escapes uninjured, too precious is this character for permanent damage.

She also has a married, pregnant sister, Helen, who is frustrated with (and perhaps a little jealous of) what she views as Poppy's frivolous existence. Helen tells her one night, "You gotta take your life seriously, Poppy. You can't go on getting drunk every night. . . . I just want you to be happy."

"I am happy," insists Poppy. "I am. I love myself. Yeah it

can be tough at times, but that's part of it, isn't it? . . . I love my freedom. I'm a very lucky lady. I know that."

I burst into tears watching it. It had been so long since I had remembered what I was fighting for with my life beyond just getting healthier, not being in pain, and not losing my mind to my aloneness. That there could be a simple pleasure in just existing sounded so foreign to me.

My clothes didn't fit me that day, I remembered. I had lost so much weight—at least two sizes—that my pants kept sliding down my waist. I hadn't known what I looked like, what I felt like, the newest version of me unrecognizable.

I had been one person at the beginning of the summer, flying, fleeing, racing across the country, wanting to be on my own again, and now it was nearly the end of the year and I was just so grateful anyone knew I was alive.

My leg healed enough for me to make the drive back cross-country to Brooklyn. I picked up my Portland novel again to see if there was anything there worth salvaging, and it was so unfamiliar to me it was as if it had been written by someone else entirely. I threw myself at it anyway.

Sometimes we make art in the moment in relation to a trauma, when we need to make art about it in retrospect instead. Certainly, there is something to be said for the purity of the instant response, that flash of hot fire and emotion.

But what if we let time pass, looking at an incident in the rearview mirror rather than at the moment of impact? We can wave goodbye to it, but still see it so clearly, captured in a pristine reflection. And what do we gain? Perspective, wisdom, and perhaps not acceptance—some things do not deserve to

be accepted, after all—but at least a sense of calm. And then, perhaps, we'll be ready to tell a more fully realized version of the story.

But at that time, all I had to hold on to was my writing, it was my steadying force, and I believed I needed to process my pain through my writing. And I still believed every book needed to be finished. I hadn't learned yet that not all of my words deserved to be published. Sometimes we write books to learn how to do something we can use for the next book or the book after that. Sometimes we're making mistakes so that we can learn how to fix them. Sometimes we're just practicing. And sometimes we just fuck up and need to move on.

Why did this book work? This writer sitting across from me at the bar, she wanted math. But all I had was the intangible, the accidental, the breaks and the heartbreaks, and the nurturing.

I moved into a new apartment in the building in Brooklyn, a smaller one I could (mostly) afford, with a view of the Williamsburg Bridge. I started physical therapy. I threw away the Portland novel. I reconnected with my friends, and I realized this was where my people were. Why had I been running away from them? I started throwing salons in my apartment, group readings timed with the sunset so we could finish the night off on the roof watching the glorious sky over Manhattan. Kiese Laymon read there, and so did Alex Chee. Catherine Lacey and Kathleen Alcott, David Goodwillie and Teddy Wayne. I finally recognized I was getting older, because all

the younger writers started showing up in my house. I had written three books by then. If there had ever been ingenue status in the first place it was long gone.

I heard a new voice in my head, one story, a woman waiting in the suburbs of Chicago to meet her mother, who was sick, dying perhaps, or at least in a dangerous place in her life, because she couldn't stop eating. I was not that mother—I had never been dangerously obese, though I had certainly been overweight in my life. I was not that daughter either—my parents were alive and well. And yet I understood both characters immediately, the push and pull of abusing one's self, watching someone you love abuse themselves, the spectrum of decadence and pleasure and overconsumption. Weariness, fear. Wanting to take care of someone, rejecting affection. Writing moments between mothers and daughters will always be my most beloved territory. I sunk into it so easily. The warm, nearly bloody comfort of writing something you recognize immediately as good. I wrote the first chapter and I let it sit for a while, knowing I would return to it eventually.

Why this book? Why not this book? Why not me?

A year after my injury, I had surgery to remove the pin inside of me. There is a Frankenstein-like scar that runs down the side of my ankle now, where it has been opened and closed twice. It has shrunk a little over time, but it serves as a reminder of my hubris, my carelessness with my flesh, and the loneliness I felt those months. But also, how there are some people who love me, who have helped me in my life. I think also of the

books that comforted me at that time. I was never truly alone when I had those books.

My mother comes to take care of me again after this surgery, though it's only a few days of recovery this time, and some hobbling around on crutches for a week after. She attempts and fails to make me chicken soup. In the days after she leaves, all my friends visit me at my apartment. Rosie brings me lasagna and Julie brings me a tuna casserole, and I have more food than I could ever eat for weeks, and I think: That was my problem in Los Angeles, I didn't know enough Jews there.

My third book comes out. I go on tour. Portsmouth, Davenport, Laramie, Big Sur. I come back to New York and I stop drinking for a while and I decide not to write about anything that has happened to me recently, but instead to write about where I grew up, that idea that has been simmering in me since I had been sitting on that couch all by myself in Los Angeles, that chapter I wrote last fall, coming to the surface again, a mother and a daughter, sitting at a train station in the suburbs. The place where I grew up, now twenty years past. For that was how long I needed to be away from it to consider that place: twenty years.

Why did this one work? I believe that one must arrive at an intersection of hunger and fear to make great art. Hunger to succeed and create something brilliant and special and affecting. Fear that your life will remain just as it is—or worse—forever.

I was hungry, and I was scared.

* * *

I rode my bicycle in the melting sunshine of the New York summer up Kent Avenue along the waterfront, from South Williamsburg to Greenpoint, where I worked once or twice a week at WORD Bookstore. Sometimes when I rode my bike, I found myself crying out of nowhere. I felt like I was saying goodbye to something, though I was uncertain of what it was. I just remember having this sense of shrinking further into a specific version of myself; I knew I was actively putting myself there, to be sure. But I knew in order to fit within that part of myself, I couldn't be outside of it. There could be only one version of me.

I was thirty-nine. I was on my own, and there was not any part of me that was in a place to alter that. I had a desire for closeness, love, affection. I was capable of it—I had seen it in myself. But I was still trying to figure out how to write, and how to be an artist. And I think I can only do one thing at a time. Maybe that is the only thing I will ever do. Writing. The desire to create my art was fully inflamed, had taken over my interior, like some high-fevered virus, one that causes hallucinations, and I liked the hallucinations, appreciated them, was fascinated with them, and I chose to stay sick—though it was not a sickness, not to me.

Because I knew I was working well, and the satisfaction I got from that fulfilled me more than anything else. Certainly more than most men I have had relationships with, most sexual encounters. Even if I found (and still do find) sex thrilling, the act itself is always momentary. The books I wrote had

the possibility to thrill others long after I had created them. I could make something that would last. To fuck was divine, but to write was eternal.

Why this book? Because I wrote hard.

I finished it. My friends gave me notes. It was the best thing I had ever written, of that I was certain. Still, my publisher dropped me. It didn't matter that it was good. They were done with me now. I was tarnished in their eyes and in the eyes of many other publishers, too. They all looked at my track record, my sales figures. No one wanted to touch me. Except for two editors who offered me a low sum of money. I chose the editor who called me and said, warmly, confidently, "I know exactly how to make this book work." And when she got off the phone with me, she called my agent, and doubled her offer. The book you are reading right now is the fifth I will have done with her.

I read something my interlocutor on the barstool had written recently in a newspaper, about new passions and hobbies, and a breakup in her life. She makes a convincing case for her existence. Sometimes I think the only difference between us is she grew up on the East Coast and I grew up in the Midwest. Or maybe it's that she grew up pretty and I didn't. We cover the same subject matter, but differently. I could be writing the same pieces about a middle-aged breakup. I *am* writing the same pieces about a middle-aged breakup. About getting

together with someone and finding things difficult and ending it and still seeking to find someone, until the day we will not care anymore about finding someone and we will write the essay about how we're just fine, by ourselves, on our own forever. Which will be the truth, but when we write about it the first time, it will still feel like a specific kind of death. "I'd rather be alone" is a thing I say all the time when I am talking about love and my work, but I could easily add "But just not yet."

She still looks great on a barstool. In my memory, she will always be in the prime of her life. I'll always picture her there, even if I read every essay she writes about her life from now on. She is trapped in time in a bar in Brooklyn, looking for an answer that I can't give her because it doesn't exist.

Why this book? Because I was broken and then I healed, but not entirely. That book is my joy, a gift, for myself, for others, an object I can hand someone with the hope it will bring them pleasure. It is a thing that changed my life for the better. But also, always, forever, it will be a scar.

Brief and Dire Spasms of Turbulence

5

Three Bodies

1.

That flat, quiet midwestern town I grew up in was mostly dry. There were manmade ponds in new housing developments, streams running through forest preserves. A tiny creek over by the baseball fields, which I remember tripping and falling into once as a child while wearing brand-new white jeans. (The early sting of mortification; I hated it, but at least something was happening.) A forty-minute drive to Lake Michigan, but my parents both worked; who had time to drive to the lake more than every once in a while? My surrounding universe was newly emerged strip malls and two-family housing developments and apartment complexes with mansard roofs and the abandoned cornfield behind our house, which was eventually sold to make more houses. There were plenty of parks. Things were green, certainly. There were community

pools we could walk to lazily in the summertime. I loved to go swimming. But it did not feel wet there in the northwest suburbs of Chicago.

Wet was reserved for summertime trips out east, which was where my parents had both grown up. My father in his earlier years outside of Boston, my mother in suburban DC. We would pack up our station wagon and drive east, often stopping for a night in Ohio, to visit some distant cousins on my father's side. Ohio was always the longest state to me; it stretched on and on. There would be no "new state" excitement for two days. It was just Ohio. But once we crossed that threshold, we were on our way to Ocean City.

At Ocean City there were two places we stayed, the reasons for which each year were never clear to me. (Family dynamics were always a grand and fascinating mystery, and I watched for unspoken nuances with the reverence of a daytime soap opera addict.) One source of lodging was with my mother's stepmother, Naomi, who we thought of as our grandmother and was known as "Nana Honey." It was a condo she'd owned for years in a small private building. I faintly recall a decor of pink seashells, scented hand soaps in the bathroom. A small balcony overlooking the ocean where we would sit sometimes at night to watch the sunset. The beach was quieter near her, it felt more intimate, and we liked being with this woman, who had taken care of three children she had not given birth to for so long, all the while running a shoe store called the Shoe Horn, which catered to rich senators' wives in downtown Silver Spring. She was a grandmother, and she was happy we were there. She told us stories about the grandfather we had never met, my mother's father, gone for a long time now. We always drove to her

house first, and, after a long ride in the car, would tumble out and run straight to the beach and jump right in the ocean. We had worn our bathing suits in the car all day, just for that moment.

The other condo was in a fancy high-rise building farther into Ocean City, where the beaches were full and flourishing, and there were more treats to be found, ice cream stands, shops to buy various sundries, plastic beach buckets and shovels, smeary jars of suntan lotion, boxes of saltwater taffy. We'd beg money off our parents just for the joy of spending it; already we understood the thrill of capitalism. Upstairs was a loaner condo that my aunt Sandy had access to from her employer; this was where the party was. This aunt and uncle were younger than my parents, childfree, successful, well traveled: they were a good time. The building was called The Quay, and every year we discussed the correct pronunciation of it as we drove up. It had cable television, and we watched the early years of HBO, Stiller & Meara hosting summertime marathons. We'd come in salty from the ocean, sunburned from a long day of play, and eat chocolate chip Entenmann's cookies, grabbing a handful and sitting on the couch after changing out of our wet bathing suits. Outside was the sky and the ocean. Inside was my family, kibitzing, eating, occasionally bickering, and whispering about inter-family struggles that only seemed to shift slightly year after year. What did it matter what was actually wrong? That was for me to make up on my own.

Naomi's house was quiet, sandy, damp, dim. Lights out early. The high-rise was electric, full of conflict and pleasure. The grown-ups drank. Another uncle, Howard, went fishing at sunset in the ocean, stoic, possibly unhappy in his

marriage, silent, smoking, brooding, though he seemed to love his children, but perhaps not children in general. (Later he was discovered to have cheated on his wife with another woman in their marital bed, and he was disappeared from our lives forever.) My mom read Danielle Steele novels and also everything John Irving wrote and I used to sneak them from her and be riveted by the sex scenes. When I was fifteen, I had my first makeout session with a punk rock boy from New Jersey I met on the beach, his tongue slipping in and out of my mouth in a rhythmic fashion, as if he were calculating every move. I did not technically enjoy it, but it was thrilling, nonetheless. The water was alive. The surf crashed.

The summer I was eight there was an afternoon I took the raft out on the ocean. It was something we all took turns using. That year I am flat-chested and chubby, smiling for the picture, but I remember I couldn't wait to be by myself. I was always satisfied on my own, although occasionally I worried I was supposed to have friends. I went out past where the waves crashed, where we all would body surf in, screaming and laughing, or we used to jump up high over the waves just as they approached us. We would scream, "Here comes trouble!" and then jump over the waves. This was beyond that, where I floated, beyond the action, just me and the ocean.

I ask my mother about this day now and she can barely remember—she thinks she wasn't there, maybe she was up in the condo. "But that sounds like you," she says. "You were always off in your own little world. You were always thinking." I remember looking up at the sky, being utterly peaceful and calm and dreaming about whatever I liked. Satisfied to be away from my family for a while, too, and all the energy that went into being present, behaving, the dynamics, the re-

lationships. It was just so hard not to notice things. I could never shut off my general state of awareness.

But away in the ocean, on the raft, I could just be in my head. It was the same sensation as when my mother used to give me a pen and paper and just tell me to play. The most content I could be was to be by myself dreaming. Away from the crashing waves I felt safer. I was nearly asleep. Everything felt calm and still.

But, of course, it wasn't still. It was a body of water, full of life and movement. I was a child on a raft in the ocean. The water dark-green and purple and midnight blue with tiny crests of white rippling along it. A ceaseless motion underneath the August sunshine. Later we had plans to go out to dinner for boiled crabs drowned in Old Bay seasoning and we would each have our own little mallets to smash the crabs to bits. Right then I was floating above the crabs. Everything was connected, I knew that already. Knowing things like that—knowing anything—was a soothing feeling. Now I could close my eyes, hold a thought in my head, the sun above me, while far away my family was being noisy, talking, eating. Do you know this continuous tension of needing and not needing people? Knowing they're nearby, happy they're there, but wishing them away, too. They were on the shore, where they belonged. And I was motionless, I was one with the ocean.

And then there was a surprising jerk of the raft and it was Howard, who had swum out, urgently, to retrieve me. I had drifted too far. They could barely see me. For a moment they had worried they had lost me. It would not be the first time I hadn't realized anything was wrong with what I was doing, or that something was amiss around me. When I was just happy to be dreaming.

He paddled me back to shore; I held on to one side of the raft, and he the other. He wanted to be the hero. He had raced out to save me, but had I needed saving? I wasn't convinced. On the beach, I was embarrassed by my family. I didn't want the attention. Not that kind of attention. My body had gotten me into trouble. I felt bad for worrying people. My family chided me. I sat glumly in the sand. The end of the daydream.

2.

I did not wear a bikini until I was forty-five years old. I have tried to remember why I never wore one before, unpacked that particular logic. I know there was a sense from a young age that a bikini was something I *shouldn't* wear. Picture a country (America) where the notion of a "bikini body" is a very specific thing. And a girl who developed early, an awkward, book-loving girl, who took no pleasure in the attention her body got her. A chubby girl. Curves that had shown up all at once, without warning.

Bikinis, I felt, were made for girls with flat stomachs and willowy shapes, and that has never described me, except for perhaps two weeks somewhere between the ages of ten and eleven. I just wanted to run and play and not have to manage anything, pay any attention to what was sticking out. And boys always seemed to be racing around swimming pools trying to undo girls' tops. It was enough that there was so much of me already—I didn't want to have to worry about what might happen if I wasn't covered. I didn't want to think about what people saw when they looked at me.

I am sorry that I fell into the trap of America for so long

and its impossible notions of body perfectionism, but I am a child of the '80s, when everyone was on cocaine and skinny and John Travolta made movies about aerobics class and spandex was suddenly a thing people wore regularly, in public even. Even as the patriarchy has been practically translucent to me my entire life, I have still managed to internalize parts of it. And if I didn't look like that specific bikini vision I saw in the magazines, I should cover up this body of mine. America, I love thee, and I curse thee.

But no one was looking at me, I know this now, at least not in the way I worried they were. And also, my body is my own and I can do with it what I like. To view things through another's gaze as it applies to my own flesh is exhausting. Can you imagine viewing everything in your life through two sets of eyes? Yet surely, I have viewed myself through thousands of sets of eyes in my life. Without even knowing it.

In 2016, my gaze changed. It was my final summer in the city, right before I left New York forever. I decided to take a bike ride to the beach before I left.

This was something I did at the beginning of every summer, when I lived in Brooklyn. I'd ride from Williamsburg, on Kent Avenue, down Vanderbilt Avenue, through Prospect Park, and then take Ocean Parkway all the way to the water's edge. I'd park my bike at Brighton Beach, where the Russians live. It has always been a special place to me. I never truly felt connected to my Russian heritage growing up in the Midwest. The first time I ever visited Brighton Beach though, in the late '90s, people approached me and started speaking to me in Russian. I looked a certain way; I was of a certain people—I had never really considered that before. I was instantly comfortable in my skin there, even if I didn't speak the language.

And that day, twenty-odd years later, as I spread my towel out on the sand and took off my cover-up, instead of worrying about how I was seen, I saw the Russian women on the beach, as if for the first time. The old women, the round women, the narrow women, the young women, the wrinkled women, the *women* all around me. They cared naught if they looked one way or another. And almost all of them were wearing bikinis.

It hit me hard: What did it matter what flesh showed or didn't? Why hide? Who was I hiding from? I was only ever going to be me. I was only ever going to have this body forever. Life was too short not to have radical acceptance of my body. And who am I to hide or ignore this flesh when there are so many fighting all over the world for control of women's bodies? And who am I to ignore this body when it is still healthy and strong? And who am I to deny myself the comfort of the sun against my stomach, or the way the ocean feels on my skin when it surrounds nearly all of me?

At the end of the day, I wiped off the sand from myself, rolled up my towel, slid my beach bag into my basket, and biked all the way back to Williamsburg. A week later, the moving truck arrived.

3.

There is a stretch of land on the edge of the Upper Ninth Ward that is often referred to as The End of the World. This length of grassy land lives at the intersection of the Mississippi River and the Industrial Canal, and in order to access it, you must cross a set of train tracks and uneven ground, and

from there climb up the short but steep side of the levee, follow the levee south, past a point where an abandoned shack sits, sometimes occupied by an unhoused New Orleanian, and then, just to the east, when you hit a picnic table, flanked by a short, rickety, rusty watchtower, you've arrived. Behind it, to the south is the river, where shipping barges and the riverboat Natchez float; farther east you can see the edge of the lower Ninth Ward, and to the west, you can see Algiers across the river. Look back north where you came from to see pelicans and cranes often adrift in the canal, and behind that, the St. Claude Avenue Bridge, which raises on occasion to let boats pass through on their way to various other industrial canals.

On a sunny day, with a blue cloudless backdrop behind it, The End of the World can convince you that you are in the most special place in America. Look at all this sky, look at all this green, smell the river, this is a city but also it is the country, can you believe it?

Scratch the blue skies, have you ever walked on it at night when it's foggy and humid and you can feel the water and earth rising to meet your skin? Haunted, you're convinced. Haunted, one of your favorite things.

Or have you seen it at sunrise near the end of Carnival season, when there's a chorus of young singers welcoming the dawn and their annual anarchist parade, and you're swigging from a bottle of champagne or pie-eyed on something stronger or perhaps still up from the night before and you think how can this be real, this moment?

Have you been there at sunset when the dogs run with their owners all over the land? Their magic hour, the dogs, the happy, panting dogs.

It is at this location where I attended the funeral of a

man whom I had never met, invited by a friend who knew him, who assured me it would be OK. We trudged along to The End of the World, behind a small second line, the tail of which was comprised of a few musicians, intimates of the deceased, not particularly organized in their performance but sincere nonetheless; sad white men with horns. I was in the middle of falling in love with the city right then. I was in the middle of imagining a life for myself outside of New York, where I had lived by then for fourteen years. I had failed and succeeded and failed so many times already that I had no lessons left to learn except this one: I would be a fool for staying any longer. But I had never figured out where I could live besides New York. What place could occupy me as much? But what about a city of sad men playing trumpets? What about that? Where you are both sad and alive at the same time because this is music, after all, this is a city of music. Where people drink and dance when people die. I was nearly done with New York, or maybe New York was done with me. Maybe I should blow up my life, I thought.

On the levee I was learning bits and pieces about the man who had died. Katrina had been rough on him. He had led a wild life. He didn't take care of himself. He abused all manner of substances. He died too young from all these things. He was tough to love but he had been loved, nonetheless. People had flown in from all over the world for the funeral. I didn't know if people would do the same for me. This is what we think about at funerals: the dead, but also ourselves, too. I stood back when we reached the very tip of land. It was there that personal words were spoken by his friends and family, pieces of their heart offered to the sky, and then his ashes were flung in the river. But those were

not for me, those words. I removed myself from the crowd. I said a prayer for him, this stranger, as I leaned into my own quiet. No pain for him, I wished. Only peace for this person. Ships on the river moving slow but steady. There was wind that day, and it rustled the skirts of the women in attendance. Ashes in the river. Goodbye to you, stranger.

Years later I will have moved to New Orleans, bought a home, made a quiet life of letters and people. My old friend Will comes to town for business and after a few drinks I will take him to The End of the World and it's the foggy version that night and I see him fall in love with the city a little and he insists dramatically that I must live there forever—"Promise me you'll stay here," he says—and I think he has some idea of me engaged in a fantastic existence when I know my truth, which is me at home alone with my books and my journals and always looking for pens and never finding them and then ordering more online and checking my Instagram all the time to see if someone I have a crush on is looking at my stories or not and why can't I ever get my glasses clean, or rather, why are they always so filthy, maybe that is the better question—and I laugh at him a little bit because where else would I go? I was already here, didn't he see that? I had arrived at my destination. A place where I could live and write. But it would take four more years to get there. To be able to put my body in the place where it needed to be. Four more years to get home.

6

Extra Life

I went to Vilnius, Lithuania, to teach. 2013. One year before I had just recovered my apartment keys after couch-surfing for months. Now I was living in a serene apartment off the city center, in a building with a vaulted ceilinged staircase, and brusque, well-heeled neighbors who nodded curtly to me when we passed. The sun didn't set till ten every night; I was dazed and wired all the time. I ate fermented cheese and smoked fish and black bread and pickles in cafés. I ate cherries I bought at a market from a woman with berry-stained hands. The drinks were cheap and strong, but I never felt drunk. The weather changed on a dime there, rain would roll through for fifteen minutes and then out again, and afterward the air was clean. I walked cobblestone paths alone, for hours, until my bad ankle gave out on me. Every street looked the same. I got lost a lot. I never recovered from the jet lag, I never adjusted to

the time zone. I barely slept. I was simply off, for two weeks straight, in Vilnius.

I was teaching a fiction class in a program that catered to North Americans. It was an expensive enough venture that the students were there either because they really meant it or because they could afford it, and it had sounded like a good time. I did not blame those who were there for the party. It was my first time teaching a workshop that had lasted longer than an afternoon. I was nervous. Not only had I not taught much before, but I also hadn't been in academia for twenty years. In a way, even though I had written four books, I didn't know what I knew. But I hadn't mentioned that to anyone when I was invited to join the program. Just say yes to everything, I thought frequently at the time. So much was being offered to me after years of no one noticing I existed. I had been on tour for nearly a year and would stay that way mostly for two more years. Say yes, I thought. To everything—whether it seems like a good idea or not to be working that much, traveling that much. Because it could all be gone again tomorrow. This is your bonus round. This is your extra life.

I was a newly moderately successful writer. I have friends who are famous writers, friends who have sold millions of copies of their books and have had movies made out of them and who get paid tens of thousands of dollars to speak in public multiple times a year and who make cameo appearances as themselves on television shows and who are interviewed by Terry Gross and profiled in the *New York Times* and who are recognized on streets and airplanes all over the world. I was not that. There were three cafés in Brooklyn where someone might recognize me, plus my parents' gated community in Florida, where my mother had thrust my books

into the hands of every neighbor within spitting distance of the pickleball court. What did being moderately successful get me? A low-paying teaching gig in a foreign country. (It still sounds pretty good now.)

At night we gathered at different historic venues to hear readings by the faculty, and afterward flitted off to bars and clubs. The city was full of young women, tall, slender, with long blond hair, long legs, wearing tight-fitting jeans and white T-shirts and blazers and Converse high-tops. The men were fair and masculine and distant. I wondered if all of Lithuania was just comprised of beautiful people. A man affiliated with the program who had spent a lot of time in the city told me one night drunkenly: "The women in this country, eh, they don't age well." I studied his face closely: I wondered how he'd age. I avoided him after that.

But most people bonded quickly; the students were all neighbors in nearby apartments. Late nights, booze, freedom. My apartment was far enough away from my students that I maintained a sense of privacy. What did they know about me anyway? Not much, and I wanted to keep it that way. I spent time with the poets. Poets aren't gossipy like fiction writers, or maybe they just gossip about different things. Poets always ask you what your sign is—that is, if they haven't intuited it immediately. I sat with Rebecca and Eileen outside at cafés and we talked about New York and writing, being a writer. We were all hungry for so many things. At Eileen's reading I wrote down a line from one of their poems: *We thirst*. All the beautiful things they said and there I was, focusing on consumption.

* * *

One night I walked home, late, through the streets of Vilnius with a poet named Ariana. She was a small woman, just five feet two, with a body as delicate as a bird's. She was studying to be an astrologer and she dressed like an art student from the 1980s, black leotards and lean jeans and oversize glasses. She had recently published a highly lauded collection of poetry and was as confident a speaker and performer as I'd ever seen. She was also savvy; she knew how to operate in the world, get teaching gigs, and fellowships, and assert herself to be paid to do what she liked. In my imagination, she was a tough, New York street kid all grown-up.

Yet, that night, as we walked through the darkened streets of this not-so-formerly oppressive Eastern European city, two Americans, two women, two artists, two people who had been raised as Jews, I felt like I wanted to watch out for her as I would a child. We became friends that night, I felt. When you are instantly protective of someone, a sliver of a bond forms. I have always felt protective of other women. And I have always trusted them on impact and given them all I could. For while it is men who I crave and desire, who I would like to lie down next to and smell their skin and allow them within me in an intense and foreign way, it is the women I seek comfort from, and to whom I would like to provide comfort. It is possible for me to walk with a woman from one location to another in a short period of time and think to myself, Now I know this person and care about her, and she is my friend.

With men, it will take days, months, years, to arrive at the same place. I will have to assess and evaluate them and adjust my understanding. It is not the man's fault. The man may be perfectly fine. It is just that I have had an entire life-

time of men doing terrible things to me. Even as I desire them so deeply, it is difficult for me to feel like I can rely on them. My trust issues are of the classic variety. But they did not spring forth from the earth unwarranted. I see no issue with whether I trust men easily or not. Let's put it this way: I'm probably right.

Though it was just us on those cobblestone roads, I imagined there were men moving drunkenly in the night. I was much taller than Ariana, bigger in general, and even though she had those street smarts, I worried for her in that moment. She could have been scooped up and taken so easily, disappeared forever. Nothing happened, but I pictured it anyway: the possibility in the darkness. Even when no one was around, there was a chance of danger. I saw something in the empty space.

Class wasn't going well. I had left my glasses on the plane during the flight over. I bought readers at a pharmacy, but they barely helped; I struggled through reading student work I revisited the morning before each workshop. I knew a lot about writing, but I didn't yet know how to express it. I doubled down and spent long afternoons devising writing exercises that promptly flopped in class the next day. I knew I was disappointing them. What did I know? What did I need to learn? I thought this every day.

The city in which we were all living and working for two weeks had, as many European cities do, a tragic past with the Holocaust. In this instance, there had been two Jewish ghettos in

Vilnius. The Jews in the first ghetto, which was located centrally in the city, worked construction and factory jobs. The second ghetto, which was on the outskirts of town, housed Jews who were incapable of work, the elderly, the infirm, those without skills. By the end of World War II, 90 percent of an estimated 250,000 Jewish Lithuanians had been wiped out; most of the two hundred Lithuanian Jewish communities were destroyed entirely, as if they had never existed. It is worth mentioning many of the Jews were not killed in Nazi death camps, but instead by their neighbors, who either shot or beat them to death. It is also worth mentioning that today a well-funded Museum of Genocide exists in Vilnius, but it was not until 2011 that the Jewish genocide was even mentioned within its walls; the museum instead focuses on the Russian occupation of Lithuania post–World War II. Prewar, there were 105 synagogues and prayer houses in Vilnius. Now, only one remains.

Part of the program I was attached to supported a group of people who were there to investigate their ancestors who had either died in the Holocaust or fled from the city during that time. Holocaust tourism is a particular thing: one can visit ghettos in Warsaw and Kraków, or death camps in Treblinka or Auschwitz. A person can get on a plane and arrive in a city and then get on an air-conditioned bus with other interested parties and then walk on this land where people were mass murdered eighty years ago. Perhaps there is also a fascination with haunted locations. (This I understand entirely.) But Holocaust tourism appeals directly to Jews. We are on the tail end of the generation of survivors—eighty years out. People still feel the absence of those people in their lives, even ones they have never met. Because these were the stories we

were told as children, our parents before us, the generations after mine, too. There are spaces we can contemplate, walk through in our minds, but they will never be filled, because those people are gone. To engage in Holocaust tourism, one can see a town, a marker, a stretch of land where someone once was. Share the same air, feel the dirt beneath your feet. Where they lived, died, were buried. I do not argue it is an important piece of history. But I revolt against this sense of there being a Holocaust machine. An economy around it.

I am Jewish, was raised Jewish, had a Jewish education and a bat mitzvah, read and was quietly devastated by *Night* like everyone else in high school, watched PBS documentaries, visited museums dedicated to Holocaust studies both in America and abroad, including Anne Frank's house (I had read her diaries, riveted, as a youth, of course, of course), and felt thoroughly informed and paranoid about that particularly dirty and devastating part of history. On top of all that, my grandfather fought in the Battle of the Bulge, for which he was revered in my family. My brain will be flush with images of the Holocaust and the war that surrounded it for the rest of my life. And I did not share the instinct to visit locations like these at that time. I do not mean to sound flip or blithe about any of this, but I had thought enough about the Holocaust for a while. There are so many versions of this kind of mass murder to consider in America alone. I have made space for these atrocities over the years, swapping in and out which of them demands my concern in the moment, who I should mourn in my mind. Hundreds of years of spilled blood to wade through before we even arrive at the Holocaust. They are all connected, and they are all worth our time.

Yet one day I went on a walking tour of the Jewish ghetto

that was being offered through the program. When I think about it now, I feel certain I went just so I could tell my parents I did, because they would have loved it. Not enjoyed it, but loved it nonetheless. So, in part, I went in their stead. The fears and concerns of my parents and their parents before them had been impressed so thoroughly upon me as to become cellular. I did not seek it out, but I could not ignore it when presented to me.

Our tour guide was a young, dark-haired Canadian writer named Menachem Kaiser, who had gone to Vilnius on a Fulbright a few years before. While there, he had been asked by a tour company to create a tour around the Jewish ghetto. He discovered there were virtually no physical records of its sordid history on the streets of the city. He set about to correct that, not just by designing a walking tour but also by creating a virtual map with cartographers and historians, called the Vilnius Ghetto Project. A map of the invisible. I think about it every time I see a map that regularly circulates on social media, particularly on Thanksgiving and Columbus Day (often reclaimed as Indigenous Peoples' Day), which allows the user to type in their zip code to find which indigenous nations inhabited their land originally. (Choctaw over here in the 70117.) I appreciate being asked to honor the past, honor ghosts, even if they aren't my ancestors. I am grateful for the knowledge and the opportunity. We should want to know the truth.

I also appreciated imagining the space where they lived as different from where I was standing for a moment. I came into it not wanting to contemplate "The Holocaust"—but how could I not contemplate the ghosts?

On that summer afternoon, we visited various locations

on that map. Here is where the town hall was, here is where the soup kitchen was, here is where the lecture halls were, here is where a theater was. Nothing was there on that day (or now, I would imagine) to indicate any of this had existed. It was just a city, functioning in a modern way, cars, office buildings, apartments, people walking freely, phones in hand. Our guide's tone was correct: serious and informed, but not depressing. He was just asking us to pay attention and imagine and remember, even if we had never known it in the first place. Remember someone else's memories. Recognize that history.

Then he brought us to the library, which had been busy and successful; a hundred thousand books, more, had been checked out of it. After that we stopped in an empty courtyard encased between some residential buildings. Inside it was peaceful and still, with sparse patches of grass and some trees. It was hot; the sun was steady. Imagine this was here, imagine that was there, imagine a time more than seventy years ago when people were struggling and suffering and held against their will simply because of their faith.

But he wanted us to consider something else, too, he tells me now, over text. He is in Brooklyn, and I am in New Orleans, it is May of 2020. We start off the conversation with the usual "Are you fine, are you safe, are you sound." Yes, we are fine, yes, we are working. "An acceptable kind of terrible," he says. Then he tells me this: "I wanted people to appreciate just how rich and varied and strange ghetto life was, that it went way beyond just a place where people were rounded up, waiting to die."

I know that there is one small part of me that is always grieving for those who were lost, and it has been that way

since I was a child. I did not need to reignite a flame that was permanently lit. But I took a picture of one particular corner of the courtyard. In it, the walls of two of the residential buildings intersect, they're a faded pink stucco, water-stained in parts, the concrete crumbling a bit at the base. There's a tree with a narrow trunk shooting out at an angle, with a short weedy plant to one side of it, and a metal grate leaning on the wall to the right, covered with some light green ivy. I was still thinking about the library. What he had told us minutes before. The book that was checked out the most from it? *War and Peace.*

And I could picture someone holding a copy of that book, sitting in that corner of the courtyard. Did they read it to occupy the time? Did looking at the past help them to project into the future? I imagined a man holding a heavy book. Maybe a member of the resistance. The days were long in some ways, but not long enough for what they needed to accomplish.

It is cold in the winters, in Vilnius.

Later, outside a small Holocaust installation in a building known as The Green House, a man dressed in rags spat at someone in our group. He called us "dirty fucking Jews." The only reason I knew that's what he said was because someone in our group spoke Russian. And if he hadn't been there to translate, I would have assumed instead he hated us because we were Americans.

Facebook always tries to tag Ariana as me in photos, and me as her, even though we look nothing alike, except for big

glasses, and big hair, and big eyes. Jewish, is what I always thought Facebook was saying. The interchangeable Jews.

In 2019, my friend and New Orleans neighbor Ann Glaviano directed and co-choreographed (along with five other women) a dance performance called "St. Maurice," which was inspired by the history of the St. Maurice Church in the Lower Ninth Ward, just across the river from where we both live now. Post-Katrina, the 151-year-old building was deemed by the Archdiocese of New Orleans not worth the cost of repair. That the church was an important center for the community and its members had raised more than two million dollars to maintain it was disregarded by the Archdiocese, and it was eventually closed and sold, with the Archdiocese keeping the money. Ann told me that she had gone into the project with this question: "What's left after the church that is the hub—the institution that the community relies on—what's left when that is stolen from them?" She went in with no answer, she said. But by the end, after doing some focus groups, and through the process of devising and performing, she had one.

"Tell me," I said. I really needed to know.

"What's left is the people," she said.

The last performance of "St. Maurice" I attended was held in a warehouse space in our neighborhood, and the dancers reconstructed the church with their bodies and just a handful of props: a maroon piece of chiffon, for example, and a bedsheet that became a kite. A bathtub, chalk, oranges, flowers. The show lasted for more than an hour. The performance was sprawling: each woman acted as an anchor of a new location

in the venue, and the audience was invited to walk around where they pleased. (When I ask Ann about it later, she claims the audience as co-choreographers, too, because they were asked to move through the space and in some instances interact with the dancers.) There was a live soundtrack played on a keyboard, an experimental Mass. When I watched this performance, I was convinced they were conjuring up a space of a kind—another map of the invisible—just as I was convinced that when they stopped, the church disappeared like droplets of water evaporating. I've had several conversations with Ann since about it, and what I was most interested in was what she wanted to have happen by asking people to imagine something that wasn't there.

"What do you hope people will get out of it?" I said. "It makes them engage as audience in a really different way than if I'd brought them into the actual old church," she said. "When the audience has to imagine it, they are building it with you."

I thought I saw the library that day in Vilnius. I thought I saw the man holding that book. If you ask me to imagine it, I will. And if I write about it, if I document it, it gets an extra life. I could ask people to imagine that courtyard, that library, even if they weren't there. I could ask you to remember it for a little bit longer. I could ask you to honor the ghosts.

What happened to Ariana after that? Once I attended a party at her house in Bushwick. A year later I ran into her on the street in the Financial District, outside an art show. Occa-

sionally we text. She moved to this place and that, residencies and fellowships and graduate programs and speaking engagements. Somewhere in there she wins a big award. I didn't see her for a long time. Then no one sees anyone. And then finally there was her face on a screen: we were both teaching at a conference, late spring 2020, and all the faces of the advisers were lined up in rows, *Brady Bunch*–style in a Zoom. I had become better at teaching. Incrementally, through practice. Acquired language, honed the ability to assess work. I was still there, I was still in it, and so was she. I thought for a second I could reach out and touch her. I waved at her and looked at her in the eye, though of course she couldn't know that she was the one I was looking at. But later we texted each other that it was nice to see each other's face. Once we had ambled down those darkened streets so boldly, and now we were reduced to boxes on a screen.

At the end of the program in Vilnius, I spent two days meeting with each student individually for an hour. I wanted to offer them the best version of my brain. I felt I had failed them, but at least I could offer them this. I had an idea of how to get an agent, what they looked for in an author, and I was also friends with a number of editors and had listened to them talk about buying books. I had a good sense of how to come up with a strong title. I had thoughts on how the beginning of a book could capture someone's attention. I didn't think I had done a great job during the workshop. I was mad at myself. I was sick of myself. I sat in a café and met with students for a full day. I wanted to help as best I could.

Two of my students—both men—asked me directly if I

thought they were ready to quit their jobs and devote their lives to their work. One of these students had left town for a few days during the program to attend an outdoor festival in another country. I told them I had been working steadily as a novelist for eight years and had only that last year been able to quit my day job. None of that mattered. They just wanted to know: Were they good enough?

I didn't tell them that I feared at every moment that this new kind of freedom would be taken away from me, that at any moment any of our freedom could be gone.

And how do you explain that nearly no one is good enough, it has to do with how much work you put in, your diligence, your persistence, some fortune, some luck. And I suppose it has to be with your willingness to imagine things that aren't there. They didn't need me to give them permission to live their dreams. No one had ever given me permission to live mine.

The better questions to ask: What kind of stories should I be telling? What would I be willing to do to make it all work? What do I love about writing? What are the voices that need to be elevated from my world and from outside of my world? What secrets of mine would I be willing to tell? What do I know already? What do I need to learn? Is that a ghost in the shadows or just another person slipping into the night?

7

Air and Smoke

An early morning flight leaving from a midwestern city. 2013. This is when the anxiety kicked in.

I had been in town for an appearance. It was a small event; no more than fifty people had attended. I had sold a few books, collected my check. I had no real sense of caring one way or the other, although I hoped everyone had a good time. Later, I had one of the hosts drop me off not at my hotel near the airport but at a past lover's house in the city. I'm sure she thought I was acting oddly. I wasn't offering her the whole story. An old friend, I said. We were having dinner. But I took my luggage with me. She kept offering to buy me dinner instead, this nudgy, but kind woman. Somebody's mother, I was sure. Not my mother, though. I didn't feel like explaining anything. She was a stranger. It was my personal life. I had done my job for the day—was I free to go now?

The next morning, wrecked at 5:30 A.M., I caught a cab to the airport. I boarded a plane, a small one. A toy plane, I thought. It had two seats on either side of the aisle, except for the very last seat, which was a single, directly across from the bathroom. This was where I was stuck. The last seat in the back, where the troublemakers go. The flight attendant was in her fifties, no-nonsense, unsmiling. Getting you from here to there and that's it. She'd leave me be, I thought. I'd had about two hours of rest the night before and was hungover on arrival. I fell asleep almost immediately, a hazy, buzzed sleep. Twenty minutes later, the beverage cart rolled over my foot, and I woke, gasping. I felt a solid pounding in my chest, beating me up from the inside, and I was terrified. An instantaneous anxiety attack.

The beverage cart had me locked into my seat. I asked the flight attendant to move it and she wouldn't. Please, I begged her. Let me up. She ignored me, served drinks to the row in front of me instead. I was not her first anxiety attack, and she would not be rushed. Finally, she moved the cart. I stood, but there was nowhere to go. It was just me on that plane and my deadly beating heart. I knew I couldn't sit in that seat anymore. That seat was the enemy. This airplane was the enemy. I asked a man sitting nearby if I could join him. I made him move over. I caused a scene. I hate causing scenes. It was the worst flight of my life. At least up until that moment—for there were worse flights to come.

On my first book tour, sixteen years ago, a male bookstore owner hugged me too long after an event at his shop. "I could

tell you were special by your picture," he said. I wondered if he'd even read my book.

The flight had rattled me, but I kept traveling. Why didn't I just stop right there after that flight? Why didn't I take a pause? Because it was business. There is a limited amount of money writers can make selling the physical objects we create. These speaking engagements paid some of the bills, too. I was not in the position to walk away from these opportunities. I did this for three years.

I started taking antianxiety medications. Never prescribed. I realize this is not how it is supposed to work. That if you have anxiety you should go to a doctor and discuss your issues with them, and then they determine if and what kind of medication you might need. That these were bigger problems than just issues with flying. That a pill is just a temporary fix.

But, hear me out, another option: it was much easier to just get drugs from friends with excess supplies. Who has time for therapy anyway with all that travel, and other writers were more than happy to donate to my cause. They knew where I was at, shaking out a few pills from their bottles, smiling at me in sympathy. It was rough out there on the road. It was rough back at home, alone. No matter where you looked, it was rough. Best not to look.

Once I did an event where a man standing in my signing line said to me, "You remind me of my daughter; she's also a narcissist."

* * *

A literary festival for women in the South. I talk for forty-five minutes, I sell fifteen books. The big-ticket speaker is a famous mystery writer, and I envy her signing line. Later I sit in a hotel lounge, drinking happy-hour pinot grigios with a bestselling novelist who is sober—besides all the pills she takes. She offers me an array of sleep aids and anxiety meds, six kinds, different sizes and colors, details their powers. Which one knocks you right out, which one eases you through life gently. Only take half of this one. Half is all you need. I bet she learned how to share as a child. Offering her sandwich to the kid next to her during lunch; sharing the last of the blue paint during art class. I could see a teacher commending her for her natural instincts. She taps one more in my hand. This one is *great* for a plane ride.

On one tour, to support my novel about a morbidly obese woman and her family, I lost track of how many people greeted me with "Oh, but you're not fat at all." It made me nervous, people noticing my body. I became a fiction writer in the first place because stories are a beautiful place to hide.

A festival in a European city along a glistening lake, where we sat outdoors at tables with stacks of our books in front of us and spoke with locals who knew English better than we did. One of the most famous writers in America at that time disappeared the morning he was supposed to do press. The

festival organizers wandered around, asking all the writers who had been out drinking with him the night before if they had seen him that morning. We began to retrace his steps. Who had seen him at the end of the night? Someone remembered him walking off with a local who had attached himself to the group when the rest of us had headed home. He was still in bed now, we all presumed. Sleeping it off.

I thought: That guy needs to get off the road already. And then I thought: Tell the press I'm here. I'll talk to them. I'm available for interviews.

There was always the question of clothes.

It's 2015, and I'm about to release my fifth book, and before I leave on tour, I stand in my closet, whispering to myself: pack light. All those season changes, all those topographies. Pack light, even though what I am about to do is heavy, standing in front of rooms of people, presenting my wares, my brain, my book, myself. I want to look presentable for the people. I want them to think I had a sense of style. And that I was a good person, or at least an OK person. Look at that nice woman up there in the cute dress. Let's buy a book from her.

I take eight dresses with me. Also, one pair of jeans, a sweater, and a T-shirt and some leggings, for all the yoga I am going to do, ha-ha-ha. I make a deal with myself that the first thing I will do upon entering every hotel room is unpack my dresses. I invent a ritual for safety. If I do these things, if I hang these clothes, if I keep them clean and neat, if I tend to them, then it will be the same as tending to myself.

I mistake control of my outward appearance as architecture for my soul.

* * *

It was somewhere in these years that my periods began to destroy me. I had fibroids. By the time I was forty-three, my uterus had turned into something like a floating, abandoned spaceship upon which alien life forces had attached themselves, wreaking havoc on its mainframe. I suffered through all the greatest gynecological hits: cramps, extra-long PMS and periods, and excessive bleeding.

My emotional crashes during PMS were extreme. I was either an intolerable bitch or on the verge of collapse. I often bled through my clothes on flights where I had to sit too long. I was a miserable wretch, dark-haired, big-mouthed, often correct but still intolerable. The suffering made me insufferable.

My gynecologist told me it would only get worse. She more than once suggested I get a hysterectomy, but each time I hesitated, and a handful of hesitations that take only a second added up to years of failing to make a decision. I was aware of what was going on inside of me—I had pain, I recognized it—but I could not bring myself to contend with it.

The reasons piled up: secretly lodged somewhere in my psyche was the sense, however irrational and antiquated, that the ability to have babies felt relevant to my physical identity as a woman, though I have never actually wanted to have a child. My bare-bones freelancer health insurance meant that having the operation would have emptied out my bank account, and then some. And there never seemed to be a right moment to take the six weeks off required for recovery. But

draped over all of those rationalizations was my most powerful and seductive weakness: denial. I was fine! I didn't even know what anyone was talking about! I was fine!

"Time's up!" I imagined my uterus chirping at me. Someday, something would have to be done about it. But who had time to think about that when there was another plane to catch?

One night, early on that tour, in a tight dress made of charcoal gray wool, I don't make it home, not to my home anyway. I have an excellent time in this other home, owned by a man with children staying elsewhere for the night, the doors to their room politely closed. There is an unexpected piano, the lacquer on which I stroked when he wasn't looking, maybe leaving a fingerprint behind. It is a fine way to spend an evening, for both me and the dress. But the next day I find myself not wanting to wear it again. My dresses were about me and my tour and being independent and strong and focused on getting to the other side of this adventure, even if it felt like there hadn't been an "other side" in a while. I didn't need anyone else's fingerprints on me, however invisibly. I pack it in the bottom of my bag. I am down to seven.

The other thing was, if I stopped touring, I'd have to face who I was, where I was in my life, all the days of making art I'd lost to the business side of things, all the friendships that had fallen by the wayside. How distant the whole world felt to me even as I was meeting new people all the time, how shut

down I was, how much I fucking hated flying. Who wants to stop and think about that?

The summer before that tour, I'd cut off four inches from my hair because it was heavy with stress, and I felt different afterward. The dresses remind me of those inches of hair. They start to carry an energy with them, airports, air-conditioning, Xanax, red wine, tight smiles, those thoughts late at night and in the morning on repeat every day: Did I say the right thing, did I charm them, did anyone even hear what I said? Do I look fat? Do I look old? How do I look? How do I look? How do I look?

On the festival circuit I begin to notice other authors' attire, all the women dressed beautifully at the cocktail parties, while all the men show up in wrinkled button-downs and jeans, call it a day. The boys have it easy, I think for the millionth time in my life. They're presumed brilliant. No suit, no tie, except for some of the older gentlemen, still trotting out their wares after all this time. They come dressed for business.

I hang the dresses, brush them straight with my hand. I post another picture of myself in a hotel room on Instagram before I leave for the night. This is me, this is where I am, this is what I am wearing. I post it so people can tell me I look OK. I post it so people know I'm alive. I post it as a proof of life.

I grow accustomed to seeing myself in a box on my cell

phone. Did I live in the box? I peered closely. Is the box where my real life was?

The internet fucks with your head, but we already knew that.

Did I mention in all this I am approaching middle age? A collapsing uterus isn't visible, but my neck sure is. And I am documenting my physical appearance every step of the way, online. One day I realize my face has changed. I look in the box, at the box-shaped picture of me. I don't even know if I mind it that much, but I *notice* it. My face is longer and more drawn, and I have circles under my eyes, in fact they have a purplish tint, and I'm not bright-eyed anymore; my eyes, they have lost their sheen. Hilarious that you thought you could stop time if you never stopped moving, I think. But I am better now, I can see that, too, I can see those lines and I think: Well, at least I know something now. I had to have acquired knowledge along the way. But I wasn't quite sure what.

Years later I'll meet a man who has no social media presence, has never experienced a like or a comment or a retweet in his life, and I'll think, You goddamn beautiful unicorn, what's that like, being entirely self-validating? What's it like to wake up every day and not worry what anyone else thinks?

In New Orleans, I have a few days off, and I visit a friend's house while she packs for her own trip. It seems like she's

taking everything in her closet for a two-day visit to a local city. She watches me watching her and says, "I think it's my one vestige of PTSD from Katrina. I feel like whatever I take with me is whatever I'll have for the rest of my life."

Three days later, it's my birthday. I check into the W Hotel in Dallas, the day before an event. I eat an enormous cheeseburger and fries, room service, and then decide to iron my dresses, however pointless the act. Unfamiliar with the hotel iron's settings, I singe one of the dresses. Six remain.

A few days after that, at a hotel in Austin, I realize I've left the black sequined dress behind in . . . Mexico City? It must have been Mexico City, but that had been weeks before. It was the only place I wore it, to a wonderful dinner out with my traveling companions, Zach and Sarah, who I met there for a few days. They had traveled to Mexico City before; Zach was working on a novel set there. He and I were to give a reading at a library, invited by someone at the embassy. It was my first time in the city, and I spent the first two days dazzled by the galleries in the mornings but by midday exhausted by air pollution and altitude sickness, and I would take to bed for a few hours. In the evenings we drank and ate with great lust. It was my first time trying mescal. I found the city overwhelming; I didn't love it like everyone else did, all these people saying "You have to go to Mexico City," but that wasn't Mexico City's fault. I really needed just to be home in bed, probably. Still, there was a night I met a bunch of young poets for drinks and they were radical and smart and fun. And a special meal at Máximo Bistrot. Zach and Sarah had been there before and thought I would love it, and they were right. I brought that dress on tour specifically for that dinner.

How did I lose the thread on it? How could I have misplaced it? Doesn't matter. Now I was down to five.

The last freelance job I had before I started working as an author full-time was at an interactive advertising agency in the Flatiron District. My boss was tall, a burly Australian man, actually physically intimidating, with a booming voice, and not a day went by that he didn't comment on my facial expressions as he passed my desk. Particularly if I wasn't smiling. That loud voice could be heard all across the office. Why aren't you smiling? What's wrong? Sometimes tapping his finger on my desk. Why don't you smile more?

On shorter flights I chip at quarter pills. I begin to hate Xanax, and hate my dependency on it. The flights day after day after day in a row are the toughest. Even if it's only half a pill, I have to take it. I am deeply absorbed by the anxiety, and how to deal with it on a regular basis. I've let it shape my life. What was I so anxious about anyway? Could I even remember?

I was anxious about being seen. About having to put myself out there in front of an audience, both in person and online. About my work being reviewed in a more critical fashion. I had a vulnerability about my public/private persona, and about having to engage an audience in a specific way, not just as a person who had written a book but also as a personality, as an Author with a capital *A*. Having any success as an author is like getting a promotion, only they don't hire anyone to replace you at your own job. I had to be a good writer

and I had to be a good salesperson. No one told me this specifically. I imposed this on myself. But I did not want to take a step back, because back meant couch-surfing and disappointing my editors and my publishers and even my family.

When your soul cries out in the night do you listen? Or do you just roll over and go back to sleep?

I'm jealous of the sleepers.

At the opening night ceremony of a literary festival held in the ballroom of a suburban hotel, I stood chatting with another novelist. I was drinking cold white wine, as much as I could find. There was no food, just booze. A city council person spoke, toasting the visiting writers. The man genuinely loved books. I could see it in his eyes.

In the background, the other novelist and I quietly whisper our fears to each other about the future. He has a wife, kids, mortgage. We talk about our Plan Bs. His is to be a UPS man. He's a big guy, broad shouldered, friendly, and he knows he can reliably lift heavy objects. He tells me there is not a day he didn't worry all his success would go away. Not a goddamn day.

Near the end of the fourth week on the tour, I begin to collapse.

In Texas I decide to drive with a friend from Houston to Austin. I wanted just one day free from the claustrophobic confines of a plane. In doing this, I skip a flight, which sets

off a chain of events; all my flights were linked together by the same travel agent. The airline boots me from the next leg in Austin, and I can't catch a flight to Portland until later that night. I spend seven hours in the airport watching the first season of *Master of None,* blaming myself for all my choices. I arrive at the hotel around midnight.

The next day I wade through rain and massive crowds at a literary festival. At my event I am introduced as living in Brooklyn. From the crowd I hear it. A boo. For being from Brooklyn. I had traveled all that way just to get booed.

That night I gave a public reading in a packed bar so noisy I couldn't hear my voice. I had no idea if my words were being heard at all. Someone I hadn't seen in ten years, from many cities ago in my life, came to the reading with his wife and I was pleased to see them but felt detached from the moment. I had no idea how I was supposed to be anymore. In fact, I don't remember much from that night. I drank whiskey. There are periods of time that went dark.

That guy needs to get off the road already.

In 2020, a therapist tells me I'm hardwired for anxiety. I was screwed from the get-go, I think. I'm an excellent compartmentalizer of my feelings. I can organize my thoughts and emotions to protect myself and to build a shield, but that will only take me so far. I say, "I have been doing it for years." I can tell, she says, with what sounds like sympathy.

* * *

The day after I get booed, I fly back to Brooklyn. I throw all those fucking dresses in the hamper and do not look at them again for months.

Three days later, I'm off to a large southern city. The flight out, predictably, is delayed, and so I spend another four hours in an airport. Upon my arrival, a driver takes me straight to a chain hotel outside of the city. I don't even pause outside; there's nothing to see there. I eat in the hotel restaurant and crash in bed. The next morning, another car takes me to the event. A gasp of fresh air before I slide in the backseat of the town car, and then a few more breaths as I get out at my destination. I do my event. A Jewish event, a panel of four authors. I sell five books. Thanks, Jews. Another car to the airport, two hours before my flight. And there I sit.

An hour before boarding I take a whole Xanax. Put me out of my misery, I think. Then the flight is delayed for an hour. I nod off. I wake as the plane doors close. In a panic, I run and bang on them. "You're too late," says a flight attendant. I beg them. I just want to go home. They tell me they can get me on a later flight. I walk to a quiet corner of the airport and I sob. This is it; this is the end. I couldn't take it anymore. It had been three years. I couldn't do this anymore, whatever this is. Be afraid to be on a plane? Take these drugs? Travel nonstop? Be this person? Whoever this person was.

Eventually, my brain goes on strike. My brain says: You need to feel better about yourself. You need to put yourself in a situation where you can succeed more days than not, and the times you feel most successful are when you are sitting quietly at your desk, doing your work, writing your books, con-

templating your characters, thinking about the why of your story and the why of life, and putting it down on the page, for you first, and then for everyone else. My brain says: Stop.

I don't fly again for six months after that meltdown in the airport. I take most of the rest of the next year off from touring. I blow off promoting my paperback; no one seems to care or notice. I finish writing a new book. I let the quiet fill me up. I had been the one to impose all the hard work on myself; I was also the only one who could impose the time sitting still.

The next time I flew, it was to Australia for a festival. A twenty-four-hour flight. On the way out I took a Xanax but it didn't even seem to matter, because time moved differently on this plane ride. On the way back I took absolutely nothing. And I am here to tell you, if you can survive a twenty-four-hour flight on nothing but yourself, you can survive any plane ride.

A year later, I get a hysterectomy. This thing that had tortured me for so long had disappeared, in a snap. It took me a few months to recover, but then, that was it: I hadn't understood I could just feel better. It felt so good that I nearly forgot what it was like to feel bad in the first place. For years, I'd just accepted there would be times when my emotions and mood could be affected by the pain and the hormones, that the miserable wretch would run the show. (I don't miss her, but I'll never forget her.) Now a clearer and calmer version of me was in charge. Now I knew I had the power to remove other things in my life that I'd held on to for too long for all the wrong reasons.

A few months after that: another book, a new tour. I leave for the first stop. Midflight, there was turbulence, enough that I briefly imagined a dire ending for myself. And I thought, If I die, it will be OK. I've done a lot with my life. I have nothing to be ashamed of. I hadn't considered it before that moment. That I had been traveling with some sense of shame as I raced around the world. But the whole time I had been up in the air, I had been accomplishing things. That the whole decade before this one, I had been accomplishing things, too. I don't know if I had ever believed that before, but I believed it then and I believe it now. I had been so busy working and questioning myself and judging and assessing my own moves through my own eyes and the imagined eyes of others that I was unable to reflect on what I had actually been doing with my life. I had been unable to capture a feeling within myself for years. All the snapshots I had taken were just of an image. They were ephemera. Air and smoke and then they were gone.

8

A History in Sales

My father was a salesman, and his father, Sidney, was, too, and so was my great-grandfather on my paternal grand-mother's side. Her father, Papa Joe, owned a grocery store, but that was not quite the same as what my father did, insists my father, I suppose because groceries sell themselves, like nothing else does. My father and his father were on their feet all day, shake your hand, let-me-tell-you-about-my-product-and-my-kids kinds of salesmen. They believed in what they sold, and they liked to have a good time with people. That's the kind of thing that comes naturally.

I'm on the phone with my parents, letting my father talk mainly, my mother filling in a few details here and there. It is June 2020. It's a rainy day, we're waiting for a tropical storm—Cristobal, this time—to show up in Louisiana. The storm is supposed to make landfall this afternoon south of here. It's already pouring. My parents are in Florida, catching

some of the tailwinds, and they're waiting for the rain to stop, too. I am interviewing my father because it is something I've always wanted to do but for some reason never found the time. And now all I have is time.

"Your grandfather had a furniture store, in Randolph, Massachusetts," my father tells me. "If business was slow, he'd bring home all the furniture, sell it out of the house. You'd come home some days and the whole living room was gone." Wayside Furniture, that's what it was called. In the 1950s. "He had a little red truck that we schlepped stuff around in."

My parents' house is silent except for the rain, too.

"He was a consummate salesperson," says my father. "He never stopped selling. He could talk anybody into anything."

They're still in bed, my mother tells me. When the rain stops, they'll walk the dog.

Eventually my grandfather moved the family to Chicago, to Highland Park. He worked for Macy's and Gimbels, home furnishings. Furnaces, upholstery, drapes, carpets, anything that could be sold in the home. He introduced a service on behalf of the department stores where a salesperson could go into a home to sell things, rather than a customer having to come into the department store. A traveling salesman but with cachet, a big name behind you, higher-end items. He started working for Goldblatt Brothers. My father remembers visiting him at work on State Street in downtown Chicago. Ninth floor, specifically. "When I was a kid I'd go there, and he'd attempt to teach me about fabric." My father muses. "He was a person who got along well with lots of people," he says. "Not only able to sell merchandise, but to sell himself."

I drag up some memories of my grandfather. He had been a war hero. He'd seemed reserved. He was bald and rotund.

He smoked pipes and cigars. He always seemed old to me; it's hard to imagine him as a young man. We had some old photos of him holding my father as a child. His firstborn, his only son. I don't recall him being particularly charming or charismatic, but I don't think he was trying to sell himself to me, or to anyone else in the family. The salesman persona was reserved for those who were ready to buy things. We were the family; we were supposed to just love each other no matter what, and listen to him as the patriarch. I remember him being annoyed with me on occasion. I hadn't written him from summer camp as I was supposed to, and I recall him being angry about it the next time I saw him. "You couldn't bother to pick up a pen," he said. That was perhaps my only negative memory. I don't recall him finding me particularly interesting after a certain age, but there were other things going on in his life, other children, other grandchildren. But I liked him all right, my grandfather. I had no complaints.

"He made lots of friends because of his gift of gab," says my father. And that is how he shall be remembered.

I am interviewing my father over the phone because there is a pandemic and they live in Florida, a two-day drive from me, and no one trusts that it will be absolutely safe for me to travel there to see them. For me, perhaps, it is safer. But it is definitely not safe for him.

They've lived in Florida for about four years, after living in Chicago together for forty-seven years. They bought a small house in a gated community with a lanai out back where my father sits with their new dog, a goldendoodle named Rosie, a recent rescue, who is sweet but a little slow. My mother is

still busy as always, now with volunteer work in the community and with her temple. She grows orchids, too. They saw an alligator in the small creek out back recently. Mom tells me what birds she sees sometimes, and she posts pictures of them on her Instagram. She also posts pictures of sunsets, often with the caption "Every night . . ." because every night it is beautiful there, except when it is raining.

It is what I wanted for them, this sweet, uncomplicated, sunny kind of life, after so many years with those cold Chicago winters. I had never really pictured what would make them happy, but this is it, this is the thing that makes them happy. They love the weather and the swimming pool in their gated community and their neighbors, who have become their friends. My mother plays pickleball with the intensity of an Olympic athlete and my brother and I were both relieved when they got recumbent bikes, so they can still get their cardio, but be lower to the ground. Less chance of injury. They're in their mid-seventies. No one wants any injuries. They had hoped to travel more, too. They had a list. But that seems unlikely now.

I ask my father about his history in sales.

"I worked in my grandfather's grocery store, and I was in charge of the penny candy counter, selling buttons and root beer barrels, that kind of thing. In Chelsea, Massachusetts. On Saturday mornings I'd get up and go to Papa Joe's grocery store—I'd take a bus and go over there. And one of the advantages of doing it was my grandmother made me a baloney sandwich every Saturday morning. She would pay me twenty-five cents for working. After work, I'd take the bus again and go to the Orpheum and see a movie. It was the years of 3D movies. I saw *The Charge at Feather River*. Because it was in

3D you could see the arrows coming over your head." These details shimmer before me. Sixty-plus years ago, and he still knows them.

"Just don't ask him what he had for dinner last night," says my mother.

At sixteen, he worked at a Howard Johnson's, washing dishes and doing counter work. Then he worked for a midwestern grocery store chain, Eagle Foods, stocking and working on customer pickup, making extra money from customer tips. In the same shopping center was a Sears, and he decided he wanted to work for them.

John Maloney was the general manager of Sears, and Al Bailey was the manager of the garden shop where my father found work, he remembers. "Former Army Ranger, skinny little guy, Al . . . well, there was a barrel of mud in the garden shop, and Al decided he wanted to lift it and he broke his back, so I became the manager of the garden shop. I was sixteen, and suddenly in charge . . . a few months after that, they took us off commission and I was pissed off because I was losing money. One afternoon I walked into John Maloney's office, it was a dark office, I remember. I said, 'We got a problem here, I'm losing money.' John Maloney said, 'I know you're a good salesman, because you hustle out there, so I tell you what I'm gonna do, I'm gonna give you a twenty-five-cent raise.'"

You gotta ask for what you want in this life, a thing my father taught me.

A few years later, he joined the Coast Guard Reserve and served on active duty. After that, he spent some time working at a Montgomery Ward, and then moved from there to a Sears on Irving Park Road in Chicago, selling furniture. One

winter, he met my mother, and he fell for her immediately. Then when he was already married and the father of two, at a Holiday Inn on Algonquin Road, he had an interview for another opening at Sears. John Maloney was the man who interviewed him that day, and he remembered my father right away and gave him the job.

He became the manager of the sewing machine and vacuum department at Sears at Woodfield Mall, then the biggest mall in the United States. A big deal, that mall. He moved into home entertainment, TVs and stereos and CB radios. "It was all sold the same way," he says. "You had to learn a little product knowledge, but basically it was the same sales techniques."

Vinyl records were part of his department. "Debby Boone came into the store once," he says. Her big hit was "You Light Up My Life." And the Charlie Daniels Band, too. Those were the days when a new album came out, record companies sent stars to the department stores. "It was a pain-in-the-ass department," he said. "Because you had to count all those records."

"Working for Sears back then was fun," he says. "You had to work hard, no question about it. Working for them as a company was fun because we were all one big family. Once computers came online, and they could track sales, it became less fun. It became more mathematical."

He stayed at Woodfield Mall from when it opened in 1972 to 1976. He was perfecting his craft.

He sold himself to my mother, too. They met when she was a junior in college, visiting some relatives in Lincolnwood. Her

father had passed away the previous spring. It was a blind date, a fix up, an out-of-town cousin and a nice Jewish guy from Highland Park. They went out every night for a week.

"In 1967, in the middle of this snowstorm, I sold five thousand dollars' worth of furniture. It was a floor sample of a ninety-inch sofa. I was excited, it was the biggest sale I'd ever made. I called your grandfather to tell him. He said, 'You gotta get off the phone.' 'Why?' I said. 'Because you're hot right now,' he said. That was the storm I went to see your mother at her cousin's house. I got stuck in the snow."

After less than two weeks, my father proposed to my mother. My mother said it was too fast, and she didn't know him well enough.

It took three months for her to agree. "Persistence is his middle name," says my mother. "Dad would leave his job at Sears and go to the pay phone booth on a nearby street with a pocketful of quarters and call me every night for the next two months." He convinced her to come back to Chicago for her spring break; he saw her again every night. This time, she accepted his proposal.

"If you can sell one thing, you can sell anything," says my father. "Everything's a widget. It's just a thing. If you can sell a refrigerator, you can sell a sewing machine. If you can sell fabric, you can sell sewing equipment.

"Product knowledge is the big thing," he continues. "That's what makes a salesperson successful, is that the salesperson can convey the knowledge to the customer. If you feel confident, they will, too.

"How many times have I gone to one of your readings and

they've asked you what your process is?" he says. "They want to know you know what you're talking about."

This pleased me. We had never really discussed what happened in my readings before. He would always just pat my shoulder at the end and say, "Good job, Jame." I had no expectations he was actually paying attention. He's heard the same answers to the same questions over and over. I wouldn't blame him if he had checked out. But he hadn't.

My father left Sears to open a sewing store with my mother, Prints Charming, which stayed open for twenty-one years. Quilting classes, notions, big bolts of beautiful fabric, all for the ladies who crafted in the suburbs of Chicago. It was a warm and friendly shop, with a loftlike feel to it, located in a historic town called Long Grove. Nearby was a confectionary, which sold enormous chocolate-covered strawberries, and the Apple Haus, where I would buy bags of warm apple cider doughnuts and eat them one after the other, next to the small man-made duck pond around the corner from my parents' shop. For a few years, I had dreams centered around that pond. Once I dreamed an alligator came up from it and my mother saved me and entered the mouth of the alligator in my stead.

I used to work at the store after school sometimes, running the cash register. It was no penny candy counter, but it kept me busy. I was inclined to deal with the public, it seemed.

They expanded to two stores. Then there was just one. My brother was going off to college, and I would follow soon

enough. They needed more money coming in. It was decided my mother would run the store alone and my father would hit the road as a traveling salesman.

He traveled until he retired. He sold everything. All the widgets. He had persistence. At first, he sold fabric to small sewing stores all over the central part of the country. Fly out, rent a car, drive an hour or two, make one sales call, drive another hour, make another sales call. "I spent a lot of time in Minneapolis," he says. He recalls selling fabric to an Amish colony in Arcola, Illinois. "Horses and buggies and what-not," he says. "But they had computers, too." It was raining like crazy the day he visited. "The lights were out. And I was pissed because I had driven hours to get down there. So, I pulled out a flashlight and sold her fabric by flashlight."

Then he moved on to a bigger distributor. Exercise equipment, sporting goods. He sold to gyms and physical therapy offices. Hardware home center goods, pet supplies. Resistance bands for use in hotel rooms, to stretch and work on core muscles. Exercise mats. Growing up, our garage was full of samples of different products. There was a time when the garage was full of toolboxes.

"I enjoy selling anything," he says. And he enjoyed meeting all the people. "Everything was a people situation."

"And to this day, he can't stop talking to people in elevators," says my mother. I know she needs to explain this to me. My father has always talked to waitresses, was excessively friendly out in the world. My brother and I would roll our eyes at dinner. He can never stop. "Dad is friendlier with strangers because he's used to talking to strangers more than to people he knows," says my mother. A thing she has wanted us to realize forever. It was just who he was. He was a sales guy.

* * *

Being a sales guy treated him well enough. Joined with my mother, he was able to own a home, save for retirement, send two kids to college, buy or lease SUVs every few years, bike across Italy on a wine-tasting tour, live a middle-class existence, all because of the life of a salesman. "I worked from sixteen years old to sixty-six. Fifty years of selling. That was enough. I met lots of interesting people along the way. I was never bored."

The rain stops outside my window.

"But the travel was a killer. It's tough."

"What did you like least about it?" I asked him. My mother kept filling in his sentences. She said it was his back, in that era the portable computers were heavy, and he'd lug them around for days. "His back still bothers him," she told me. I told her to stop and let him talk. "Yeah!" said my father. "Let me talk."

I am interviewing my father because I am trying to figure out why I am the way I am. The daughter of a salesman, now a salesman herself, in a way.

And I am interviewing him because I want to capture these stories from his life before he forgets them forever. Penny candy and snowstorms and bolts of fabric.

There are some things my work can't save me from, this I have learned. I can write things down, I can process the events of my life, I can put them in a box, on the page, or on

a screen, or in a book; I can package them safely there. I can change my life with the written word, but I can't fix everything. Some things I just have to feel, some things I just have to experience. I have to dangle my legs over the edge of that cliff and feel the breeze on my skin and embrace the world all around me and just feel it all, feel it for myself. The words won't save me every time.

I have learned other things, too. That people will age. That time will not stop. That eventually we will all collapse, in one way or another.

And that I cannot alter my basic truths, where I came from, who I am. But I can rearrange their importance in my life. I can alter the hierarchy. I can choose which needs are in charge. What is running the show emotionally. That is perhaps the only thing I can control.

9

No Lambs

Somewhere in all the travel, I make a friend. Her name is Viola, which sounds like the name I might have given a doll as a child, or perhaps an imaginary friend. I saw her across the room in the crowded hospitality suite of an international literary festival in Canada, in 2013, amid all the writers eagerly suckling the free liquor. She was standing alone, like me. Neither of us knew anyone. Viola was fifteen years my junior, an Italian baby goth princess: pin thin, long blond hair, a childlike face, wearing dark eyeliner and a dramatic black Victorian gown. I immediately thought: Her, I must know.

I smiled, maybe gave a little wave. Viola is serious-looking at rest, but easy to laughter. She must have smiled back. I had nothing to lose by saying hello. I don't remember what we said to each other. Perhaps I complimented her look. I have always wanted to be able to draw a cat eye, and I envy those

who can skillfully apply it to themselves. Maybe we both just shrugged at the noise in the room. Acknowledged the weirdness of the moment. Everything was always a little weird out in the world. The only thing that ever felt normal was being at home with my books and my pen and my paper and my computer screen and the document I was filling with words all day long. I knew she knew all that, right away.

The next day we became friends on social media. It is always good to have a new contact in a foreign country, I thought at the time. What more could I expect from this stranger I met for only a few moments? What did friendship mean to me anyway?

I knew who my people were, even though I didn't see them that often anymore. The ones who had stuck by me in my worst moments. The ones I hoped I offered something to in return. Looking for depth, stumbling on ideas together. Craving collaboration, a shared sense of something bigger than myself, and finding people seeking the same. I had been lucky. I had lost some friends in my life, or sometimes they had lost me. The thing about bad friends is you never realize when you're being one until it's too late. Forgiveness and understanding? Regret and apologies? Not in this economy. But I had sustained a life with the ones who counted, the ones I could talk to for hours. The ones I would build something new with every time we met. When I got to meet them.

And it is hard to make friends on the road, I learned, at these workshops and conferences and festivals. Friends you get to keep, anyway. We are not meeting each other in our real lives, where we are responsible human beings who pay our bills and clean our houses and do our laundry and cook for ourselves and walk our dogs and mow our lawns and

check our mailboxes daily. Instead we are living this dress-up way of life, a fun house business trip where our job is to perform a version of ourselves; and where we are fed our breakfasts and lunches and dinners, and are led around like children from place to place, conference room to classroom to auditorium; and in our hotels, in the mornings, we crinkle up empty wrappers of honor bar snacks on the nightstand and make coffee from stale prepackaged pods and leave our towels on the floor for someone to pick up after it is time for us to go, placing a tip on the unmade bed, the one small thing we can do to feel like we've accomplished something that day. That is a half version. That is a faint outline of a soul.

But Viola and I became fast friends, having long, funny, intimate chats. Soon she became a confidante. Her novels, I was to discover, revolve around young, unconventional women who have complicated relationships with reality, and are often otherworldly. I asked her once if she was afraid of death and she said, "I only fear my brain and the mystery of bodies."

My favorite book of Viola's, *Hollow Heart*, is written from the perspective of a ghost, a suicide victim who is haunting the living, following her loved ones wherever they go. The first sentence: "In 2011, the world ended: I killed myself." But the narrator, Dorotea, is alive on the page, of course, even as her body deteriorates underground, which she details for the reader. The book is written in an epistolary fashion, direct messages from Dorotea's heart to us, even as nature takes its course and the heart hollows out throughout the novel's pages. The state of the flesh does not matter though: it is only Dorotea's words and thoughts that count.

* * *

I had wanted to write a ghost story myself, ever since I had seen a ghost. This happened on that book tour in 2010, for my third novel, the one with the terrible sales. In Portsmouth, at the beginning of the trip.

That afternoon, I had driven from Brooklyn, bad winter weather chasing me as I drove. I could nearly see the storm behind me; I could sense the electricity of it, a white-gray crackling wave of doom. I was to stay at an inn built in the late 1880s, first used as a home for one family for generations, until the 1930s, when it was sold and then resold several times after that, until in the 1950s it was reportedly used as a half-way house for the mentally ill. A thing I didn't know until I googled it later. By 1986, it had been turned into an inn.

In the hotel, I changed for bed. It might have been 8:00 P.M. Outside the storm raged, snow crystals fluttering up against the window and then securing themselves against it. I pulled out my laptop and got under the covers, sitting with my back straight up against the headboard. I typed for a while, and then . . . I felt something in the room with me, a presence, just outside of my eyesight. I slowly lifted my gaze, tilting my head upward.

In the front of the room, between the television set and the foot of the bed, I saw a noose of bloody red roses. From that noose hung a form, a dark form, that I knew to be a body, although it was too dim and hazy to be defined precisely. A face in penumbra. I could not identify a specific gender, although I sensed it to be male, and perhaps wearing a suit, as the arms and legs hung as if encased in something. It was neither dead nor alive in my mind, although I suppose in a way it was both: it was an otherworldly presence, and it was making itself known to me.

I stared at it for probably ten or fifteen seconds. I knew that it was bad, this was a bad thing in front of me, but I didn't want to stop looking. It was completely new and foreign; a deep curiosity had now been born, even as it was mixed with fear. I told myself repeatedly, "Don't look at that thing, don't look at that thing," until finally I forced myself to break my stare, and shift my head and gaze downward again, centimeter by centimeter. When I looked up a minute later, the presence was gone.

How did I sleep through the night? I just did. I felt I had seen something, that he had wanted me to know he was there, and then he was gone again. Even if he was floating around the perimeter somewhere, I sensed it would be fine if we shared the same space. We had been introduced, hadn't we?

Since that night, I have found myself wanting to live in that moment a little longer. I wanted everything to be as weird and different and surprising as that experience had been. I believed in something new. Ghosts, the other, the unseen, these are intangible things. They are just possibilities. But those possibilities were thrilling to me. It was the same as dangling my pen over the first blank page of a journal. A whole unknown world. I wanted a life of knowing the unknown. I started to look everywhere for more than what was right in front of me. And Viola was the same. Only she already saw it.

In 2016, my Italian publisher arranged a tour for me, starting in Milan and ending in Palermo in Sicily, where I had been once before, two years previous. Viola is from Catania, on the opposite side of the island, less than three hours away by

bus, and she was staying there with her family in between writer's residencies. She agreed to meet me for two days, with two nights of readings at the bookstore Modusvivendi Libreria—a long time to spend with someone you have met only for a few minutes in person. But Viola was game, and she had a mission during her time there: to take me to see the Capuchin Catacombs.

I took one book with me on my travels: a galley of *There Are More Beautiful Things Than Beyoncé*, written by a poet named Morgan Parker. I had seen her just once in person, at an all-day reading marathon in Brooklyn called Popsickle a few months before. It was held at a watch company showroom, and everyone there was young and smiling and glistening from the heat.

Going to readings like that, where people just gave it their all, sometimes with their nerves showing, sometimes with a charming bluster, I found it exhilarating. The audience came and went, filtering in and out for hours and hours, in a warm room, on a summer day, everyone there for no other reason than they just wanted to be around other writers and maybe they had a little something to say. It meant a lot to me to be a part of it.

Morgan was dressed in all white that day, along with some other poets, and that is always how I think of her. Dressed in white, chic, and smiling, beaming, charismatic. Happy to be with the poets, I thought. Happy to be with her people.

And now I had her book with me.

The books we carry with us when we travel become a part of that journey, as much as a special meal we eat, a piece of art we see in a museum, a viewpoint we climb to, so we can look out at the world. And I had been doing some press,

foreign press often being trickier because of the translation, and had been tussling a bit with my Italian publisher about how much I talked about feminism. Morgan's book propped me up during those days before I was able to meet up with Viola. I remember walking around the Jewish Quarter in Rome just after finishing the book and thinking what a revelation it was to hear this distinctly American, Californian, Black, female voice, strong, self-assured, pissed off, sexual, brilliant, lighting the pages on fire.

"We have ideas and vaginas, history and clothes and a mother," she wrote in one poem. "Will you untag me from that picture / Do you think I should cut my bangs / Do I have any friends / Do you believe in me," she wrote in another. "With champagne I try expired white ones / I mean pills / I mean men," she wrote in a third.

What a relief to know she was out there. These books that are life rafts, these authors who never know exactly what they're doing for all of us when they're writing them. I can't imagine that when they sit down to work on them, they think: Today I will save a life.

Finally, I arrived in Palermo, to be reunited with my long-distance friend. For me, the best way to get to know a city is the same as with a human being: learn both the flaws and the charms. I cannot fully love something until I know both. To my eye Palermo had seemed like a pretty, crumbling city, perhaps careless in its beauty. Viola saw something else. Viola had opinions about Palermo.

"It's a Jackson Pollock painting in city form," she said over coffee on our first morning together, before we set out

on our adventure for the day. "There is an abstract quality in the structure of its everyday life, in the way cars and people and everything interact, and it's very violent and unpredictable. Like, you never know, a car could hit you while you're walking on the sidewalk." I had not yet seen this side of Palermo—I had only ever stuck to the tourist areas. I was ready for some chaos.

We left our lodgings, taking the pedestrian path of the city's oldest street, Via Vittorio Emanuele, home to many historic buildings as well as beautifully weathered, balconied apartments and tourist shops.

As we walked she told me about a current government campaign that was both enraging and entertaining her: Fertility Day. The premise of this campaign was to encourage young Italians to procreate more. It had been created in response to a decrease in Italy's population. The images included a picture of two sets of feet under a blanket with the text "Young parents: best way to be creative." And another of a woman in her thirties holding up an hourglass with one hand and rubbing her belly with the other, with the text reading "Beauty has no age. Fertility does."

"Unbelievable," I said, gobsmacked, offended on behalf of all childfree Italian women.

"Incredible." Viola furiously nodded her head. "I know."

She knew, I knew. We knew.

I was nearly forty-five years old. I was just coming out of a collapse then. I was just starting to heal. I was trying to take charge of my life instead of bending to it. Things can change, and life doesn't have to turn into a disaster; I was learning

that. All the yeses I had said for the past few years had got-
ten to me. But here I was, with a friend. A younger person. I
appreciated knowing people who had fresh voices and ideas,
and I treasured the knowledge of people older than myself,
who could show me I had something to look forward to in
the future. I was dead center in my life. The vibrations of my
youth gently subsiding. I was still anxious, still neurotic. An
artist's mind, always churning, always creating. But I could
see how life could be calmer, too. How many older women
had I met who had assured me that after turning fifty, I would
stop caring as much, stop sweating the small stuff? I wanted
that. Not to be fifty. Don't wish away your life, someone told
me once. But to be able to see beyond that which could hin-
der me. That was I wanted. A new thirst.

We passed the broad and impressive Palermo Cathedral, its
many towers softened by the occasional palm tree. And then
we walked beneath the Porta Nuova, a triumphal arch that
dates to the 1500s, and I felt as if I were leaving one part of
the city for another. Until that point, everything had been
tall and spacious, a testament, as I always feel in so many
European cities, to masculinity. But as we veered up Via Cap-
puccini toward the catacombs, the streets grew more clut-
tered, the buildings more humble, the sidewalks more narrow
and crowded with garbage and oddly parked vehicles, and we
were forced to weave back and forth off the sidewalks, alter-
nating between dodging people and speeding scooters. Viola
was annoyed by the tumult, but I think slightly pleased, too,
that her point was proved. Here was the chaos.

We arrived at the catacombs, their exterior a plain, graying

building with a small plaza and parking lot. Nothing seemed suspect. Heretofore my main understanding of catacombs had been from *The Sound of Music,* in a scene where the von Trapps seek shelter from the Nazis; it was a place where dead bodies were hidden away from innocent eyes. The Palermo catacombs, first founded in the sixteenth century as a place to house deceased friars, were not made for Technicolor. We entered, and walked down to the depths of the building.

That was the year I didn't travel much. Australia and Italy, New Orleans and New York, that was it. I had cut myself off from all the other touring. I had stopped myself short, right before I fell off a cliff. My heart was racing, racing, and then suddenly it had slowed. I was catching my breath. I was catching myself, because there was no one else who could do it but me. All a friend could do was embrace me after I landed.

As I stepped into the catacombs it occurred to me that I had anticipated something different. I was expecting graves, I was expecting coffins, I was expecting death, but hidden away somehow, perhaps with an ornate covering. I was definitely not expecting hundreds of mummified corpses hanging in airless, limestone corridors beneath the city streets. I let out a genuine noise of surprise, a mumbled "Oh my God." The corpses—1,252 in total—were all dressed in centuries-old attire. Viola, of course, was delighted by my shock. A gift from one writer friend to another: a genuinely memorable experience.

I sensed a specific energy in the particles in the air; there

was a thickness to it, as if they were parting and allowing us in as we moved through the space, pushing us along. Practically every inch of wall space was decorated with a dead body. The bodies were showing us their insides. There was no downtime for the mind. We were fully present with death— yet I couldn't quite appreciate that fact at that exact moment.

Instead, I was having what might have been an inappropriate response. The shock of it—so little shocked me anymore—was actually entertaining me. I spent so much time imagining things. But this was the shock of the real. It was strange because I didn't enjoy horror movies. Once I had walked out of a haunted house during the Halloween season because someone had jumped out at me, and I thought, I don't need this. I don't enjoy being scared. But this scenario wasn't that anyway. It was just the weight of it was so immense, and there were so many forces of the past at play. I was speechless, but I was consuming it all intensely.

We approached the *cavallo di battaglia*, a small child encased in a glass coffin.

"This was what I wanted to see," Viola said excitedly. It was Rosalia Lombardo, the last person to be embalmed in the catacombs. She had died at the age of two in 1920. Viola explained that because the child had been embalmed much later than the friars and the rest of the townspeople, a different method had been used on her, which helped to preserve her better. She appeared perfectly human, but her skin was purple. There was a small bow in her hair. "That is . . . no joke," I said, and held myself steady. A hundred stories blossomed in my head about a purple child sleeping in a glass case forever.

Around the corner was a nook of female forms hanging

high on the wall, with words painted next to them. Viola translated: "They are virgins, they follow the lamb"—they had kept themselves pure for God. We both smirked. "Why is it the women always have to be the virgins?" I said. "Stuck sexless for eternity, that doesn't seem fair at all." I thought about that advertising campaign, the aging woman with her hand on her belly, the sands of time dropping steadily in front of her face. For a second I was so sad and tired from this endless cycle of men being men, and women having to deal with it. We cannot win.

It had been six years since I had seen the ghost in New Hampshire. My life had changed so much since then. I walked through the final recesses of the catacombs thinking: I had never been somewhere so haunted before. I felt all the stories crowding in front of me. I was so overwhelmed with them, I didn't know what to do with them.

Viola was in her element, though; she knew those rooms.

Later, I asked her what she had felt about all the bones, and she seemed placid in response. "I didn't feel much honestly. For me, really, it's like walking through a crowd of living people. I don't feel that difference which is supposed to make you uncomfortable." It was true, she had walked through the catacombs so confidently, looking directly for Rosalia. "I am way more fascinated by silent, embalmed bodies than by ordinary living humans. Because they belong to somewhere else."

Before we left, I bought a postcard of the virgins, so I could remember them forever, remember them for their bones. "I will take you to eat something good now," said Viola. Then we

wormed our way through back streets, clotheslines overhead, passing a small pup watching the world go by in a sunny window, until we found the Pasticceria Cappello, a gleaming bakery overlooking Palermo. We sat outside and ate a slice of *setteveli*, a seven-layer chocolate hazelnut cake, reportedly invented at the *pasticceria*.

Cars zoomed by us, precariously close, and we stared off at the crooked, gritty facades of buildings across the city. The chaos of a Pollock painting, I thought. I took a bite of the *setteveli*. Our friendship was sealed forever. Surprise me and then feed me, that's all I desire.

Writing had taken me here, to be with this person. My friend. To be near those ghosts and to see Rosalia. We were there together, amid the gorgeous disorder of the city. Two women, two writers, not lambs, not angels, just ourselves, just women, free.

A moment when I was happy. It had taken me a few years to get there. I had been writing toward this light.

10

The Wrong Side
of the River

For fourteen years, I lived on the East River in Brooklyn. From 2002–2016, RIP, Brooklyn me.

I was the occupant of a crumbly, old concrete loft with fourteen-foot windows, red pipes running all across the ceiling, and a view of a girls' yeshiva and a hint of the South Williamsburg waterfront. I could walk out my front door, across the street, down the small dead-end street next to the Hasidic-owned lumberyard, and there it was, the river, swirling and filthy.

No one wanted to live out in Williamsburg then—it was the wrong side of the river. Taxicabs didn't want to drive there; I learned quickly to get into the cab first before telling the driver I needed to go to Brooklyn. (If you told them through their front window, they'd often drive away before letting you inside the car.) None of my friends would visit me except if it was my birthday party or the like; there had to be

the guarantee of a good time. Williamsburg was too far, it seemed, but from what? The familiar.

But I loved it there. There were two perfect dive bars in the area, a few bodegas, friendly, life-saving businesses with cats curled amid shelves of potato chips, and one grim C-Town grocery store with cracked floor tile and bugs scattering in the corners. It was simply a neighborhood, where people lived, a mix of Hasidim and Puerto Ricans and Dominicans and artist bums (gentrifiers, and I do not say that glibly) like me looking for some affordable space. Warehouse buildings, public housing, and blocks and blocks of Hasidic-owned apartments. Every so often someone would hold a rock show in an empty parking lot or a beat-up loft space. The Hold Steady, the Yeah Yeah Yeahs. "It's always entertaining when you're hanging out with entertainers," sang Craig Finn. "They don't love you like I love you," sang Karen O. But mostly the neighborhood was quiet, with functional, empty streets in comparison to bustling Union Square, where I had last lived. I felt happy and at home there, that this was where I belonged at last, and that I would stay for a long time, even if I couldn't actually afford to live there all the time.

I know I romanticized it. There was plenty that was difficult about living in that building. Sizable jagged paint chips fell from the ceiling of my apartment hourly. Some sort of seemingly toxic dust blew in from the East River, covering my apartment with a layer of film on the days I kept the windows open. There were three muggings in the lobby the first month I lived there. A few times I passed the shells of cars on the street, stolen, dumped, and then set on fire. People used to tell me it was like New York in the '80s and I'd say, "But it isn't the '80s, it's right now."

The walls were so thin in that building, you could hear all the little things, the morning coughs, the sex noises, the arguments. My neighbors to the right were young artists (art handlers, anyway), who liked to drink and get high, stay up late on the weekends, every weekend, and Thursdays, too, and also sometimes Wednesdays. My neighbor to the left, he was quieter, but I was still so aware of him. We were friends on instant messenger, and he was always online. He played video games, and I would hear the gunshot noises from his computer. Sometimes I would borrow cigarettes from him. He was such a heavy smoker. He coughed a lot, especially in the mornings. He smoked Camels unfiltered. One of those set me up for a few hours. I didn't want to start smoking them—I smoked lights—because then I would be like him, a real addict. But when I was desperate, if it was late or if it was raining or cold, I would message him and he would invite me over and I would sit in his smoke-filled apartment and smoke his strong cigarettes. He didn't leave his apartment much, but he liked to have visitors. He did something with computers, I never understood what. He was friendly. We were friends. He was older than me, maybe he thought of me in a brotherly way. He didn't want anything from me, I knew that. A man who didn't want anything from me. And he was sober. Smoking was his one regular vice as far as I knew. Sometimes I came over when I was drunk or high. He was polite to me then, tolerated me. He had pockmarked skin and long hair and he was pale and overweight. He rode a motorcycle, and when I would see him outside of the building he was always in his leathers.

One winter he got into a motorcycle accident. I didn't see him for a while, maybe a month—I suppose he was hospitalized, or bedridden. I recall a leg brace. He didn't stop to

chat anymore in the hallway, so I didn't ask to borrow ciga-rettes. I thought he wanted to be left alone. I messaged him every so often, but he was brief in his response. I knew he was there. I could hear him. I could see him online.

In the spring, his apartment flooded. The water crept un-der his wall into mine and I went and knocked on his door and he was just standing there in inches of water. He talked to me then about the battle between good and evil. I asked him if he was going to fix it. It was hard to get him to focus. But he said that he would. I told the building management about it. I didn't know any of his friends.

That summer, he was found dead, facedown, his body rotting in the summer heat. No one knew he had died. The only reason anyone had known anything was wrong was the smell. For months after he was still online on my instant mes-senger screen.

We looked out for each other but sometimes people fell through the cracks.

If bad things ever happened to me in South Williamsburg, though, it wasn't the neighborhood's fault. I liked it there, by the river. Living by a body of water felt like a luxury. I never knew what Manhattan looked like until I moved to Brooklyn and could look back at it. I felt like I could stay for a while, in this place where no one I knew wanted to live.

And then everyone did want to live there, beginning in 2005, when the waterfront got rezoned for twenty-story con-dos, and people got pushed out by Manhattan prices, lured

by (relatively) cheap loft spaces, made glamorous (ish) by ass-holes like me who kept writing about it and talking about it and posting pictures of it on the internet and document-ing it in other places. Suddenly, I kept having to give direc-tions to tourists. Go that way, I'd say, and I'd point north. We were at the edge of cool, down there by the river, on the way to the intersection of the expressway and the Navy Yard. I couldn't get mad at the tourists. It was my fault, and the fault of people like me. If you want something to stay secret, don't tweet about it for a decade. If you don't want to ruin a neigh-borhood, shut the fuck up. (Or don't move there in the first place.) And anyway, it was beyond any of our control. You can't stop the monster, the city of New York, the hungry gi-ant, looking for land and sky and space. If there was a way to destroy something and then build on top of the rubble, New York City would do it.

I moved to the building a year after 9/11, from the apartment I had occupied in Union Square, the pretty studio with the fireplace, which I could finally afford because of my corpo-rate entertainment job, an apartment that at any other time in my life I would have appreciated, but in that moment symbolized a trap. This happened to a lot of people after 9/11, not the moving-to-Brooklyn part, although plenty of people moved somewhere new after 9/11. But this desire to do the thing you had been waiting to do immediately. What were we waiting for? It could have been any of us in one of those buildings, staring out at this city that had blessed us and then cursed us. Everybody knew someone or knew someone who knew someone. There were photos of missing

people everywhere, taped up to walls and the subway station, and there were vigils at the square, candles, their drippings piled high, and flowers, and messages of all kinds, everything just strewn about, our feelings strewn about.

It was the thing we never imagined could happen, and for a while we believed it could happen again, and then that city ate itself and ate itself again and new people moved in and there were new problems and a new mayor and they erected a building we could all visit so we would never forget, and every year they have a light show to remind us and they had posters and signs for years that said NEVER FORGET, and I have to tell you there are plenty of people who have forgotten. Even sometimes I forget, except for what it looked like, standing on the roof of my apartment building, watching a building burn and then fall. Nor can I forget the unpleasant roasted plastic smell of the city afterward for days, and how I had to show my ID to get in my neighborhood, how suddenly everyone was suspect, and also how sad everyone was, an entire city, so devastated and sad and angry and scared.

I didn't want to live in Manhattan anymore, where I had lived for four years. Manhattan seemed like a dead end to me because I was never going to be rich, I was always just going to be working, endlessly working, and I didn't know if there was any other way to get rich except to marry someone with money, as if life were some Jane Austen novel, a thing people actually talked about openly, jokingly, but also quite seriously, and that seemed unlikely, based on my taste in dirtbags. I hated working in corporate America. I had just turned thirty-one. I kept getting jobs and raises and then I kept quitting the jobs. If I quit working my corporate job, then I wouldn't be able to afford my apartment in Union Square. I

was about forty pounds overweight and I did cocaine on the weekends and also sometimes during the week and I worked late and ate dinner out and drank martinis, like several martinis in a night, without blinking. I spent sixty hours a week at the office, easily. I worked so hard, but nothing I made belonged to me. I knew I wanted to hide out in Brooklyn and make some art, although I didn't know what yet, because I didn't quite believe I could write an entire book. I just knew signs pointed across that river.

There was never a time I looked at Manhattan across the river in Brooklyn and thought: Take me back, Manhattan. I only ever thought: I made it out alive.

There was another thing about Manhattan: for that year after 9/11, I had claustrophobia, which manifested in anxiety attacks. I didn't even realize that's what was happening to me because I had never had them before. I only knew that I had trouble now in trains and bars and movie theaters. That's how I thought of it: "trouble." I was always searching for the exit, I always had to sit on the aisle. I always needed to know I could get out. What was the escape route? My heart would race otherwise. I walked to work for months and months except when it rained. I didn't want to go underground. I had read Murakami's *Underground: The Tokyo Gas Attack and the Japanese Psyche* coincidentally just a month before 9/11, and the book, a nonfiction examination of the 1995 sarin gas attack in the Tokyo subway system told in interviews, remained stuck in my head; I quietly believed that was where

we would be struck next. Eventually I got over it, but all I did really was pack the anxiety away for a rainy day. For another future event. Because hadn't I been looking for an escape route all my adult life?

One way I took care of the anxiety was to move near the river. I couldn't have articulated it then, but I felt more secure living next to water. The buildings couldn't collapse on me if there was a river there where I could escape to, I thought. I could flee from fire.

Once Lauren came to town for business and stayed the night in my loft. She had just finished a new book, had a certain confidence and glow in her red cowboy boots. The next morning we walked across the street to the ferry terminal, and while we waited, she squinted at the river, gauged it, and said, "I could swim across that." She was a star on her college swim team; when she looked at the river, she thought of it as a challenge, something she could surmount. And I just looked at it as a safe distance between me and Manhattan. I'd been there twelve years by then and still felt that way.

My building in Brooklyn grew to be one of those places that everyone I met in New York had been to for a party at least once: on the graffiti-strewn roof during the summer, on the Fourth of July, a famous photographer's monthly dinner party on the third floor, a New Year's Eve party on the sixth floor. Even I had been to a party there before I moved to the building: I remember I met a man that night who, in an extremely specific late '90s brag, claimed he had been dancing

with Cameron Diaz in a club the night before. What was she like? So *sweet*.

I paid $1,150 a month for the first three years I lived there, utilities included; I think I was a small fry to the building owners, so they forgot to raise the rent on me. The building was owned by a grumpy old Hasidic man of indeterminate age (he was either a hundred years old or a thousand years old) who mumbled when he spoke so you never were really clear where the conversation had landed when you walked away from him; sometimes I wondered if his manner of speech was a deliberate act of subterfuge. Nothing in the building got fixed in a timely fashion, if at all. It was, reportedly, once a pasta factory, and after that, storage for weird odds and ends, electronics, clothing, off-brand sodas. Outside, prostitutes and junkies roamed. It took until the mid-aughts for that to change.

A shrewd red-haired woman named Marla managed the building from an office in the lobby; I gave her advance copies of all my books because she loved to read, and I appreciated a reader, and because I wanted her to like me, because I like it when older Jewish people like me, and also so things would get fixed, or at least so attempts would be made. For a solid year I had roaches in my apartment, and no matter how much I cleaned or the exterminator, who visited monthly, sprayed, I couldn't get rid of them. Marla and I both scratched our heads. Then my latest next-door neighbors—who had a baby—finally moved out and Marla informed me that their apartment was filthy and riddled with bugs. After that, I had no more roaches.

In January 2008 we were all evicted by the Fire Department because the building wasn't up to code. There had been

a matzo bakery in the basement for years. There were grain silos down there that were fire hazards. And it turned out that all those rustic red pipes running through my apartment did nothing in particular but add to the charm. There didn't seem to be much in the way of a functioning sprinkler system. The building could blow at any moment, according to the Fire Department. Two hundred people forced out of their home on a Sunday night before a government holiday on one of the coldest nights of the year.

And yet, six months later, when the building was up to code (or close enough), many of us still moved back into the building. Because we loved our space. It was our home.

A few times a winter it would snow and then get cold enough that the East River would freeze in parts close to the shore and then one day the sun would come out and I would walk down to the river to watch the glittering chunks of ice and snow break and flow with the river, sunlight bouncing like mad against the ice, the water, the city itself. When I first moved to Brooklyn, I still went to rock shows at night, I drank too much, I did drugs, I slept with strangers. I did this well into my mid-thirties. I made bad decisions, but after a while they were the only kind I knew how to make, so then they just became simply decisions. Chunks of ice, breaking in the sunshine.

I had Thanksgivings in that building, I had Passovers, I had Halloweens, I had birthdays, I had love affairs, I had friendships. I went broke several times. I adopted a dog. I quit smoking in that building.

I was living there when I sold my first book at the age of thirty-four, and also my second, third, fourth, and fifth. Five books in a decade, in one apartment building.

The address was 475 Kent Ave. The building is still there, but it is not what it used to be.

2015, an essay assignment from the *Wall Street Journal*. A distillery sent me four enormous bottles of whiskey, one bottle of double cask rye, two bottles of aged bourbon, and a single malt. Immediately I knew I would share this boon with my neighbors, who had spent the last dozen years sharing with me. When I moved into the building, I had never expected to be friends with them. After four years of small Manhattan apartments, I had gotten used to the idea of home simply being where you slept. But here they were, these lovely, creative, edgy, brilliant people inviting me into their homes and parties and Sunday-night gatherings on the roof. The magnificent graffiti-strewn roof, with its view of all of Manhattan, the bridges, the East River. This is where I would bring the whiskey.

On the roof, more people were waiting. I set the bottles on one of the picnic tables another neighbor had made a few years back for his girlfriend on her birthday. I began pouring. Soon enough, Alison and Rob showed up. They've lived in the building since 1998 and are still there now; Rob was the first to sleep in the building overnight after he accidentally got locked in when it was still a construction site.

They're both professors after studying and working for years—Rob in art, Alison in biology. Until recently they'd had a five-thousand-pound printing press in their apartment. Every year they throw an all-day New Year's Day party. They were a significant part of the heart and soul of the building.

Alison was my favorite neighbor; a week previous to the

whiskey tasting we'd swapped the shoes right off our feet. We extolled the virtues of the "give and take" clothing pile in the building's lobby, from which we both had gathered a sizable portion of our wardrobe from our well-dressed neighbors. She was an artist, too, and a creator of things in general. She cocreated a program—now five years old—called "Art in the Lab" at St. Francis College, which offers free public workshops held in laboratories where attendees can create art inspired by science. I have watched her turn the contents of what seemed like an empty cupboard into a beautiful charcuterie plate as if by magic, and I've never seen her show up anywhere without a plate of food in her hand, ready to share. That night was no different: she sat at the picnic table with two pears and serenely began to slice them.

A few weeks before, Alison gave me a tiny notebook, no taller than a few inches, and it made me laugh—I write long, of course. What could I fit in there?

But I carried it with me one night anyway, grabbed it as I walked out the door to meet Courtney for dinner in Manhattan. I walked up Bedford Avenue, admiring all the outfits of the proud and stylish young men and women of Williamsburg—that summer all the girls wore vintage dresses and the sandals the old Polish women wore in Greenpoint, the Worishofers; the *New Yorker* even mentioned the shoes in a piece titled "Happy Ugly Feet"—then took the train into Union Square where I planned to walk to the West Side as the day cooled into night. I stopped at Barnes and Noble first, the big one on the square. For years and years, it had been my dream to have my books in that store, and now it had already happened several times over. It had once seemed intimidat-

ing, and insurmountable, and now I viewed the store just as a friend I needed to check in on to hear the latest news.

There were plenty of books in that window directed at women in the summertime, targeted, whether correctly or not, toward the kind of woman who travels through Union Square daily: the farmer's market here, the Sephora there, getting out of the subway on the way to meet friends for drinks after work, living in the East Village, working in Midtown, trudging through life, or was it strolling, or was it power walking. I harshly judged the books by their covers on their behalf. The how-to-bes, the sunshiny solutions, the presumption of conventional desires. I pictured women around me, all of them thinking: Is that what you got for me? Whatever it was they were looking for, this wasn't it. At least not for the character quickly forming in my head.

I needed to come up with a new book idea, and I felt fertile and game. I was thinking a lot about being on my own. I had been by myself for a long time. I did not know the lives of the women who were standing at that window, looking at those books, but I could imagine being them, I could imagine being annoyed at being talked to in that way, being told that these were the books that defined them, when they were busy enough trying to define themselves all on their own. I pulled out that small notebook and started writing in it as I walked, stopping on street corners, channeling the voice of someone new, as all the women in their strappy sandals and the slippery sundresses walked by—Manhattan women looking decidedly different from the North Brooklyn broads I knew—the last residue of sunscreen melting off their skin and merging with whatever new scent they had applied as

they walked out their office door into the night, to meet someone special, I hoped, even if it was just a friend. These New York women are gorgeous. Never in my life was I so pretty as when I lived in New York.

By the time I reached Courtney in Chelsea—we had dinner along the Hudson, that other river—I had written the first chapter of my next novel, about a woman who lives in Brooklyn, on the water, trying to avoid reading a book about being single. I wrote it in this tiny notebook. I read it, laughing, to Courtney. My pretty, bright-eyed, funny, novelist friend. One I had managed to keep all this time. It sounded good to the both of us. It sounded like a book.

I never ran out of ideas, living in New York.

As the sun set and we continued to drink on the roof, I talked to Rob for a while. He's a bearded, boisterous, funny man who does large-scale print and wood installations. "I'm the most particular, least picky person you'll meet," he said. "What does that mean?" I said. "I have a discerning palate, but in the end, I'll drink it anyway." He poured a glass for himself; eventually he began to drink directly from the bottle.

I realized I'd had enough booze when I saw that the notes I was taking had turned illegible. The river was dark then, the night was clear, and we saw stars over Manhattan. Hello, New York, I thought. Hello from over here. I left the rest of the double cask—the heaviest of the bottles—with a neighbor who had liked it a lot. Earlier he'd offered to watch my dog when I traveled over the Fourth of July, so it seemed a

fair trade. Another one. We could keep trading things for-
ever. There was always something left to give.

A few years later, the apartment building was sold. The new
owners were reportedly connected with Jared Kushner, who,
among his other crimes against humanity, had been rumored
to be one of the worst landlords in the city, employing aggres-
sive tactics to intimidate or evict longtime tenants. Almost
immediately people lawyered up. I'll spare you the intricacies
of the state's loft law, but the residents who lived there only
part of the year, renting out their apartments otherwise, were
the first targets for eviction. And if your name wasn't on the
lease, and you were a subtenant, even if you had been there
for years, you were in trouble. Cameras were installed all
over the building. Eviction notices were posted on doors. And
yet, still, nothing that needed to be fixed was fixed. People
moved out—kicked out or bought out—and rents got higher.
Everyone was stressed and anxious—all the time. That year
I realized I didn't enjoy living there anymore. I didn't enjoy
the sunsets or the river outside my front door. There were
new, big condo buildings everywhere. The neighborhood had
changed, it's not like it used to be: a typical moan in that city,
but it was true, the actual physical landscape had changed.

But that night, when we all drank whiskey together, all
those buildings weren't in existence yet. The sky was veiny
and blue with hints of peach. There were plenty of construc-
tion sites, which we sometimes spoke of on the roof and
sometimes chose to ignore. We knew soon enough our view
would change. I began to be wistful and then reminded my-
self: We've had a good ride.

I had started thinking about what my life was going to look like when I was fifty. The fact that these concerns had surfaced was as much a surprise to me as to anyone else. Living day by day had always seemed a valid way to operate. I had started to see how my life could look different. Quieter, and calmer. I wanted things to be easier and sunnier. And I did not want to grow old in New York. I had been young there, and that was enough. Friends drifted away. Often, we saw each other only blinking on a screen. I thought that if I stayed there forever, I would be sad.

This was when there was another president in the White House, and I felt at least a little bit differently about life in America. It did not seem as indulgent as it might now to want to be happy. I wanted a better life than the one I had, and for me that meant moving to a new city. To New Orleans, where I had spent several of the past winters. I didn't think about how I would feel after making a dramatic, permanent change from a city of eight million to a city of four hundred thousand. I had absolutely no idea what I was doing or how to do it or what it would mean for me to start over again; I just knew it was time to go.

A Landing, of a Kind

11

Risk Factors

1.

Once I fell on the ice.

When I was younger, I broke a lot of bones, had a lot of wounds, did all different kinds of damage to myself. I broke my wrist three times before the age of seven. Left wrist twice, right wrist once. For a time I was ambidextrous, and I wish I could have held on to that skill, if only so it would have made me special in some physical way, instead of merely cerebral. I didn't like pain or the healing process, but I saw how there could be a story to come from all of it. A story to tell.

I fell on the ice when I was in third grade. It was the accident that would most form me in my life, the scar from which I still linger upon occasionally, prodding it, longing nearly, for what I do not know. Possibly the alternate timeline where

it did not happen to me, and for that period of my life I did not look the way I did because of it.

It happened one winter, at my grammar school, Joyce Kilmer Elementary in Buffalo Grove, Illinois, where we were all made to memorize Kilmer's most famous work, which begins: "I think that I shall never see / a poem lovely as a tree." I enjoyed memorizing it. Give my brain, then a brand-new sponge, something to do. I particularly loved the line "Poems are made by fools like me." Give this fool a task. Give her a poem to know.

During recess all of my classmates would slip and slide on the frozen ground that stretched across the sunken basketball court while I stood wistfully nearby on the edge of the snow-covered grassy slope that surrounded it, watching everyone scream and laugh and fall. I had learned not to take physical risks by then. I was weak-boned, I was clumsy, I was overweight, I was uncoordinated. All these things I had intuited, by the way my gym teachers spoke to me, and various family members, too, or other classmates' observations of me, meant to be cruel or not, or even just by watching how other children moved differently than I did, freely, without hesitation, running and laughing and embracing the world. I did not want to hurt myself. And was there anything wrong with watching anyway? Observing their play. The way they chattered and laughed and teased each other, these girls and boys, still only just that. A lifetime of the observing of others awaited me, and perhaps I already knew that, I was so comfortable with the behavior, even if part of me knew it would be nice to have that kind of fun, too.

So I stood and watched. At my desk, in this moment, I can still see the kids slipping in front of me—right before

the moment of impact. Another girl—a little heavier, a little more awkward perhaps, but unwilling to give up the joy of her physicality for safety—fell off the ice and onto me. I was caught off guard; my defense mechanisms failed me. As I fell, I bit forcefully through my lip. I screamed. A teacher ran to me and hurried me away from the crowd gathering around me. There was blood everywhere, on the ice, on the snow, on my yellow puffy winter jacket with the faux-fur trim; I saw it on my sleeve. I was rushed to the nurse's office while the principal's assistant searched through a filing cabinet for contact info for my parents. Everyone was shaky. The nurse told me to wash off my face, and I stood at the sink and looked in the mirror, my torn lip and blood-smattered face, and screamed again, and kept screaming, unable to stop looking—always I am unable to stop looking when I should know better, as if I am willing myself to be affected—until finally the nurse came in and pulled me away, directed me to a single bed in the corner, covered with the scratchy army-issue blanket, a place for children to rest for a moment but not to linger.

In a few hours, I was on an operating table. The surgeon was cheerful and chatty as he sewed up my lip from the inside. I trust he did his best. It would take two weeks to heal and I would be disfigured for the time being, a portion of my top lip hanging down over the lower lip. I was still growing, so there could be no plastic surgery yet. Not for another four years, in fact. I would be chubby, smart, and weird-looking for a while.

I always laugh at this part of the story when I tell it to someone out loud. It's not funny, it wasn't funny at the time. It's just that there was such an attrition of badness, social maladies heaped upon me. I would be unhappy for so long,

but, now, finally, it's funny. The excess of it all! If you wait long enough, everything gets funny.

Who knows what my life would have been like if I'd had any confidence in my appearance as a youth. Instead, I reveled in my brain, and all the places it could take me. I was as fearless as I liked in my imagination. I would not trade my relationship with my brain for anything—it has always served me best; it is truthful, reliable, powerful; it solves problems; it makes art; it helps me to be of service in the universe. It is my reason for being. And I was not destined to be a great beauty regardless, nothing more than pleasant-looking, brown-haired, brown-eyed, a woman with a nice smile, a not-small nose, big breasts, big ass, a comforting body, rather than any kind of challenge. I am a comfort in my appearance. I am familiar. I am frequently told I look like someone's cousin, or college roommate or the like, and it seems a fond-enough comparison. Still, I wonder what it would have been like to feel pretty in those formative years, or pretty enough, or simply not a freak.

On a Zoom session in April 2020, I'm talking to a few friends from Brooklyn, and I tell them I'm writing about this part of my life. We talk every two weeks. We drink. We miss each other. We try not to be scared. My friend Emily, always pragmatic, scoffs at the question of how my life would have been different, tells me it doesn't matter, being pretty. My friend Alice, who writes speculative fiction, lights up at the idea of it, the fictional alternate path, which I agree could be an interesting exercise, although I do not know if imagining it

would be necessarily *helpful*. I'm of the same mind as Emily: What does it matter? Here we are.

"If you were pretty, you would have gotten a lot more slow back rubs from local community theater directors," says Emily, sage and wise. And pretty.

Being a smart girl is always better. This I know and can promise. Being a smart girl means you can always take care of yourself. Being a smart girl means you can figure shit out. Being a smart girl means your self-worth does not alter with time.

I invest heavily in being a smart girl for a long time after that fall. I still do.

2.

Once I slid down the side of a mountain.

This was in my twenties, after I became a risk-taker, after enough bad things had happened to me that I didn't give a fuck anymore, that you could act just as you were supposed to and it didn't matter, you were still a target. A woman, a target. A new decadence invaded my life. I was nearly steam-rolled by it. I wanted everything at once. To try it all. After so many years of being well behaved, working hard at school, writing down everything, because of an instinct that I should, that work—so American! So midwestern!—was good, a good idea. A purpose was what I needed. And anyway, wasn't I a writer already? Wasn't that what I was best at? Find something you're good at and then just keep doing it, and so I did until I needed to not do it for a while in my

twenties, to see who I was if I was not that, even if the answer turned out to be lost.

There were so many other risks I took then. All kinds of drugs, but only a few I suppose that could have technically killed me. I could have damaged myself in other ways, emotionally, for example. I could have destroyed relationships, gotten arrested, fallen in with people who took advantage of me. I could have ruined all the opportunities ever available to me. I have a rotten memory for periods of time I sadly have no records for, but perhaps it is better that way, anyway. I've slept in cars and train stations. I've hitchhiked. I've gone to strange apartments for all manner of unwise activities. I've gotten into cars with people who were driving drunk. I've walked alone at night in dangerous places, when I knew very well I should have been home by then.

I don't regret any of it, except for how much money I spent on drugs. And also, sometimes I was an asshole. And for that: I'm sorry, I'm sorry, I'm sorry.

If I haven't apologized to you in person by now, it's only because I know you won't care either way.

I slid down the mountain when I lived in Seattle. My memory is this: with three of my girlfriends, we had set out in the morning toward Stevens Pass. I drove. Everyone threw in a few bucks for gas. This would have been in late 1996, and we were all in our twenties, all still developing our street smarts. Everyone had service industry jobs except for me; I worked in a nursing home. One of us had dreadlocks. We rolled down the windows when we lit our cigarettes and blew our smoke out the window. We listened to the radio until we hit the

mountains and it turned to static. I put in a tape of a loca band we loved instead, and we sang along until we found the trailhead. We were in search of some hot springs, one in particular that we had heard was a real party. One of us had been there before, and she led us up the side of the mountain. We stopped once along the way to smoke pot. Someone had mushrooms, which we would eat when we reached our destination. The mountain was snowier than we had expected, and no one was dressed appropriately. We slipped and fell a few times. Our pants quickly became damp. Sometimes on hikes you feel like you're climbing to nowhere in particular, that you won't ever find your way to the thing you were looking for, and this was one of those days where I lost a little faith. I was high, and I was cold, but I wanted to seem cool, like I could roll with it. I had driven us there. I had gotten everyone there alive. I was the driver. I had to keep going; I was the ride. We walked like that for what felt like an hour.

And then we heard voices, a naked man stood on a platform in a gathering of trees down below us and waved in invitation, and then we were at the hot springs, nestled on the side of a mountain. There was a series of decks built around the springs, and you could slip easily from a hot-hot pool to a merely hot pool to, finally, a cold pool, when you couldn't take the heat anymore. Everyone spending time at the pools was naked up there year-round, we quickly found out, even in winter. It was all very freeing, sitting on the side of a mountain, surrounded by trees, soaking yourself in these baths laced with lithium. We ate the mushrooms, which, looking back, seemed unnecessary. How much higher did we need to be? But then, those days, I could not get high enough. We were delirious, we were happy. We were young, we were naked.

I had no future plans, absolutely no dreams about what I wanted to do with my life. Except be right there.

I wish I could channel that ability to live in the moment now. I am, I suppose, channeling it a little bit, as I write this, as I type this, as we are all homebound in this country. I can't imagine what the world will look like in a year. We can't go back to the same way, but I don't know if forward is necessarily the direction we'll be going either. Everything is just sideways. And that's how I felt then, when my future was so ambiguous. There was no career I wanted, no big dream I was moving toward. I had no ten-, five-, or one-year plan. I was just hanging out with my friends high up on the side of a mountain.

We got to know the man who had waved us down from the hiking trail. He called himself the Naked Chef, and it turned out he was a sort of host for the place. He hiked up there every weekend with pounds of food in his backpack and he would set up a little cooking area and make vegetarian dishes for anyone who wanted them. He'd had some small amount of fame for this in the '80s and '90s; he eventually offered us a binder filled with laminated articles about him. He bounced among pools and his pots and pans, distributing small bowls of pasta in tomato sauce to our wrinkled, red, spring-soaked hands. He had a sizeable penis—even flaccid—and it was darker than the rest of his body. The food he served was fine, if a bit salty.

A few hours passed like this. Eating, smoking weed, dipping in pools, hot, cold, hot again. Marveling at all the colors. How many shades of greens we could see in those trees. The shifting of the light against the sun-riddled peaks of the opposing mountain. It got late; soon the sun would set.

The drugs began to wear off. We could take more, but then we would have to stay the night. Did we want to stay the night? Stay up until the morning there in the pools. A new batch of people showed up. The people who would stay up all night with us. Coworkers at a restaurant who had gotten off a lunch shift, rolling in with beer and more weed. They were older than us. They were regulars. They had been doing this—everything—longer. This life.

We could just keep going, take the rest of the drugs. We hemmed and hawed. We needed to decide soon. We were too soft and high to make a decision. I think this is what happened: one of us had a dog. She had roommates who could look after the dog and yet—she should probably go home and look after it. That was what decided it—the dog. We'd spent so much time deciding and it had only gotten later. That was how "late" worked. It would be later and later until it was early, but we couldn't wait for early. Now we had decided to go. One of the regulars suggested we take a shortcut. The path we had hiked up would take too long, we'd get stuck in the dark. Where was the shortcut? They pointed in the opposite direction of the path. They did it all the time, it was perfectly safe. Should we do it? Let's do it. We dressed, packed up our shit, and headed to the shortcut.

The shortcut was the side of the mountain. There was no beaten path. "Are we just supposed to . . . slide?" we wondered. The answer was yes. Our clothes were already wet. Our hair, our skin, our backpacks, we were in a general state of dampness and dirt. There was nothing to lose. And the regulars had told us we would be OK. The sun was just above the opposing mountain and sinking fast. Now, we needed to go now. We sat in the snow, and then we began to slide. At

first, we used our hands to push ourselves, but soon enough gravity took us, and we moved quickly, stopping ourselves when we approached the tops of trees. A few times the trees stopped us themselves. I laughed the whole time, in part because I was experiencing a severe adrenaline rush, but also because I was scared shitless. When we really got moving, we were going so fast. I can't imagine it lasted longer than ten minutes. Ten minutes of sliding down the side of a mountain. The last few minutes there were no trees in the path, and we just fucking flew, and had we run into anything we probably would have broken a bone. It was dumb, it was a dumb thing we were doing. I had been so smart for so long and now I was so stupid. Anything could have happened but it didn't; why worry about what didn't happen, I know. When I got to the bottom, I felt a new level of high: every cell in my body was flinging itself from the inside out. I thought: I would never do anything like that again. I will never consciously take a risk like that. Not where bones can be broken.

A few months later I would move back East, to New York City. A new risk. I could not get any higher out West.

3.

Once I jumped off the side of a cliff.

Don't be impressed. I was in Guatemala, in a park, above a lake, where there was a line of people waiting to jump; it had been done thousands of times before. Still, it felt like a risk. I had long since forgotten my wilder youth. When I broke my ankle when I was thirty-eight, it had taken me so long to recover I had stepped outside my body and refused to return.

The deeper I plunged into my writing and the fictional worlds of my head, the less important it felt to be connected with my body. I had chosen a way out. But here I was, jumping off the cliff when I was forty-six years old. This when I was just starting to realize I needed to take risks again.

I was on Lake Atitlán, an astonishing, lush, sparkling lake at the base of three volcanoes, in the Mayan village of San Marcos, on an assignment from a travel magazine *Afar*. I had taken a ferry there the morning before. The village had built up a healing community, and who was I, as a middle-aged, middle-class white woman, if not at least a little attracted to that kind of thing? And indeed I found a village full of new age opportunities, yoga studios, meditation centers, and holistic healing venues. The lower village was full of sneaky, charming little back alleyways, which offer entrances to these healing centers, as well as youth hostels, restaurants, and hotels. Across from a hostel I found a framed chalkboard listing that day's meditation times and other spiritual activities. There were flyers everywhere, offering classes in mushrooms and cacao, sound journeys, massages, healings, tarot readings. Most were offered by gringos. "Aggressively hippie" I wrote in my notebook at the time.

Travel pieces are garbage sometimes. They ask you to go and be yourself in a world that hasn't necessarily invited you there. Your company is not desired, even if your dollars are. And then you go and impose yourself. Here we are, using your resources, stomping on your land, leaving our footprints behind. I think often of that Ray Bradbury story "A Sound of Thunder" when I travel, the one where the time-traveling safari guest destroys the future by stepping off the prescribed, levitating path. How am I destroying the future by walking

on this land? So many of us stepping off the path willy-nilly. Surely my measly tourist dollars are not worth the cost. Surely this fee I will earn will not justify my being there.

Still I go, I pay attention, I listen.

That night in San Marcos I took a stroll just for the sake of it. There wasn't much to do there otherwise. A few bars in youth hostels, some dancing, some meditation. Most restaurants closed early. I didn't see a television set anywhere I stayed or in most bars and restaurants there, but I suppose they existed somewhere. Everyone I encountered greeted me. I passed a tiny gymnasium, the locals smiling as they pumped iron. It was quiet, but also there were plenty of noises. The motors from the tiny tuk-tuk cabs, waiting to drive passengers up the swirling hills. Dogs barked incessantly for much of the night, mostly from far away, but there were a few that lived at the property next door to the hotel, and when I looked out the window at them, I saw a man urinating in the trees below. Placidly, I watched him. It was its own kind of noise.

I rose early again the next morning, this time to take a yoga class in a studio about a twenty-minute hike from the waterfront. It was an indirect path, with a steep incline. I walked through the barrios, taking a more complicated route than I probably needed to, past the man herding goats singing "la leche" over and over, and the lazy dogs, and the squawking chickens, and the wall murals, and the one determined puppy hassling his mother for feeding, until finally I arrived at some long, curving roads through trees, all the while the sun rising behind me.

There, at this gorgeous place, flourishing with tropical plants and waterfalls, I met another traveler, a woman from

Alaska, a few years older than myself, easygoing, grinning, a designer, who, despite being married with a child, managed to spend at least a month a year traveling by herself. I admired her immediately. We made quick friends, as women traveling alone often do. The yoga class was fine; the company was better. We agree to meet later, to visit the Cerro Tzankujil Nature Reserve. There was a diving platform somewhere in the park, off the side of a cliff, and I intended to jump off it.

After we met, the Alaskan told me her travel ideology, how she liked to visit countries in transition, like Guatemala, where things were changing, where there will be a before and an after. She never visits Europe; things are locked down there, she feels, its history firmly established, its present aligned with the future. I admitted I felt lazy as a traveler. I went where I was sent, on assignment, by publishers and literary festivals and the like. I rarely thought about where I wanted to go, what I wanted to see. There was a snap of recognition in that moment.

I had been hiding myself, even though I was living a much more public existence. The more I put myself out there in the world—touring, talking, meeting people, being interviewed—the less I felt in my body. When I travel too much, I get stuck. Sitting in an airplane, in the back of a taxi, packing and unpacking, dragging the luggage, checking the phone over and over, sinking deep into myself. Arriving at my destination but never seeing anything. I used up all my adrenaline on getting there. I was somehow both in motion and stagnant.

We found the diving platform easily, the lake and the volcanoes all around us, the sun shining, a few clouds in the sky moving quickly as the late afternoon wind—known as Xocomil—began to pick up. There was a line. I eagerly

stripped off my clothes to my bathing suit. I was excited to do it purely for the reason that it was something I had never done before.

The Alaskan had no intention of joining me, but she offered to film me. She told me a story about herself, about why she was less likely to take risks. In her youth she was in the Peace Corps in Africa, and had a terrible skydiving accident, in which she broke her leg, forcing her to give up her assignment and return to America. To move back in with her parents, in a small town, in a religious community. Exactly where she had been trying to escape from in the first place. She had made it so far and then . . . "Your life can change in an instant," she said.

I didn't care. I wanted to jump. Foolishly, I hurled myself off the cliff without even considering my actions, or a strategy at least, perhaps to arrange myself in a straight line. Instead, my body was wild and willy-nilly, my bottom smacking the water first, and it was as if a thousand hands were spanking my ass at the same time, a great, resounding pain, all at once.

And so, on this trip, there was the before that jump, and there was the after. It was unlike me to jump so blindly, and I was punished for it, and yet I would do it again in a second. I felt transformed: I was not just the observer, I was the doer. As I dried off, I noticed there were instant, massive bruises on my backside and along my thighs, bruises which would haunt me for days. I felt giddy and ecstatic and a little damaged. I liked it.

Later the Alaskan and I drank mescal in an empty bar. Two middle-aged women with sunburns, sipping strong drinks on a quiet lake. My bruises had crept up my backside, and so I

drank to numb the pain a bit. A million stars in the Guatemalan sky. I told her about a man I had started to date back in New Orleans, who was handsome, and kind to me, and seemed like the type of person who would look out for me without me asking. I liked him, even though we were different in so many ways. I felt extremely "why not" about that, too. We had only been seeing each other for a few months. A fling that kept going. Why not. Why not try love, or something like it? We both agreed it was worth a shot. Another risk.

The thing with being a novelist—or really with any creative endeavor—is we have to willingly enter into the not knowing. We have to embrace that fact that there are myriad nuances to be unfolded. Characters we haven't met yet, actions we haven't invented. Thousands upon thousands of words waiting to be chosen. If I know how a story ends when I start writing a book, I throw it aside. It's not worth writing if there are no surprises. When you slide down a mountain, or jump off a cliff, you accept the not knowing. Don't tell me how it ends; let me see for myself. The trick of life is understanding that even when we are simply standing to the side, as I did as a child near the ice, watching other people taking risks, we are engaging in the not knowing, too. Everything is a risk. That's what's hitting so many people so hard right now, here, as we approach May 2020. They didn't know that they didn't know.

12

The Bone Chapel

I took a trip once by myself to the coast of Sicily. I was forty-five years old. It was the end of a book tour on behalf of my fifth book, and I added on a few days so I could see the sights. I stayed at a hotel in a small city my friend Cynthia had recommended, because she has traveled all over the world and has excellent taste. "Here's what you want to do," she said, and I did it. (I have many flaws, but I am good at recognizing which advice I should take.) I worried on the internet about driving in Italy and enough people told me it would be fine, so I listened to them. I rented a compact car, I drove up and down the winding hills, and it was wild and scary and a fresh experience and I loved it. I saw the Temple of Segesta, walked it, paced it, thought about the past, about how we are basically alive for a second, blink and it's over, it's done. I took pictures. I posted them on the internet so people would know I wasn't dead and also as evidence of some kind of new

existence. If you see something new, then, at least slightly, you are changed. On the warmest day of this trip, I soaked myself in the Mediterranean Sea. The water felt like silk on my skin. I sat by myself on a small, rocky beach across the street from the hotel. It was romantic, and it was lonely. I felt lucky and I felt sad. I wished I could fuck someone. All around me people much younger and more attractive than myself zoomed by on motorbikes. I had wanted this trip so badly, to see this new place. I had been traveling by myself for many years. It was part of my identity. I felt proud that I had made my way there. I felt all these things, and then I looked out at the sea. That night I walked to the nicest restaurant in town, one that sat on a cliff, and asked if I might dine there. They told me that they would not seat a party of one. They shrugged and dismissed me. I walked back to my hotel, hungry, and I cried. I did not want to change anything about my life—I had worked so hard for it—but also at that moment, I did not want to be alone. I was exhausted with doing all the work of being on my own. I wanted someone to dine with at the nicest restaurant in town.

I resolved not to travel by myself anymore, or at least not as much. But I was worried I was too spoiled and selfish. I also worried no one would want to spend that much time with me. I had been on my own for so long; it had been eight years since I had been in my last serious relationship. I wish that everything was natural and easy for me, but sometimes it is not. I spend too much time alone, which I love, but sometimes when I surface it takes me a while to acclimate myself to other people. I blame it on being a writer, but also, actually, it is just me. It is both my solution and my problem. Being alone.

✳ ✳ ✳

An important book of poetry in my life is *Absolute Solitude* by Dulce María Loynaz. I discovered it in the spring of 2018, when I was browsing through the poetry section of Dog Eared Books in San Francisco. It was one of their recommended books at the time, one that came with a strong letter of reference from the staff. "Read this immediately," I think it said. So I bought it.

Absolute Solitude made me think about the ways that loneliness could be different from solitude. I write a lot about lonely people in my fiction. For some of my characters the quality of being alone is—at least potentially—something rich and sustaining, almost to the point of being a worldview or an aesthetic. Loynaz's work expresses this outlook beautifully. After all, the book isn't called *Absolute Loneliness*. Loneliness and solitude turn out to be two different things entirely.

"The world gave me many things, but the only thing I ever kept was absolute solitude," Loynaz writes, in a one-line poem from her "Poems without Names" series. I love the idea of solitude being a gift. I think we can be afraid of being lonely, but if you figure out a way to own it and see it as a treasure and a pleasure and a joy, then it can be quite comforting. I have a place to go in my head that's just my place, and no one ever gets to that place. I value that alone time so much. I wouldn't be able to be me without it.

Still, Loynaz also seems to recognize that too much solitude can be isolating, alienating, maybe even dangerous. In a subsequent poem, she writes: "Solitude! Ever dreamed of solitude! I love you so much I sometimes fear God will punish me by filling my life with you." Be careful, she almost seems to say. The idea that solitude is a be-careful-what-you-wish-for

thing is something I think about and write about all the time. Like, what if it was only you? What if the plane crashes and you're on an island by yourself? I don't know how happy I'd be that way. There's a tension there. Solitude is better as a block of time than as an entire existence.

"Loneliness is solitude with a problem," wrote Maggie Nelson in *Bluets*.

After that trip to Sicily, I began to practice being a different version of myself. I took weekend trips with friends. I shared hotel rooms. I traveled with smart people, who knew more about where I was going than I did. I found I enjoyed it when I relaxed the reins. I let someone else pick the restaurant. The nice one, where we dined together. These strategies impacted my business travel, too. I made dinner arrangements with friends in as many cities as I could when I was on tour. I worked hard to open up my world. It is difficult to express this properly and how could I even know that it is true, but I believe this: I was born a writer. I knew that I would live with a certain kind of heartache forever, that it had been ingrained in me since birth somehow. But maybe there could be moments where I soothed it.

Eventually I met a man who wanted to travel with me. Our courtship was as such: all the body parts lined up correctly, eliciting small electric flames along the shared threshold. Day trips to the country, crawfish on the levee. Long texts. A ride to the airport. More sex, with gusto. I appreciated how generous he was to his community with his time.

I liked teasing him. No children, no desire for them whatsoever. No old marriages rotting in the past. We both owned our own homes. We both had flexible schedules. He even pretended to quit smoking for me.

We decided to take a trip together. To Portugal. In 2018. I had been planning the trip by myself—I had an Italian book tour with some social stops in Tuscany and Sicily and then an appearance at a festival outside of Lisbon—but he wanted to join me at the festival, and we would go from there. We had a whole country to explore. We sat next to each other on the couch, side by side, scrolling through pictures of hotels and Airbnbs and tourist destinations. He told me he had found a town that had a bone chapel, and my face lit up, and his did, too, in seeing my excitement. Then I pointed to a place on the map that was called The End of the World. That also sounded appealing.

We quickly grew overambitious in our planning. Should we go there? And there? We were being amateurish and in the early stages of falling in love (although we had not said it, said those words, and if you do not say them are they even true?), where we wanted to please each other while still figuring out how to negotiate in our relationship. We also wanted to impress each other, too, and we were emboldened by the numerous road trips we had taken together through Louisiana and Mississippi. All spring he had shown me everything he knew about the place where he had lived for more than twenty years. So we decided to drive around this new country together, this foreign land, to the bone chapel, to The End of the World, and more. Whatever was beyond, we would go there.

There was one hitch: he wanted to rent a stick-shift car.

He had learned how to drive on stick, he said, and he missed it. I only knew how to use an automatic car. "Are you sure you want to drive the entire time?" I said. It was true, whenever we took road trips, he was always the driver, and I was always the navigator, but this was going to be days on end, in a different country. We talked about it for a while, but perhaps not long enough. I may have doubled back on the subject later. It was a lot to ask, for someone to always be the driver, is what I said. I did not know how to say: "This is a terrible idea." Or even: "What if I wanted to drive? What if I wanted that shot at control in this new, foreign landscape?" All the words that were in my mouth and on my mind all day long, every day, and I could not say those for some reason. He seemed so certain. He wanted that stick.

A few months later, we met in the small city of Óbidos, where the literary festival took place. The event oddly turned out to be somewhat controversial. One of the other authors on our panel hadn't shown up, leaving just me, and a writer who was much older and more conservative than I was, to be in conversation. At most literary festivals, the visiting foreign writer is assigned a translator, who can act as a conduit between the writer, the other panelists, and the audience. In this instance, someone was simply asking me my questions and then translating my responses roughly to the audience, but not translating what my co-panelist was saying word for word to me, just sort of briefly summarizing it instead. So while it was a two-sided conversation, neither one of us knew entirely what the other was talking about until well after the

other one was done speaking. By the time I caught up, we were in trouble.

The audience largely understood English as well as (obviously) Portuguese, so they seemed quite thrilled by the entire exchange. The woman I was in conversation with was extremely antifeminist, a fact I hadn't realized until after the third round of back-and-forth, and I had been nodding and smiling as if in agreement, only to discover we were completely at odds. I recall she was quite insistent that it was a man's job to change a flat tire, and that she didn't want those roles to change, ever. I said that I did not know how to change a tire but that I thought I could learn quite easily, and at the very least I hoped I'd be paid the same as men so that I could afford to hire someone to change it. I think perhaps she was not a fan of homosexuality either, but it might possibly have just been the general idea of gender fluidity, which I mentioned in a positive light. We will never really know.

By the time I figured out I was supposed to argue with her, she was quite angry, and I think I treated her with amusement. It was all quite riveting if pointless. I was told later by one of the organizers that this literary festival was unaccustomed to controversy, and they were pleased with it. The audience was responsive and seemed entertained; they had applauded and engaged with this battle of stutters and stops and aggressions. I was happy at least to have shown them a good time. In America it would have been an unlikely conversation to have at a literary festival—an older female novelist arguing against feminism—and I felt as if I were just swatting slow-moving flies away from my face the entire conversation. I don't know what she was so scared of. Being left alone,

perhaps. At the end of the talk a smiling young woman approached me and said she had been in the military and that she knew how to change a tire.

My traveling companion and I were both quite exhilarated by the whole event, its offbeat energy, and the enthusiasm of the audience. It boded well, we thought. Who doesn't want a little weirdness in their travels? The next morning I stole a bunch of fruit and granola bars from the breakfast buffet at the hotel we had been assigned, and then we packed and took off in our stick-shift rental. We headed east.

Almost immediately, we got lost; it turned out the car's GPS was quite useless outside of big cities. Instead, I was using the GPS on my phone, which had a strange delay, so that I was always telling him where to turn moments before (or slightly after) he had to actually make the turn. And, I was wearing new glasses, progressives, for the first time in my life, and my eyes had not adjusted to them yet.

I squinted at the GPS as we drove. I moved my head up and down at different angles. "Fuck these glasses," I mumbled. My head was buried in my phone. I stole glances at the countryside when I could: the forests of cork, their trees freshly shorn of their layers, and the big skies above, overcast, gloomy, but with pockets of light everywhere. There was small-town life every sixty miles or so. But mostly I was looking for the next turnoff. We had gotten lost once, and I did not want to be responsible for that happening again. Almost immediately I resented everything about the fact that we had rented a car I could not drive. This was the kind of thing I had been afraid of, traveling with another. I had made a concession, and it was the wrong one. And that I would be displeased by something, and be stuck in a situation that I

could not rise above, even though I should be able to. But I should, I could, I was a grown-up, I could do this. I sucked in my breath.

We made it to our destination, arriving only a few hours later than we had planned. The GPS led us to a city center with a million dead ends and signs we didn't understand regarding where and when we could park. Finally, we called the hotel, and they directed us to a parking spot that would cost us ten euros a day, at which my traveling companion flinched. He would have preferred to park for free outside of the city and walk a half mile or so to the hotel with the bags. I was of the thought that we should probably just park already and get out of the goddamn car, which I did not say out loud, but perhaps tonally, I did, as in, I said the "maybe we should park already" part out loud and let my tone say "and get out of the goddamn car" part. We parked.

He had picked a charming historical hotel with vaulted stone ceilings and parquet floors; immediately the stick shift was forgotten. A beautiful hotel room counts for a lot with me. (In many ways I am not easy, but in this way I am.) First, however, we had to get into the room. The front-desk clerk gave us the key, and we made our way up the stairs with our bags, found our room, unlocked the door, only to see it was already occupied—we had been given the key to the wrong room.

Now we stumbled in on an older couple, gray-haired, and lean. They were sitting up in their sleep garments, side by side, under the blanket, his arm around her shoulder. They looked up at us calmly, only a hint of surprise. There was nothing sexual happening. They were just sitting closely. Being right next to each other in bed. They said nothing. I wondered if

they had been married a long time. I thought it was sweet he held her so close. I wondered if my boyfriend would hold me so closely twenty years from now. Surely these people bickered once or twice while driving to this destination, and yet still they could sit right next to each other, in such a loving embrace. Was this some sort of future version of ourselves? We apologized and shut the door.

Finally, we made our way down the cobblestone roads, through the city center, toward the bone chapel. There were tourist shops selling every imaginable object made of cork from the nearby forests: purses, shoes, wallets, hats, notebooks, cork, cork, cork. Everybody has to have their thing, I thought. We grabbed a few pastries from a café and sat on the steps outside Igreja de São Francisco, the church complex which housed the bone chapel, known as Capela dos Ossos. It was late in the afternoon by then, a sunny day still, and while there were still people on the streets, it didn't feel overwhelmed by tourists as it had in Lisbon, or even Óbidos, which had been packed with crowds for the literary festival. We both wore shorts. We drank water. For the first time that day, things felt tranquil. We were there to see the thing we had driven all that way for. The thing he had found for me. The thing he had thought I would love. We agreed it was time.

At the entrance of the chapel, on a pillar, there is a poem in greeting, attributed to Father António da Ascenção Teles, who was a parish priest in the village in the mid-nineteenth century. It translates to this:

Where are you going in such a hurry traveler?
Pause . . . do not advance your travel,

You have no greater concern,
Than this one: that on which you focus your sight.

Recall how many have passed from this world,
Reflect on your similar end,
There is good reason to do so,
If only all did the same.
Ponder, you so influenced by fate,
Among the many concerns of the world,
So little do you reflect on death.
If by chance you glace at this place,
Stop . . . for the sake of your journey,
The longer you pause, the further on your journey
 you will be.

Capela dos Ossos was built in the sixteenth century by a Franciscan friar. It is a small chapel supported by pillars of skulls and bones piled together straight to the ceiling, and also surrounded by walls of bones upon bones. A few mostly intact skeletons hang from those walls, and on its vaulted ceilings there are graceful paintings of skulls. It is an extremely elaborate yet contained design. The whole of the chapel contains the remains of more than five thousand people, who were exhumed from the city's graveyards at the time of construction, not just for monument purposes, but also to make way for new bodies to be buried.

The chapel was conceived not to scare its visitors, but instead to encourage them to contemplate their daily existence, to meditate on the transience of it, and to recognize the vanity of earthly life. It is a fully realized visualization of memento mori. To be asked to contemplate life and death and what I

was living for, where I had been before I got there and where I would go to after I left, felt to me, amid the quiet of thousands of bones offered to me as art and ritual alike, like a gift.

An incredible stillness bloomed with me. It was the closest thing I had ever seen to a physical manifestation of the creative experience. Everything was dead—I knew it, I could see it with my eyes, bones dusted with hundreds of years of existence—and yet it felt so alive to me at the same time. It was designed for thought. Alive and dead, stories everywhere. Thousands of possibilities, thousands of stories. The bones had been brought together in this space, the bones would never be alone. They have each other, I thought. And all of us, visiting them, every day.

I had arrived at a different kind of interaction with the bones: I had a sense of being greeted. Death, the familiar. It wasn't just the message about the entrance, although I appreciated the formality of it. I make no claim to have any sort of psychic sensibility or sensitivity. But we had clearly entered their home. They presented themselves for us, allowed our gaze to fall upon them. An invitation to examine and contemplate what remained of them, and to imagine their past as well, whatever space their past holds in the universe. In their death, in the presentation of it, in the remembrance of it, we were given a little more life, a little more to go on, something to take with us as we moved on in our future.

I was having whatever the opposite of an existential crisis was. It was a pure and deep moment of fulfillment, the same as when I finished writing the last sentence of a book, but also the same as writing just one good sentence, the moment just after that, that quickening of the heart, the peal of satisfaction that trembles through my body when realizing that

I have taken the correct action. An ability we all share, to feel that way, once we find that one small thing that pleases us, that we can be good at. How lucky we all are if we can find that one thing we love. Even if the downside is that we miss it when it's not around; or feel a sense of disappointment in ourselves if we can't achieve it on any given day. But forgiveness is another thing to learn, forgiving ourselves for not always being our best, for not always accomplishing everything. Add forgiveness to the arsenal of skills we need to acquire in order to survive everyday life. Forgive ourselves for being human.

But what of my traveling companion? We were together, but we experienced it separately. We were next to each other, but I was in a state of thrall to the bones. We were not in our bedclothes, side by side, his arm around me. I was feeling something singular. When we left, though, I recall him asking me if I was happy, and I was, I was flushed and cheerful, and I think that pleased him. I told him: "This place is perfect to me."

What I should have done right then is told him I loved him. Sometimes I think if I could have done that then maybe the rest of the trip would have gone differently. If I could have been the kind of person who knew how they felt right when they felt it. Sometimes I get so frozen in my feelings, though, or perhaps it is that one feeling is stronger than the others and that's the one that commands me. I have multiple feelings going on at the same time within me, all day long. This is why I can appreciate a room full of old bones chattering at me silently. This is the makeup of my soul. A room full of bones, a multitude of voices, all at once.

But I should have listened to the one voice, the one that

said, "I love you." (Six months later I did, but by then maybe it was too late.) I should have told him that no one had ever taken that kind of leap for me before, found a place far away, a foreign destination, and then flown there, met me in a city that held no interest for him other than that I would be there, and then drove me all the way across a country, to another city just so we could see this specific thing, this specific weird thing, that he knew would make me happy. This was a moment designed to fulfill something in me, and it had. But I did not know how to make room for him then. As much as I had wanted it, to travel with another, I still only knew how to be on my own.

13

Track Changes

I had just turned twenty the winter I passed as a man. I was backpacking through Europe alone. I had left behind America—and a thousand problems, most not of my own making—for a creative writing study abroad program in England. Others I knew at my university in East Anglia had found travel companions, but I had decided to venture out by myself, armed with an unlimited train pass and a small amount of cash. Along the way, I would intersect with friends in various cities, so people would know I was still alive. My strategy was to sleep on the night trains to save money. It was both a brave and a stupid plan. (Mostly stupid.) It certainly didn't occur to me in advance that I would need to alter my appearance.

But the night trains wanted to have their way with me. My first evening alone, outside of Paris, I found a cabin where an elderly gentleman sat. We spoke for a while in Spanish and

in French, and then he took one side of the cabin and I took the other. I woke up to find him standing over me, fondling my breasts.

Over the next few days, men made kissing noises at me, bumped up against me, and aggressively chatted me up, asking me for sex. I'd been to American fraternity parties in the past two years; I'd seen harassment. But it was harder to tell people to go away when you didn't speak their language and didn't have a home of your own.

I looked at what made me a target. My breasts, for one. My Americanness, another. That backpack let everyone know I was from somewhere else, and if that didn't, the minute I spoke would. What weapons did I have? None. All I could do was hide my vulnerability.

I put my hair up in a baseball cap. In an Amsterdam market, I bought an enormous motorcycle jacket to hide my body. I was still at an age where I refused to contend with my facial hair, so a thin dark mustache lined my upper lip. Perhaps my best asset was that my look can turn on a dime: I am curvaceous and have pretty eyes but I also have a masculine quality, thick lips, thick eyebrows, a long face, a deep voice. If I wasn't exactly a man, I wasn't definitively a woman anymore.

Passing as a man made my life instantly easier. I could sit quietly in train stations or sleep soundly at night. From Italy to Germany, no one wanted to talk to me because no one wanted anything from me. I looked like a young, male, solo traveler who wasn't interested in making any friends. I was safe.

Near the end of my travels, I took a night train from Hamburg to see a friend in Stockholm. When I boarded the train at 3:00 A.M., every cabin was packed save one, which

held a young blond man who smelled of booze and an older woman who smelled of perfume. I wouldn't have known enough then to tell you if it were a cheap or expensive scent, only that in its quantity it seemed like she was trying to cover something up.

The man, on the other hand, was trying to hide nothing. He was a Swede who worked as a skipper in Trinidad and Tobago. He'd flown into Paris, bringing with him a case of duty-free rum and had been on this same train since. He'd been drinking for hours. The woman said very little. The skipper spoke to her in German, and she replied in a low voice. Then he winked at me—the male me—and started speaking to her in English.

He asked her why she was coming home so late at night. She said she lived at the next stop and had been visiting her uncle in Hamburg. Her lipstick was faded, her hair flattened. He spoke to her again in German, roughly, and she didn't answer. I tried to make sympathetic eye contact with her, but she was either too exhausted or mortified to look back. I knew that he wasn't being kind to her. How could I make his harassment stop?

I did the only thing I could: I took off my hat and my jacket. I didn't know if it would embarrass him or shock him; I just hoped it would change the conversation. And it did. The dynamic in the cabin shifted. His gaze turned toward me. He offered us both rum, but we declined. At the next city, the woman left. The skipper said: "No one travels from Hamburg this late at night because they're visiting their uncle. That woman was a prostitute." He talked for a while about prostitutes. He had so many thoughts about prostitutes. Then he trained his eye more precisely on me: he asked

if I had a boyfriend—I did—and if he satisfied me. I said yes, and yes.

Not that it was any of his business.

Eventually he passed out, and then so did I. When we woke, we had nearly arrived in Stockholm. In his sobriety he changed yet again: now he was a perfect gentleman. He helped me figure out how to catch a commuter train to my friend's university, opened doors for me, and even carried my bag. It was as if none of it had happened. Here, in his home country, off the trains, he remembered how to behave again.

As I walked away from him I felt suddenly clearheaded. Over those past few weeks, I'd enjoyed the freedom of being a man. But now, as I hiked up my bag, off to meet my friend, I'd go back to being myself. I thought, with a bit of envy, how easy for him to become that kind of man. How easy for him to be whatever he liked.

14

A Trip to the
End of the World

My sixth book gets published. It's 2018. I go to Italy on book tour. I go to Milan and Rovereto and Pordenone and Palermo and Catania and I speak at bookstores and festivals and do interviews with magazines and newspapers and bloggers and radio shows and television shows. I wear a yellow dress that happens to match the cover of my book and a cameraman takes a picture of me holding the book and I post it on the internet and I am jet-lagged but I look pretty. A mature, beautiful, busty, tan woman in her yellow dress in a foreign land.

Viola meets me in Palermo for the second time in our lives. She translated the book into Italian, and we will be in conversation at the bookstore there, and at another in Catania, a few days later. In another week I will be in Portugal, where my boyfriend will join me, and we will tour the country together in a car. For today, it is me and Viola in a bus across

Sicily. We are tired but very content together. Two friends on a journey. She wears thick cat-eye makeup and has long blond hair and all-black clothing and laughs like a child. She tells me gossip about friends of hers I have never met, and it is so juicy and delicious I could just stay on the bus forever, as long as she kept telling me stories.

In Catania I rent an Airbnb in the city center and it is suspiciously large and gorgeous for the price. I feel like the true owner has been kidnapped and someone is renting the space out to me while they choose what to do with the victim. It is room after room after room, with frescoes painted on the ceilings, and huge windows and three sets of balconies, and faded Turkish rugs and velvet fainting couches, and two immaculate bathrooms off each bedroom, one with an enormous claw-foot tub, and it is seventy dollars for the night, and I worry about the state of Catania.

In the morning, I wander to the Piazza Carlo Alberto outdoor market, about ten blocks away.

I sort of lose my mind for a moment at the gorgeous array. I want everything. Give me everything. I buy grilled red peppers and potatoes and squid, and also the lushest olives, and fresh vegetables, finally, at last, for it had been weeks of pasta and meat. And I stand and drink an espresso for a while and watch the market around me, the displays of food, yes, and the people moving so swiftly, with absolute control of their desires. I study also the objects, the piles of used clothing for sale, ripped jeans and polyester skirts and pleather jackets, children's toys, old, battered books, all of this in the bright sunshine. There are markets like this all around the world. This is where people come to drop off their wares before the end. Where could these objects even go from here?

Fed, refreshed, alive, I am ready for what is coming next. I return to the Airbnb—still shaking my head at the frescoes on the ceilings! The fresh sunlight streaming in through the curtains!—and settle in for the rest of the day, sprawled on a bed, my laptop perched on a chair nearby. I need to watch something online that was happening back in America. Christine Blasey Ford is about to testify in front of Congress about how then Supreme Court nominee Brett Kavanaugh had sexually assaulted her when she was fifteen years old.

By then, I'd been away from home for nearly two weeks. Usually when I travel abroad I forget about America. I had thought I would feel better being away from the stress of the Trump presidency and the state of America, which had felt increasingly volatile and depressing leading up to the Kavanaugh hearings. But it had followed me wherever I went. Most of my public events and press interviews involved at least one question surrounding #metoo, even though my book had been written and first published in the US before #metoo in its current incarnation existed. (Although not very long, of course. And one might say we have always been in a state of #metoo, this just had a different name to it. We have seen these kinds of revolutions before, the waves of feminism rolling out and then crashing on the shore. Inching forward, and then being sucked back to sea.) In America, I was just another feminist, and a white, straight, middle-aged one at that. I did not feel radical in America. I felt basic, and when I say "basic," I mean it in the colloquial sense, as in boring, unoriginal, mainstream. But a thing I have learned, through trial and error, is that my basic feminism can mean different things all over the world. Sometimes it is a helpful conversation to have, and sometimes I'm just being another oppressor,

in a way. But in Italy, at that moment, people seemed interested in my feminism. It was a thing to be discussed.

And I was happy to discuss these things, happy to talk about revolution, even as I knew what was coming with the Supreme Court, even as I was living every day in the America that had that president. Were we a model for anything at that moment as a nation? A thing I wanted to say, but didn't. Instead I felt that it was best just to encourage women to claim their space, to recognize that they deserved to be treated with respect, that they should feel safe in the world. I only had a moment of their time. I would prefer they feel exhilarated when they left an event rather than depressed. I would rather leave a trail of empowering words than ones rich with the existential malaise I felt half the time. Things can't change without at least realizing our desires and needs. We have to articulate them publicly to even begin to claim them.

I clock into the internet in the absurdly large rental. I find a stream. I open a separate window for Twitter, and another for Facebook, and another for the *New York Times* live blog of the hearing. It already felt like work. Watching her speak. Watching everyone else speak. Feeling every feeling. I would have preferred to walk away from it all, but I feel responsible to this woman, to hear her truth. Continuously, through this current #metoo incarnation, I have felt a strong obligation to hear what everyone has to say, as exhausting as it is. I have worked so hard to be strong in my life. Watching the Kavanaugh hearings brought everything back, every confession I have ever read has.

I'm so tired of talking and thinking about the same terrible things that have happened to me over and over again. I can't even keep track of everything that has happened to

me. I would have to account for thirty years of harassment, ever since puberty. Every honk or comment from a stranger as I walk down the street, all the inappropriate stares from peers and strangers, actual physical assault both nonsexual and sexual, not to mention professional condescension and limitations based on my gender. Not to mention, not to mention, not to mention. I am exhausted with still having to have feelings about any of this. I wish I could disappear it all and not have to think about any of it ever again. I will be angry about it forever, but I almost never think about my past. But Christine Blasey Ford speaks and I am forced to consider it. One more time.

When I was seventeen years old and a freshman at a small private prestigious East Coast university, I took a creative writing class in fiction. Fiction 101. I had started out school as a poetry focus but my instructor in this class conveyed to me that I had aptitude in the fiction arena, and also that writing poetry, while not a waste of time, was an even worse way to make a living than writing fiction. To me he seemed incredibly glamorous, with his horn-rimmed glasses and his soft-looking skin and suit coats and his general East Coast, WASPy way of being. I was a small-town, lower-middle-class midwestern Jew. I had grown up around people who dressed comfortably and casually and without a great deal of style. We were a sweatpants community. He was what a writer looked like, in my opinion. I took everything he said as canon immediately. If the semester went well, and if more praise were forthcoming, I would reconsider my focus on fiction.

Perhaps only half the class had any real skill, but one

could take the class whether one wanted to be a writer or not. One other writer stood out from the rest to me, not only because he was talented, but also because everyone agreed he was talented. He was a brash, funny, loud, incorrigible, bold, brawny young man named Brendan. (I've changed his name here.) He was on the rugby team, and he was pledging a fraternity, but he was still a reader and a writer like the rest of us.

In his stories, things happened. His characters were physical and often violent. They engaged in sharp dialogue, and they said things they'd regret. They drank a lot. His stories were different from mine, which were more internal, and felt, and also more contemporary and colloquial. We became instant friends, regarded each other as familiar curiosities. He had gone to a privileged all-boys school, and I had attended a suburban public school. We'd both had access to things, but different kinds of things. We both had read Joyce, for example, only his was James, and mine was Joyce Carol, although I, of course, had read James, too, but he would never have bothered with my Joyce. He had grown up around money; I had grown up around aspiration. Yet we both had arrived at the same place. In the same program, in the same class.

That first month or so of college, we stayed up a few nights talking in the dorms. I didn't have a crush on him, and I didn't think he had one on me. I want to believe we were genuinely connecting as writers do, even nascent writers. Male writers were already like brothers to me, blood, with shared neurosis and eccentricities. I could always see right through them because I am them: an absolute living nightmare in exactly the same way they are, except slightly more tolerable, because I'm a woman.

Also I was sexually inexperienced, a virgin, which I had

told to him in confidence one of those nights. I was waiting to fall in love, I supposed. We argued about it—he felt anyone would do, but he had gone to an all-boys school, where things sounded more desperate. It was what I believed at that time, though, that you were supposed to wait for the one. All my friends in high school had. Just because I hadn't found him yet didn't mean he didn't exist.

It was odd, maybe, not to have any sexual desire for him—we were spending time together, we were young and hormonal—but he wasn't my type at all. He was kind of this slobby, preppy guy. Sweat-stained polo shirts, unwashed camel-colored corduroys. He had a smug mouth, a narrow, pointed nose, squinty eyes. There was a ravenous quality to him in general that I suspect his peers found appealing, and he laughed a lot, wildly, although he was deeply focused about his work. He drank a lot, but who didn't? (And still doesn't?) I appreciated his friendship because I felt understood by him. I had spent so much of my life feeling not understood. Writing was the only place where I felt entirely successful and in control. I knew exactly who I was as long as I was doing that. And now here I was, going to school for writing. I was in a class of people, most of whom wanted to do the same thing I did. And this person, who lots of people thought of as the best writer in the class, wanted to be my friend. Never mind that I thought I was the best writer in the class. (Hadn't I always been? Hadn't I won every award in high school that told me I was?) In my mind, we shared that title. Anyway, we were equals, I knew that. And because of that I trusted him and felt comfortable with him.

During midterms that fall, I went to study at the library. I was wearing a green, black, and blue checked sundress, with

a white T-shirt underneath it and white Converse low-tops. I had a book and a notebook with me. The key to my room was attached to an elastic cord I wore around my wrist. There were no cell phones then, no laptops to carry with you. You could travel quite lightly in that era. You wouldn't need any of those things on a college campus in 1989. You just needed your brain, maybe a word processor or a typewriter or you'd sit in the computer lab if you wanted to work that way, but the back-and-forth between your dorm room and the library on a warm fall night would have been very simple. Depending on what you were studying for. Depending on what you needed to know.

I traveled from the lower quad to the upper quad. Nearby was the dorm of a guy I was seeing. We had nothing in common, but he was really sweet to me and I appreciated his enthusiasm for life in general. I had fooled around with a few people since school had started. Nothing had stuck. No one was looking for anything in particular, it seemed, or at least not with me, still being all the things I was in high school, even if I wanted to pretend things could be different now. One guy I had made out with the first week of school told a bunch of people a lie that we'd had sex and that I had recited Yeats to him in the middle of it. (Years later, he tried to friend me on Myspace.) One night a guy walked me home from a bar—we were both drunk—and we had passed out in the same bed. I woke up to find him masturbating next to me in bed, and I had pushed him to the floor. (Years later, he tried to friend me on Facebook.) All this had already happened to me. I was seventeen years old, soon to be eighteen.

And, on the quad that night, here came Brendan. Swinging his backpack, drunk, vibrating, jostling with imaginary

enemies, laughing before he even got to me. I stopped to speak with him, my friend. He swung his backpack at my head, hard. I was dazed and laughed nervously. I didn't understand what was happening. He wrestled me to the ground easily, then began to drag me around the earth by my hand, like he was a caveman and I was his, all his, until he finally stopped and sat on top of me. He was cackling. A couple passed by and I called out for help, but they kept walking, perhaps confused by what they were seeing, or perhaps they couldn't hear me correctly, my voice was jagged and broken from being dragged. I will never know why they didn't stop. He said, "Looks like no one cares if you lose your virginity." He held my hands down. I screamed at him to get off me. We were near an enormous oak tree that had probably been there for hundreds of years. In the daytime people sat under it and studied while nearby focused young men played Ultimate Frisbee, their hair tied back with bandannas. When I think about that school I always think about that tree.

Writing this now I feel a tightness in my chest, a hot sensation at the center of it. Thirty years past, and that sensation has never cooled. As good as I have become at compartmentalizing my tragedies, traumas, and fears, putting them aside, on ice, that moment remains a burning hot coal inside my chest.

He let me go. My clothes were torn and grass-stained. I had bruises for days. I was crying as I walked. What was that? What had just happened to me? I wasn't raped, but I knew that I had been assaulted. I had been violated. I went back to the dorm and I told my resident assistant about it immediately. Surely, he could see how distressed I was. The torn clothes. He said, "We can report it but . . . are you sure

you want to do this?" I didn't understand what he was saying exactly. I didn't get what college was like. I didn't get what the world was like yet. I only knew if someone did something wrong to you, you were supposed to report it. He knew more than I did, though. He could probably see it playing out ahead of him. Maybe he just thought it would be complicated for him. I'm sure it was. I'm sure this whole thing was terrible for every single person who had to touch it. I'm sure this thing that I can picture in my mind like it was just yesterday, this vision of being held down and told that my control of my body and my sexuality was irrelevant, was a huge pain in the ass for him.

I reported it.

Of course, what followed was much worse than the actual assault. If it was somehow reported to the police, I never knew it. Instead it was dealt with within the university system, and slowly, so there was time for rumors to start, one being that he had raped me and another being that I had claimed he had raped me, but that I was lying about it. He and I were living one dorm building away from each other. We had our writing class together, of course, though I recall he skipped the next one. I was told that his friends—fellow pledges in the same fraternity—had a meeting about the situation in someone's dorm room and one young man said, "Even if he raped her, we should stand by him." His friends would knock on my door late at night and curse and run away. Sides were taken. People whispered about me in the cafeteria. I cried a lot. I felt ruined by the truth. By the time I got to speak with the dean of students I was frazzled and terrified. The dean presented me with two options: I could have Brendan expelled from the university, or he could stay in school and be required to

attend therapy instead. The tone of this discussion as I recall it was that I would be ruining his life if I had him expelled. There was no consideration that if he stayed, it would ruin my life. I had no advocate. I still hadn't turned eighteen years old. I chose to have him stay in school and attend therapy sessions on campus. I imagine those therapy sessions were useless, and probably not even enforced particularly strictly. I say that based on the fact that a year later, I was required to attend therapy sessions available on campus. This was after I attempted suicide. A depression building for a year, and there I was. An early morning hospital visit. I talked my way out of staying overnight. The school sent me to the same place they had sent him. But I found the sessions unhelpful and left after just a handful of visits, with no one bothering to check on me after the fact.

I would graduate $25,000 in debt from this university. I have moved so many times, as far away as I could get from my past, that the alumni fundraisers have lost my phone number. My books have been written about several times in the university magazine, but they have never asked me to return and speak, even though I have published more novels than most of the graduates of that writing program. If they asked me back now, I would read this chapter.

Whatever I thought I was going to be in college, this fresh start I was going to have, with all those other smart people, it was over. Now I was this person that this thing had happened to, and I was going to be there for the next four years. The

word *reputation* rarely works on behalf of women. And the one thing I was best at, my safest space of all, my world of writing, my reason for being, was now forever intertwined with him.

I continued studying in the creative writing program with the person who had assaulted me for the next three years. We spoke only twice in that time. Once, late freshman year, when I saw him drunk at a fraternity party and he cornered me and told me I had ruined his life. "You ruined *my* life," I countered. The second time, at a bar after our final creative writing workshop, where he told me that the worst part about everything that had happened was that I had been one of his closest friends and he hated losing me, and I said that it was the same for me. Because a good friend was hard to find. But he was not my friend.

Throughout college I heard rumors that he was abusing alcohol, that he was prone to violent outbursts, that he was a terrible roommate, that he was slovenly, a genuinely filthy person. Who knows which parts were true? In our writing program he was still considered a star.

Years later he went on to start a literary magazine with our freshman year creative writing professor. The magazine folded after two issues. He also went to a prominent graduate writing program but dropped out. He published one book, which came and went. You can still order it online. I have never read it. It got a nice review in the *Washington Post* by a famous novelist. He got married, he had a career, children. He moved a few times. All these things I heard first from the grapevine and then via the internet when I occasionally googled him. Sometimes he taught writing. Without knowing anything about his current truth or life, I just always knew he was still drinking,

that he was a raging alcoholic, and had he been forced to contend with it his freshman year of college perhaps his life would have been different. I could feel it in my bones.

One day I woke up and I saw the news online: he had killed himself. He was forty-one years old. I didn't know how to feel. For the moment, I settled on sad. A bunch of his friends wrote about him on the internet. It sounded to me like he was still steeped in his own masculinity, a full pot of man tea. I read a blog post about how he turned over a table once in a bar, another about how he was a brilliant writer. I read a blog post about how he was a great teacher, another by a young woman who said that once she had had lunch with him seeking writing advice and he had yelled at her loudly, bullied her a bit, but it was OK, he was just passionate about writing. I read blog posts where male friends of his called him "brother." I read about his wife a little bit, and I prayed for her. I read about how he used to sleep in his car rather than drive home at night drunk. I pictured the car, the contents of it, a notebook, cigarettes, a change of clothes, books, maybe the same books he'd been reading for years. Dad's car. Then I read a status update on Facebook by someone who had been in our writing program, and he mourned him and said, "He was the best writer in our class," and I wanted to fucking scream, because I was the best writer in our class. I was the one who worked my ass off and consistently showed up and committed to my writing and had talent to spare and had proven it time and again. Why did anyone think he was the best writer in our class anymore? Why do we believe these men are the best when they are the worst? Why do we hold on to them?

* * *

Time passed for me, too. I graduated from college. I waited tables up and down the Eastern Seaboard. I did not know how to become a writer—I could not give myself permission to pursue it, I think now, because I was so traumatized by everything that was wrapped up in the writing program—but I didn't know what else I was supposed to do with my life. I lived in Seattle for a while. I finally moved to New York. More terrible things happened to me, but wonderful things happened, too. I made zines. I started a blog. I published essays. I fell in love twice. I had a drug problem. I moved to Brooklyn. I wrote a chapbook. I wrote a short story collection. I sold it. I wrote five more books. I sold them, too. Somewhere in there I turn forty, and then forty-five. I move to New Orleans. I meet a man there. I go on another book tour, to Italy. I sit in an oversize Airbnb in Sicily and watch the Kavanaugh hearings. I think about the terrible things men have done to me, which does not erase all the success I have achieved in my life or the happiness I sustain on a daily basis, but it blossoms in that moment, like a dried-out sponge sucking up water and expanding within me. I sit with it. It sits with me. I leave Italy and go to Portugal. The man from New Orleans joins me. This man of mine.

We decide to drive all over the country, a foolish mistake. We fight for so much of the trip, but still, remarkably, we hit all our travel goals. One of which is to drive to The End of the World, in Sagres, the southernmost part of Portugal. I don't want to admit to myself I am having a bad time. I want to have a good time. I do. But I can't, and I don't know why. When we have nearly arrived to The End of the World, we talk about the Kavanaugh hearings. I tell him the story from

my past. About what happened under that tree. When I hear my voice, I think I sound not sad but annoyed. Annoyed that this happened and I still have to think about it, talk about it. That I am forced to reprocess it. I don't even want his sympathy or understanding, but I know I have to tell him these things about me if he is going to know me, if we are going to know each other. I do not care about this part of my past, is what I want to say, but that's not quite right. It shaped me in so many ways. Who knows who I would have become otherwise. I would have been a writer regardless, but I can't help but feel that part of my drive comes from anger. I don't have a problem with that, though. I am fine with being angry as my origin story. And if Brendan hadn't done it, it would have been someone else, and in fact there were others, in other ways, some of them worse. But he was my friend. That's what it was, that's why it was hard. He was my friend and he betrayed me by being just another man.

I can't say any of this to this man in my life though, because I'm just getting over the hurdle of even telling him that this incident happened at all, that so many things have occurred in my life, and I'm tired of it, tired of having to tell it as part of the story of my life when there are so many other things I would prefer to think about, and this kind man does the only thing he knows how to do, which is to reach out to me and tell me he's sorry that happened and put his hand on my knee for comfort. I slap it away immediately, on instinct, without thinking; I do not want to be touched. I do not want his comfort. There is no comfort for this story. "No," I say, and I shake my head.

I'm shocked by my actions and so is he, but we don't talk

about it. My act of violence in response to his act of comfort. There's nothing he can give me that would heal me. That time has passed, if it even ever existed. This is just who I am now.

We arrived at The End of the World. It is as romantic and vast as I wanted, blue skies, the hint of crisp air to come in late September. The water thrashes below us, a tumultuous blue-green. Ragged cliffs, nearly 250 feet high. Cliffs you could jump off and plummet to your death but surely no one would blame you for the inspiration.

What I love right then more than anything is to stare off into the blue horizon. What I seek is to see nothing, to feel nothing. To be zeroed out. Still, I would not give up all the knowledge I have acquired along the way. Life is unfair, but look at these cliffs, this water, this sun, this earth, still existing. The Romans called this place Promontorium Sacrum—the Holy Promontory. They believed the sun sank here, extinguished by the water. It was a magical place, they thought. But also they believed that there was nothing good beyond it.

On the internet I post a picture of the view, just so everyone knows I'm having a good time.

15

Hong Kong

It was early spring 2019. Carnival season was over, and life felt a little dull in New Orleans. All I'd done for weeks was plan my costume, and now it was stored away in the attic, with other past Mardi Gras attire and an assortment of old notebooks from a time when I had much better handwriting. Goodbye, fun. I had started meeting with a new therapist, a young woman—my first in probably six years—but felt lackluster about the experience, as I usually did when I tried that sort of thing, only ever lasting a few months with each one. (I always felt like I was trying to entertain them—this was my fault, not theirs, of course—but surely the right therapist might call me on it eventually?) Why couldn't I just sit still and be? I don't know. One night, I added up all my frequent-flier miles and impulsively bought a plane ticket to Hong Kong, to be followed by a visit to Thailand.

I hadn't thought much about visiting the city before,

although I had talked about it in the past with my friend Sunil, who by then had lived there for nearly a decade. But I had that pile of miles I was itching to use, acquired from book tour after book tour. And I thought I should go somewhere new, somewhere that would challenge me. Also, I missed Sunil, who was one of my oldest friends. I missed his face, which was quite handsome, smooth, and youthful even in our mid-forties, and his bright, surprising laugh, and how smart he was, the way he considered words and ideas carefully, not just his, but the way he listened to other people, processing before he spoke; he always held my attention while I waited for him to reply. Within an hour I had secured a plane ticket and made a plan to visit a foreign country for an entire month, discussing it only with Sunil. I didn't even mention it to the man in my life right away. I would be gone and there would be nothing he could do about it. Did I need permission to use these frequent-flier miles? Did I have to tell anyone besides Sunil that I was going to Hong Kong? Was I trying to show that other man I didn't care what he thought? Who knows if he even cared anyway? That's where we were at, right then. Buying plane tickets and planning trips to leave the country without mentioning it to the person you spoke to every day. I kept it quiet for a few days. I needed a secret for some reason.

Sunil seemed happy I was at last coming. He had been asking me to come visit for years. I hadn't had the money, though, and even though he had offered to buy me a ticket, it was hard to imagine showing up broke in an expensive foreign city, not at this age, not anymore. I swore I wouldn't go see him until I could afford it.

And I hadn't had enough curiosity about traveling to Asia. Those long, long flights; that's all I saw. But I had arrived at a

moment in my life where I recognized I should have curiosity about everything. I wanted a perspective shift. I wanted to be somewhere unfamiliar. I wanted that feeling that comes with a lack of fluency in a language, where you are forced to converse with yourself, befriend yourself, know yourself. Also, it felt like Sunil deserved my respect and attention. I hadn't seen him in two years, and he was always making the trek to where I was, first when I still lived in New York, and even once to New Orleans. He had made the effort, and I hadn't.

He wasn't moving back to America anytime soon, a wish I had held on to, although I respected his desire to stay there. Whenever I spoke to him, he told me he loved Hong Kong; he admired its efficiency, its logic, its modernity, the food, the curious amalgamation of cultures, and also the way he could get to other cities so easily from there. He would do anything to stay there. He loved a place; I understood that feeling. If I wanted to see him, I needed to go visit him. Sometimes friendships demand you make the time for them. So, I sucked up my dread of a long flight, then added up all my miles and put them together in one big airline pot, and I clicked away. I would be leaving in seven weeks.

Five weeks later, the man in my life and I parted ways. Neither of us was willing to exert the effort necessary to fix our relationship. There was another part to it: I had finished my seventh book, and when I gave it to him, he wouldn't read it. All the trips we had taken, to the pecan farm, to the botanic gardens, a lazy walk through the French Quarter to the river, all the research I had done so I could detail those locations, I had done it with him. It was so rare for me to share that kind of creative space with someone. And now I offered to him the results of those moments and my labor, and he sat

on the book for a month. He offered no reason as to why. Whether or not he would read it eventually (he did, much later), it didn't matter in that moment. I felt entirely rejected.

Later I talked about it with Lauren, she of the stable, secure husband, family, life. "Books are your love language," she said. What if he didn't speak it?

I operate in a tunnel when I'm working. I had, for years, been accustomed to life there: the pleasantly dim environment save for a lamp tilted in my direction, lighting the page perfectly; the temperate air in the tunnel, a mild, cooling breeze; light behind me, light in front of me, so I know can get out if I need to escape. But also there are walls around me, they keep me steady, they keep me in line, while I focus on my work.

I'll just return to that tunnel, I thought. It's safe there.

When I was twelve years old, I went to a bad wedding. My older cousin Betsy was getting married, and people were happy about it, but it was to a divorced man, who already had a child. No one knew him well. The wedding was happening quickly. The night before the wedding he yelled at his child in the parking lot after the prenuptial dinner and we all stood there and watched. I thought: Is it too late to stop this? I looked at the adults. No one said a word.

Still, the union was believed to be a good thing by the older relatives. Betsy was someone who had never quite found her way, had struggled in school, and in relationships, and after college had difficulty finding work. She had always been emotional, openly, extremely emotional. I remember thinking about her that she felt things deeply. Her weight went up and down in an excessive range. I look like her a bit, when I

put on weight, in my cheeks. But I knew I was not like her, or I shouldn't want to be like her, anyway.

At the wedding, everyone was just relieved Betsy had found someone. *Finally* was the tone of that wedding: I half expected the table centerpieces to spell out the word in rose petals. She had lost all that weight and it had worked! She had met a man. And what could be worse than remaining unmarried? There would be no finally for me, I thought. Kill me before I ever settle for that kind of man.

My finally would be for something I made, not for someone I married.

Betsy stayed with that man for decades. It was not a good marriage, but it was a long one.

Ten days after the breakup, I got on the plane. Even if you scrupulously architect every last detail, you don't get to choose what kind of vacation you take. I had certainly not planned on it being a breakup vacation. I hadn't imagined it would take on the tenor it had, to be full of complicated feelings. Whenever my life turns into any kind of cliché, I am furious. Not me, I want to scream. Not me, I am special and unusual. But none of us are special and unusual. Our stories are all the same. It is just how you tell them that makes them worth hearing again.

I arrived, bleary-eyed, nearly soggy with exhaustion, to find Sunil waiting for me at the airport. This is friendship to me: being picked up at the airport in a foreign country. Boyfriends have to pick you up at the airport. Friends want to pick you up at the airport. I was grateful to see him, my dark-eyed friend. Lean-bodied but muscular in his well-tailored

clothes. With that easy laugh, that sly smile. Always where he should be.

Sunil is one of the smartest people I know. He started at our university when he was sixteen and I was seventeen and we bonded over our youth, and he couldn't have been any friendlier, perhaps the overcompensation of a child genius, but also, he is an extremely generous person. Maybe it was because of how he was raised, or perhaps he just has an inherent giving spirit. But I know that I will never be alone or truly suffering as long as I have him in my life. I would never forget how he had loaned me money when I was forty and broke, bouncing from café to café. I have offered to pay him back, but he just laughs at me. I will figure out a way to thank him sometime when he least expects it. Perhaps with an internal organ, which I would gladly give him—as I think many other people would, he is that beloved. Not that I wish organ failure on my friend.

But after that first night in Hong Kong, Sunil went missing for a few days; he had been called away at the last minute on a work trip to China. Before he left, he handed me a Ziploc bag full of Hong Kong currency, a transit card, house keys, and a piece of paper with pertinent details, addresses, phone numbers, security codes. I had all the information and supplies I needed to survive in Hong Kong, at least for a while. But I was jet-lagged and also miserable about the breakup, though refusing to admit it. I was in the "It's for the best" phase and also "I embrace the future" phase, which was also accompanied by "I will drink to celebrate (but secretly to forget)" phase. This meant my trip to Hong Kong had this sudden urgency and potency to it; instead of it being just a visit to a friend, it was me in my new life, on my own, with-

out my ex. So, I would be having the time of my life on this trip, no matter what, because I refused to fail at it.

However, I was almost instantly overwhelmed by the density of Hong Kong. It was a real city, with packed sidewalks, people moving swiftly to their destinations, with buildings so tall the sky was nearly invisible in some parts. I could not see the city for what it was, only for its lack of space. I felt claustrophobic, even outside. Not to mention I had never been struck by jet lag quite so acutely before. And I found myself living off my Google Maps to get around constantly, which made life somehow less, rather than more, efficient. I found myself stepping aside out of the busy path of the citizens of Hong Kong. I hated looking down instead of up. It felt like I was on vacation with my phone.

One of the locations that kept popping up on my Google Maps was labeled Facade of the Old Mental Hospital. (When you look at the map in the US, it also calls it Old Lunatic Asylum.) While I had by now realized I had an attraction to haunted, otherworldly destinations, I found unappealing the idea of deliberately seeking out a place that had housed the living sick. It seemed like a place that could be haunted—a state I was always interested in—but the specifics of it saddened me. It was not very far from my friend's home—maybe a fifteen-minute walk. Still, I wanted to avoid it entirely; yet it surfaced each time I opened the map on my phone as I walked out the front door. I hated that there was an algorithm somewhere that forced me to consider this place whenever I wanted to go anywhere, but there it was, every time. Facade of the Old Mental Hospital.

* * *

Once I had visited a mental institution. As a child. My cousin Betsy had been sent to one, nearly a decade before her wedding.

She'd had a meltdown at a family gathering, at a Sunday dinner, at a great-aunt and great-uncle's house. I was maybe five years old, if that; young enough to just get dragged around everywhere without knowing where I was or why. In my memory, she became angry at dinner, something to do with her parents, and it continued on through dessert. I was sent upstairs, to sleep in a guest bedroom, but I could hear her through the floor, crying and screaming. She couldn't calm down. I know this feeling, of not being able to calm down. What's wrong with me? I think, when it happens. Why am I being eaten up like this?

A few weeks after Betsy's breakdown, my parents took me to the hospital where she was staying. She had asked for me. I was her favorite, perhaps. My parents thought it would help with her recovery. When I asked my mother about this as an adult, she replied, "We were so young. We didn't know any better." She was family, and they were worried about her. Perhaps they didn't know what they would find there. Maybe they just thought it was a hospital like anywhere else. They both had an unwavering loyalty to the notion of family. This is part of growing up as a Jew in a directly post-Holocaust world. Your family could be taken away from you at a moment's notice. Have you seen *Schindler's List*? Are you aware of what they did to eight million Jews? A language of cultural shortcuts that linked us by fear. A woman sits in a mental ward, longing for connection to the outside world. A Jew, family. Who are we to deny her that connection?

Betsy apologized that day. I recall her giving me a smile

that was vague, lips barely upturned, and then crumbling, like the rubble of some torn-down old building. She was clearly drugged. I don't remember much else. Except that there were people shuffling around and perhaps someone crying in a corner, and the lighting felt dim to me, but perhaps that's just how memory works, and maybe someday it will be entirely dimmed forever, just a whisper, or a wail, in the faint recesses of my mind. But there was a lesson I gleaned from all this as a child: it was both OK and not OK to cause a scene. You would get attention, but you could get sent away, too.

I could not block the Facade of the Old Mental Hospital from my Google Maps. Why don't we have that option? To block what we choose not to see.

After a day in Hong Kong, I already wanted to escape the crowds. Sitting inside my friend's house was a terrible idea, I knew that. I'd never get over my jet lag that way. But the thought of going to the big tourist hits—The Peak, The Buddha, the night markets, the Star Ferry—just meant more people. I stared at my laptop, then typed "haunted Hong Kong." I would find a different haunted place to explore, an alternative to the Facade of the Old Mental Hospital. I found something in particular that intrigued me, about an hour south of where I sat in the Sheung Wan neighborhood. I would have to take a bus to get there. A place called Waterfall Park.

The next day I got on a bus, more of a van, that seated only sixteen people. I sat mutely in the rear, among Hong

Kong residents carrying shopping bags. I was on a goddamn adventure. This is a strange thing I am doing, I thought. I have already gone so far away from home. And now, for some reason, I needed to go even farther.

An hour later, I arrived in the town of Wah Fu, which contained fading housing projects first built in the late 1960s, a school where children chirped outside, and a small complex of restaurants. I followed the map down to the water. Light rain began and stopped and resumed again and the skies were a dismal gray until I made it to the park itself, and the gray revealed itself to be a dramatic backdrop against the sea and nearby Lamma Island. The air was clear, and I could see out ahead, a much different sensation than Hong Kong with its clogged skyline, where one feels like the entire city is a tunnel at times. Fresh sea air attacked my jet lag as I meandered down the path to my destination at the far end of the park.

Beneath a shroud of trees, arrayed on short, jagged limestone cliffs were thousands of religious statues stacked in haphazard rows. Small concrete walkways, and the occasional path of meandering stairs snaked through the rows. There were multiple religions represented: Chinese gods and Buddhas and even the occasional Virgin Mary. Dozens of versions of Kwun Yum—a goddess of mercy and compassion, dressed in white robes, who some believe has the power to relieve the pain of suffering souls. Fat red-faced Kwan Tai statues in glinting gold paint—the redness of their skin signifying masculine energy. Peaceful multiarmed bodhisattva, hands held in mudras, or clutching objects, jewels, beads, flowers, and the like. Three identical women in red robes with blue

caps in a row, with white bodies and a pink base. A cheerful husband-and-wife combo, taller than the rest, with tall
gold bands encircling their heads. Red spider hibiscus grew
nearby, red paper lanterns hung from the trees. Embedded in
one of the stones lining the pathway was a clay pink winged
pig. There was a casual brown honey-colored monkey statue,
with legs crossed, other monkey statues leaning at its feet.
Gatherings of bamboo. A Hindu shrine. Lucky cats. A white-
bearded, bald Buddha with his hands outstretched toward
the heavens, his face in a joyous rapturous praise. Hallelujah,
I thought.

On the waterfront, a battered Chinese flag, its edges shredded like paper, flapped in the wind while nearby a man fished.
Four shipping boats chugged slowly in the foreground of
smaller islands I could not identify on the map. When I look
back at the pictures I took of the religious figurines it's as if
I'm looking up a concert crowd. As if they are the audience
for those boats, and those islands, and that man, who I imagined was trying to catch his dinner.

Reportedly, the park had been in that state starting in
the late 1990s, and the original statues had perhaps been
placed there by families that had left the community, or by
people emptying out the homes of deceased relatives. Slowly,
the park grew. Who can ever pinpoint one reason why these
spontaneous altars are created? Because people need a place
to put their emotions. Or they need to create something to
guide them. Because so many of us need something to believe
in—because the other option is nothingness.

The thing was, taken individually, each statue was merely
mediocre, old, battered, nicked and chipped by the coastal

climate in one way or another. These were the rejections, saved from the trash by a belief system centuries old. On their own, you wouldn't give them second glance. Taken together, they felt like a revolution.

A man walked by and gave a small bow to the figurines, his hands in prayer. I could feel the ghosts of thousands of prayers all around me. Each of these objects had been wished upon, daily, nightly, special occasions, medical emergencies, financial crises, inclement weather, births, deaths, weddings, hopes, dreams, failures, business transactions, please let this be over soon, please let this last forever, please give us all strength to be the best we can be and survive this life with grace.

Before I left, I bowed to the figurines, too. What did I pray for? To be better.

There I was, by a body of water, in a haunted place, and I honored it, I respected it, but I also tried to take from it what I could.

On the path back toward the bus, I saw an older woman standing in the mist, massaging her cheeks, her neck, her forehead. Her skin was taut, although there were thick lines around her mouth. Another prayer. I felt my neck, which recently had begun to sag ever so slightly. I would not die soon. But eventually.

Where were you when you first realized that someday you would die? It comes in waves, the realization. I keep rere-membering it. It scares me less, each time.

* * *

Back in the city, Sunil texted me he would be back the following evening. It's fine, I thought. I could make it on my own. I could explore this whole vast city by myself. I was ready. I had a map, I had information, I had cleared my head with the sea air. But in the early evening, I fell asleep. I missed another meal. I couldn't seem to rouse myself from the bed. In the darkened apartment.

We lived together several times in our lives, Sunil and I. Once as roommates in college—he rented a small back bedroom of the apartment I shared with our friend Mara our senior year. He took a year off after his early graduation, turning down acceptance in a PhD program to wait tables instead, a completely unexpected turn for those of us who had known how studious and focused he was. And we lived together again, in Tampa, Florida, briefly in the early 1990s, when he had some sort of tech job, and I, lost after graduation, followed him there for a while, working at a lesbian bar on Pass-A-Grille Beach and volunteering for a civil rights march sponsored by the National Organization for Women. One night, after a bad drug trip involving too many hash brownies at a party (they were bite-size and delicious, how was I to know?), my deceased stepgrandmother visited me in a dream and told me I needed to leave Tampa immediately, if you can believe it (no one ever does), and within days I was gone, headed back north. I had left a message with Sunil's receptionist that I was moving. I think I left a mattress behind.

Somehow he forgave me and let me live with him again, this time in the East Village in New York City, from 1998 until almost immediately following September 11, 2001. After the buildings fell, I moved out impulsively, temporarily to Hell's Kitchen for a few months, in a sublet, until I

found another apartment back downtown. That was what so many did after the attacks, moved, radically changed locations, those of us who could afford to, and even some of us who couldn't. People are doing this now, in 2020, I hear, too. Leaving the city and never coming back.

A few months later, I returned to the apartment I had shared with him in the East Village to pick up a few objects I had left behind in the rush. He wasn't there. Things were a little cold and weird between us, but just for a short time. I had left abruptly again. A thing I did. A thing I still do sometimes, though less now. I always feel like I must leave and then I just do. I linger only with my words. That day I sat in my old living room and felt extraordinarily depressed. Not gloomy, but deeply locked into sadness. Why? It wasn't just the room. It was the walls. I had never realized it before that moment: it was the lack of light. It was an apartment with no light. A one bedroom converted to two, each with only one window facing a back alley. This happened all the time in New York. People crammed together. The living room was just a box, with walls painted red, and a paper sculpture lamp that reached to the ceiling. Minimalist and chic with no light. He was someone who was always busy—and he had picked the apartment of a busy person. He was always on another time zone it seemed, even when he was in New York. He had gigs in other countries, doing work I never understood, even though I asked him to explain it to me a hundred times. (Consultancy, the great modern mystery profession.) His apartment was for sleep and late-night activities and passing through town on the way to somewhere else. Who needed sunlight?

But when I was at home, in that apartment, I lingered at

my desk. I was still trying to figure out how to be a writer, even though I had a day job. And I didn't know it then, but I needed light, I needed air, in order to make my work.

After I moved out, I swore I would never live in a dark space again, and I never did.

That night in Hong Kong, with Sunil still missing, I woke up at 3:00 A.M., and I found myself sobbing in the quiet building in the top-floor apartment. I got in the shower; I was worried I'd wake his neighbors. I closed the door, I turned on the water, and I sobbed more. Why couldn't I feel better? That's what I was wondering. Why did I feel this bad now? What's wrong with me? Could I ever feel good again? I sobbed and prayed no one heard me. I felt like a wailing ghost, haunting the pipes of the building. I couldn't stop it. I was certain I was going mad.

The madness reminded me of that winter of my sophomore year in college, when I tried to kill myself. It embarrasses me to discuss it now because it feels like such an obvious thing to do, the young, depressed, female writer. That night started with a conversation with a couple of male classmates at a party, a lively discussion about politics that turned heated, and then one of the students telling me I was "the meanest girl he had ever met." I drank too much after that. I argued with a friend. I swallowed some pills. I went to the hospital and a doctor fed me charcoal until I vomited. Somehow, I sweet-talked him into letting me go home. I remember walking through the streets of Baltimore early in the morning by myself, the cold, blue sky, the twenty-four-hour Wawa deli on St. Paul Street beneath the fraternity house where all the

lacrosse players lived. How worried my roommates were. How foolish I felt. I slept all day. I did not know yet how books would save me over and over again. I did not know that a book was a reason to live. I did not know that being alive was a reason to live.

I would never be in that place again, though. Because a month later I spoke to my brother. We were at a family function somewhere in the Midwest. A bat mitzvah, perhaps, in St. Louis. We got drunk and stayed up talking and he brought it all up and he said to me that he had been surprised to hear it because he thought I was a survivor, that I had more fight in me. That was what he saw in me. Not a person who gave up. He wasn't disappointed in me, he was just surprised. And in my weakest moments, I still think about what my big brother saw in me. And if he saw it, it must be true. I must have just made a mistake for a moment, one night in Baltimore.

In the shower in Hong Kong I thought: I have more fight than this in me.

I rose the next day; a miracle, I felt at the time. It was monsoon season, but I got lucky, no rain. I visited the vibrant Taoist Pak Tai Temple. I shopped at PMQ, a former housing complex for police officers turned into a mall of stylish boutiques and galleries, where there was a giant KAWS installation. I ate a noodle soup outside in a small alley of restaurants. I ill-advisedly texted with my ex. I wrote in my notebook. I read Roberto Bolaño's feverish and hypnotic first English translation, *By Night in Chile*. I read *Heads of the Colored People*, the first collection of stories by Nafissa Thompson-Spires, so funny and empathetic and provocative. I have always found refuge in debuts. People just starting out in their lives, believing writing a worthy venture, generating

fresh ideas, pouring their youthful enthusiasm into it. The sincere articulation of a nascent belief system always gives me hope for the future. After, I dulled my mind with a guidebook Sunil had bought me. I went to sleep too early again. But I did not sob in the shower.

That day I also had ended up at an exhibition of Louise Bourgeois's work at the Hauser & Wirth gallery. While Bourgeois is best known for her sculptures and installations, those iconic spiders of hers, this show represented works on paper and holograms as well. The holograms in particular stunned me: images of petite chairs swathed in bloodred light, floating in an otherwise pitch-black space. Fantastic, dreamlike, but also shocking. She made these holograms in her eighties. I thought: Well, now I know her a little bit better. Now I know a little bit more of her truth. A corner into her mind, hovering in a darkened room.

The gallery was distributing a brief but beautiful booklet that contained an interview with Bourgeois conducted by Christiane Meyer-Thoss over a period of time in the late 1980s. I was struck by some excerpts:

To make art is to wake up in a state of craving, a craving to discharge resentment, rage. It's not a linear progression; it goes like a clock; every day, when you reach a certain spot on the clock, it recurs. It's a certain rhythm occurring every day. And the making of art has a curative effect. A tension you are under disappears, dramatically.

The artist has been given a gift. This word comes back all the time. It is the gift of being at ease with

your unconscious and trusting it. It is the ability im-
mediately to short-circuit the conscious and to have
direct access to the deeper perceptions of the uncon-
scious. This is a gift because such awareness is useful,
allowing you to know yourself, especially your limita-
tions.

I love sculpture eternally, because sculpture is the
only thing that challenges me. But it is also not enough.
If I have expressed today what I wanted to express,
good, it's true for a minute, but then I have to prove
myself again. So, I start a new one.

I read those words and laughed: we're cursed! Bourgeois
is speaking of the compulsiveness of being an artist. We get
up every day and do the work because that is our job but also
because there is an eternal fire flickering inside us, forcing
us to do so. There is no casual dismissal of that tension; in
fact, we *cannot* ignore it. Bourgeois makes the creative pro-
cess sound difficult—and often it is, certainly. We must push
through the difficulties though, for the ease is awaiting us,
and by that, I mean the ease of our hearts, at last, when we
know that we are done with our work.

Finally, Sunil returned from China, and the city began to open
up to me. I admired the way the stone wall trees seem to
grow out of nowhere in Hong Kong, as if the earth was re-
sisting urban progress. We took the bus around the city at
night when the streets were emptier and we could look at the
lit-up skyline. We took the ferry to Kowloon, to visit open-

air markets and eat street food. He touristed me hard. We walked for hours, and I could barely move by the end. Later, he would introduce me to his new girlfriend, a smart, inquisitive, thoughtful woman, younger than us, and her laughter and curiosity made everything lighter. For the first time, I approved of the person in his life. Not that it matters what I think—I'm so far away from them. But I liked liking her. I liked that he was settled down.

On the last evening we would eat Peking duck and scrambled eggs with shrimp and scallops with black beans on them and it would be my favorite meal of the trip. I was so grateful for that food. This was all I wanted, more than anything else, I realized. To dine with my old friend Sunil. To have him over-order for the table, not to be gluttonous, but simply to try different things. And then for us to consider the food before us quite seriously and joyfully, for him to notice when my face lights up when I taste a specific dish, and for him to take pleasure in that, that he has given me that thing, that face, that expression. To experience joy through the joy of others. He sees that as a gift for him. My sweet friend.

But before I met him and his girlfriend for dinner, I had one last stop: to find my way to that ever-present map suggestion, the old mental hospital, and its facade. Even if I didn't want to go, who am I to ignore a sign?

Betsy was in another institution recently for a few years. Eventually, after a series of physical and mental crises in her adult life, there was nowhere for her to go but away.

I often wonder if she ever had a chance. Who knew what she had really been through? In her youth, in her adulthood.

Anyone who knew the real truth about her life might be gone by now. I asked my mother about her a few months after my trip to Hong Kong, how she was doing. She and my father had gone to visit her a few times. I said, "How was it where she was?" She said, "Well it's not the kind of place you'd want a family member to be."

When COVID hit, it struck her, too, and others at her institution. She died, alone, in an intensive care unit, no husband by her side, though they were still married. I spoke to my father on the phone about it. He said she'd had a hard life, but she wasn't a bad person. He'd tried to help her when he could. He hoped she was in a better place now. My mother said later, "That was no kind of life to be living."

The Facade of the Old Mental Hospital feels different from much of the architecture in Hong Kong. Completed in the late 1800s, the design appears to be Italian influenced, like a building from the Renaissance, two stories high with cornices and parapets and ornamental ironwork and Roman gables. There is marble flooring and dramatic verandas. I learned that for forty-odd years it was used as a hospital, but in 1939, the building was converted into wards specifically for female patients from a nearby mental institution. According to the internet, it is known to be haunted.

After I walked the paces around the Facade of the Old Mental Hospital, I sat in a nearby park. I was silent and still. I thought about the way women are told we're crazy when we are just trying to claim our space in the world. The way we're treated, have been treated, for eternity; how when a woman cries foul men invent ways to shut her up immedi-

ately. I thought about women who were burned at the stake, and what it means to be believed, and what it means to speak calmly and with truth, and what it means to howl in pain.

I lit a thousand prayer candles in my mind for these women. I hoped they made their way to the sea, to that park. To a place where all the gods of mercy could look down upon them and release them.

16

Visitors

Kristen comes to town to visit.

We had met first online, on Twitter. She was funny, every-
one kept talking about how funny she was, that's why I paid
attention. She wrote short stories, was working on a novel,
too. She liked puns. She posted a picture of her dog in a rain-
coat while waiting for Hurricane Irma. Younger than me, a
Floridian, a librarian with long brown hair and smart-girl
glasses. She seemed to wear her insides on her outside, just
like me. Months later, we saw each other in Austin, at a party
there, for the festival. Now we knew each other, now we were
becoming friends.

The next summer we picked a place in between our homes
and drove there. Pensacola, where we rented rooms at the ram-
shackle but friendly Paradise Inn. In the mornings we took
our dogs to the beach, and in the afternoons, we wrote in our
damp, dimly lit rooms. I would knock on her door and hand

her pages of a manuscript I was revising, shy to let her read it; it still felt new, even though it was almost done by then. In the evenings we ate boiled shrimp and drank a lot, talked about sex and love and families. When the weekend was over, we were better friends. It was strange to me she hadn't been to New Orleans yet. How can someone who loves to have that much fun never have been there before? I insisted she come and stay in my guest room.

It's spring when she comes, nearing the end of Carnival season, and I take her around town. One night we walk all the way from the Bywater to the Central Business District, to meet Anne and Brad for a drink after they were done with the Mayor's Ball. We stop at a party in the Marigny, where a woman slices delicate pieces of Tennessee country ham for the guests, and onward to Frenchman Street, where everyone is boozy and amped up, then zigzagging through the French Quarter, toward the parades ending on Canal Street, and people are out on the streets, everyone is walking and talking, smoking, pointing, and she laughs so hard at the spectacle, with delight, what's not to laugh about, life is wild. You meet someone on the internet, then in person, then you're seeing them in this city and that one, and now you're standing together on a street corner with a big, dumb drink in your hand waving your hands in the air, trying to catch a stuffed toy thrown by a costumed man on a double-decker parade float. Why wouldn't we be there together? Why wouldn't we be anywhere we wanted?

I was still doing this all the time then. Meeting people briefly, befriending them. But now I have a room to offer them, in-

stead of asking to sleep in theirs. Now they can come show up in my house.

There is always the sense with New Orleans that I am just getting started here. That it will take me forever to understand the layers of it all. But this is the way I feel about my work. And this is the way I feel about my life. The minute I think I know everything is when I'll be dead wrong.

But I have lived in this city long enough to have favorite places. Not just beloved restaurants or bars, although that's perfectly valid in New Orleans; it would be enough, just to treasure the small corner market that serves you the best shrimp po' boy. But now I have favorite walks, street corners, trees in the park, intersections, statues and sculptures, stoplights, street noises, street cats, arrangements of potted plants on someone's doorway. Little gritty bits of the city, and big, broad gestures of land, too—but outside the well-traveled tourist areas. A place someone took me once because they loved it already, or I stumbled on it all on my own. I am spreading out a little bit, making myself comfortable, making myself feel right at home. Becoming less a visitor and more a resident in the city I call home. Learning the landscape.

I take Kristen to see one of these places.

The Lakefront Airport was first built in 1934; it is called as such because it borders Lake Pontchartrain, though at the time of its construction it was named Shushan Airport. It was the first airport in New Orleans, and all airlines flew through there until what is now known as the Louis Armstrong New Orleans International Airport was built in 1946. My neighbor Joan, who is in her eighties, recalls going on a

first date at Lakefront as a young woman and taking a flight to Baton Rouge and back.

Funded by the WPA, the airport's design was an immaculate Art Deco masterpiece, centered around an airy, welcoming atrium and decorated in Spanish marble, colorful terrazzo, walnut paneling, coffered ceilings, skyscraper chandeliers. The atrium opened up to a second floor, which displayed a series of custom murals, ten feet wide by ten feet high. Look down from the second floor and there's a brass compass built into the terrazzo floor, and each mural corresponds to a true direction. Everything is in conversation: precise, elegant, and pleasing.

The murals were painted by Xavier Gonzalez, a Spaniard who had immigrated to the United States in his twenties to study art, and who worked in Louisiana for a period of time, eventually achieving international fame after moving to New York City. The paintings, which depict sky scenes against the backdrop of far-flung locales, feel universal and worldly, while still rough and humble, perhaps something to do with the muted palette, the mix of the representational art with the occasional cubist influence. In all of them, biplanes hover over famous, historic destinations. They bear titles like *Paris and the Lindbergh Landing*; *New York Metropolis*; *Admiral Richard Byrd's Flight over the South Pole*; and, simply, *Mount Everest*. One of the murals has gone missing—it's a grand mystery, what happened to this stolen mural—but a reproduction was made and hangs now on the wall. It's the one set in Bali, which features topless women bathing.

In 1964, in the midst of the Cuban Missile Crisis, the airport terminal was converted into a nuclear fallout shelter. Covered with two feet of concrete and bricked-over windows,

disappearing all of the artistry beneath it. The one saving grace: the architects tasked with covering the building used preservation techniques to protect its design and contents. They draped rice paper over the murals and installed metal studs and stucco panels throughout the building. An airport sealed in stone, preserved. A hope for the future, when the building might be returned to its true beauty.

It sat, covered, for forty years. In 2005, the airport was damaged by Hurricane Katrina, by the winds and the water. There was talk of tearing it down entirely, but a pitch was made by preservationists to save the building. The restoration is now nearly complete.

My guest room doubles as my office, but there's more than enough room in there for a friend to sleep comfortably, to feel at home. And there's a door to close, windows, light from outside, a view of the backyard, and the trees of the neighborhood: papaya, loquat, lemon, lime, kumquat, pink crepe myrtles, ginger. Rooftops, telephone poles, blue skies. Hummingbirds in the summer. Another bed above ground. A house I no longer have to rent out to survive. I just live somewhere now. I don't have to be anywhere but here forever.

The ultimate privilege, for me. A house I have for myself and can open up for others. A room for them to stay in. The fight was never for a room of my own. I always had that in my head, no matter what. I was always going to write. It was the fight for a room for someone else. To open up my home— and myself—to others.

* * *

When we went to the airport I thought: Here is something special and unusual I can show my friend. The airport, the murals, this specific sense of history, the way it looks different from so much of the city. A story had begun to form in my head from the first moment I saw the airport and the paintings, even if I hadn't written it yet.

It's not just the mystery I like, though. These murals, they take you all over the world when you're at this tiny airport in Louisiana. The scale seems completely off, and they shine in parts with this unrealistic gold paint, championship gold, bright sun bronze. Someone's fantasy of flight. And why shouldn't it be fantastic? Why can't we dream of all the faraway places? Make them dramatic in our minds. Why should we be limited to our own view of the horizon? The world doesn't end at the sunset.

But what if I told you that even though comfort, ease, and safety were never the point, I appreciate them so goddamn much now that I have them?

Another piece of airport history: it was the second stop on Amelia Earhart's fateful trip around the world. It was supposed to be a secret visit, on May 22, 1937, but her fans found out about it after she radioed in that she would be landing, and she was greeted with a crowd on the tarmac. Earhart and her husband would spend the night in the airport hotel. The next day, she would set off again.

On the day that Kristen and I visit, there's a display dedicated to Earhart on the second floor, in an alcove between

two of the murals, and we stop to examine it. The display includes various news clippings, pictures, and facts about her visit. Amelia in her flight jacket. Amelia smiling. Amelia determined. Amelia making history.

She had made the front page of the *Times-Picayune* the next day for simply landing her plane and saying hello. The story reports how a friend of hers walked across the runway excitedly to meet her. Edna Gardner, one of the few other female pilots during that era, who ran a flight school at the airport. I lingered over it. I pictured one friend striding to see another. A friend she admired. I bet Amelia never pulled rank. I bet they were both ecstatic to see each other. One friend flying from far away. I pointed to the paragraph. "Now that's the story," I said to Kristen. That's what I was looking for. It was the friend who came out to meet her.

Edna had her own story, of course. She wasn't just a friend of Amelia Earhart. She was a navy nurse first, then an aviator, with a sixty-year flying career and her own successful flight school. She trained pilots to fly in World War II; in fact, she trained nearly five thousand pilots in her career. She won close to a hundred aviation awards. And she developed and owned her own airport—when she was in her seventies.

She also gossiped. Edna didn't seem to like Amelia's husband, George Putnam, too much. According to Doris L. Rich's biography *Amelia Earhart*, Gardner described him as "domineering and so pushy." One friend bitching about another friend's husband's treatment of her. Now that's friendship.

Yes, yes, Amelia Earhart was the story. She flew high; she had the drama. But she was enigmatic. She disappeared. And it's the smaller stories that interest me. The people, the

personalities, the flaws. The friendships. These two women who flew. And Edna was the story and also the storyteller. She went on to write a book of her own life. She did plenty all on her own.

On January 2, 2021, I called Kristen to ask her about that day we went to the airport. Four days later there will be an insurrection on Capitol Hill. Five people will die. I can barely put pen to page for a few days. This whole year has been like this. Longer. Forever, for some people.

They would love it if we stopped doing our work and making our art, I write somewhere on social media that day. Do not let them stop you.

But that hasn't happened yet. I'm still in this haze. I'd been having trouble writing about our trip to the airport and I couldn't figure out why and then I realized it was because it was difficult to channel the idea of having a houseguest and wanting to show them around town. It had been too long since my life was like that; I couldn't call up what it was like to be that version of myself. The host.

Kristen remembers everything, though. She recalls the drive up to the airport, how the architecture and the landscape shifted on the drive, the houses became more spaced out, and suburban, the homes more modern. There was a sense we were going somewhere new. "It felt like we were driving to a mystery," she says, and that I told her, "I don't want to tell you too much, so it'll be a surprise." And then as we hit Leon C. Simon Drive, there was the lake soon enough. "Popping up out of nowhere," she said of it. Across the canal, and then we were at the airport, a quiet-looking building from

approach, with just a few cars in the parking lot. But inside, she said, "It was a shocking little jewel." We reminisce about the stillness of the air there, the pristineness of the environment. "A space out of time," she said. She's a seeker, just like me.

I think about her often, Edna Gardner, walking out on the runway. How she might have felt about her more famous friend. If she wished she had flown as far and as high, or if she was glad to have accomplished just what she did. Giving a side eye to that husband. I picture a broad stride, an arm extended, rosy color in her cheeks, excited to see her friend who had come from so far away. Hair short and practical. In dungarees, with her shirtsleeves rolled up. It was the last time she would see her, but she didn't know that. It is just that striking moment of enthusiasm I spin on, that lick of electric pleasure. Here is my friend. Oh, how I missed her. Now we will talk for hours.

17

The Blue Bucket

I took one last trip the summer of 2019. There were cheap direct flights from New Orleans to Frankfurt, on an airline that no longer exists. The only direct way to Europe. That was the best strategy to get from here to there: fly to Germany, and then take a train or a plane wherever you wanted to go. Or rent a car when you get there and just drive. All the borders were open, all the possibilities were available, all Americans were welcome. I clicked; I did not think twice about it. I would go wherever I wanted. And I wanted to go to Italy.

I wanted to go to Italy to see Viola because she was my friend and I missed her. "We'll go swimming," she said. I wanted to go to Italy because I was sad because my heart was broken, and I thought Italy would make me happy again because everything I would eat there would be delicious. And I wanted to go to Italy so I could see Naples, because I had

heard there was a magnificent ossuary there and I wanted to see all the bones.

I don't know why I couldn't get over him. I suppose it was because I kept walking the same streets we had walked together. It wasn't like heartbreak in New York. In New York, things were so dense and crowded and you were always on the run to somewhere different and you could always take an alternate route home. In New Orleans, the streets were empty and I was always already home and there was no hiding from myself there. That was one of the reasons why I had moved there, after all. To be more connected with myself.

It was of great annoyance to me that I hadn't gotten over him yet. I had always gotten over people so quickly. It was something I was proud of, my ability to move on.

I remember watching Cameron Crowe's second film, *Singles,* in 1992, when I was twenty years old, on the quad of my college my senior year, and heavily relating to (and internalizing) the character of Janet, played by Bridget Fonda. She was young and single and worked in a café and wore vintage dresses and black tights and Doc Martens boots and she dated dumb guys in bands who were shitty to her and I was about three years from being her and I didn't quite know that yet. (In fact, in 1995, when I moved to Seattle for no real reason, I ended up living in a tiny studio apartment around the corner from the apartment building whose facade was used in the movie. Every time I walked to the grocery store, I heard the na-na-na of crucial 1980s indie band The Replacements' theme song for the movie, "Dyslexic Heart," written by Paul Westerberg. I could not escape Janet.)

In the romantic comedy, Janet dates her neighbor Cliff, a charismatic but mostly talentless front man of a grunge rock band who is dismissive of her time and her body. He treats her like she's cute, a little girl, and doesn't take her seriously. She contemplates getting breast implant surgery to impress him. Early in the film she tells another character that she's just looking for a man in her life to say "bless you" when she sneezes. When she finally gives Cliff the sneeze test halfway through the film, he fails. Instead, he tells her not to get him sick (he has a show he has to play that weekend) and hands her a box of Kleenex—and a revelation crosses her face. In a voice-over she says: "Wait a minute, what am I doing? I don't have to be here. I can just break up with him." She starts to smile. Through the kitchen window, we see her dancing alone in her robe, content. Another voice-over: "I have always been able to do this. Break up with someone and never look back." Now she's on the roof of her apartment building, with a pile of music magazines, sprawled on a cheap plastic lounger, again with that secret smile on her face. Red paisley vintage dress, black belt, black tights. An empty Tupperware container with a fork in it. "Being alone, there's a certain dignity to it," she says.

Those are the three lines I remember more than anything else from the film. That it's easy to move on, and it's OK to be alone. But now, as a woman in her late forties, I rewatch the film, and what's that? There's a copy of *The Fountainhead* next to her. And what's next to that? Her telephone, the cord stretched impossibly from her apartment across the courtyard all the way to the roof where she sits. Still waiting for someone to call. That part I faintly remembered, a little gag, at the time, a half laugh at the expense of our Janet. The

not-quite-feminist Janet. But as I rewatch the film the camera clearly holds on the phone. Is Janet full of shit?

I was walking around New Orleans listening to sad music and wearing my sunglasses so no one could see I was crying. I felt ridiculous for still caring about this person I could not even talk to on the phone anymore, because we would just end up snapping at each other. I feared running into him—we lived less than a mile down the road from each other—but never did, not even at the grocery store near his house, and how did I never run into him? How?

Did I wear lipstick to the grocery store? Yes! Shut up.

Was I full of shit?

I bought a plane ticket.

In Frankfurt, I spent the night, so I could meet my translator, Barbara. We had been working together since my first publication in Germany, in 2013. Barbara is probably my most scrupulous translator. She once found a historical inaccuracy in my fifth book, *Saint Mazie*, one that sprouted from a combination of sloppiness and poetic license on my part. I suggested it was fine as it was, thematically speaking, and she insisted I fix it, that in Germany this was the kind of thing that could get me a bad review and kill the life of the book. I loved her for it. But I also loved that the book could have different lives in different places, different titles with different meanings, slightly different angles and takes. There's so much I can't control in the foreign editions; it's rare I even discuss my book with the translators at all, and I'll never really know if it's a successful translation or not. And even if it read

exactly as I had meant, I had learned time and again, I could not control the way the reader felt about the book.

But the best translators work with a writer to achieve the writer's original intentions. And Barbara was at the top of her game. It was worth a night's stay in an airport hotel in Frankfurt to have the chance to meet her. She had translated me for six years by then, four books. Barbara was a little older than me, sophisticated, serene. She wore a simple white-collared shirt, silver rings, silver watch, and silver hoop earrings. She wore her gray hair tied back and had elegant dark-rimmed glasses. She spoke with a calm voice. She seemed utterly sane. Do I get to be sane yet? I thought. I was sure I would be by now. Beyond her translation work, she had been employed as a dramaturge, editor, and educator. In speaking with her I thought: All of her work seems to converge beautifully. I was jet-lagged, and she mothered me a little bit. We sat outdoors at the restaurant Goldmund, attached to a renovated library from the 1800s which was now a literary event space called Literaturhaus Frankfurt. We drank prosecco to start the meal and shared a cheese plate for dessert. We took a stroll after dinner. She dropped me off at the train station, safe and sound.

But before dinner, I went to the office of my publisher and met with an editor there. We talked about what I was working on next—this book, perhaps—and she splayed out the books of mine they had published on a table in front of me. I had seen them before, of course, but never side by side like that. The covers of women's faces looking directly at the audience, that which I had longed for so many years before when I could only get covers of women looking away, over

their shoulder, at something far away from the reader. But now, nine years later, I was in Frankfurt, and each of these women was looking directly at me from the covers as if to say: Here I am. Here is a book.

The next morning I flew to Catania, to visit Viola in her new home. She had been wandering for years, living in London and Tokyo, getting her doctorate, writing her novels, working as a translator of English and Japanese writing, visiting various artist residencies all over the world. But she had an apartment now, one that she had inherited from her grandfather, and she had been renovating it, redoing a bathroom, repainting the walls. It was purple and black and white and dramatic. There was a brass lamp shaped like a dragon, its tongue emitting a hiss. In the kitchen, a backsplash made of volcanic rock. Down the hallway, a doll resting on a red suede chair, the doll's head akimbo at the neck, a children's book resting atop the chair: *Bimbo and Topsy*. A stuffed fox with a crow in its mouth. Deceased animals, either taxidermied or their bones displayed, artfully arrayed.

It was goth and stylish. It was not a home that I could pull off: I am too middle-aged, too broad and casual and American. But I loved being there and felt at ease in the story she was telling with her interior decor. The streets below were quiet, and she left the balcony doors open in a few rooms to catch a nice breeze. She made me breakfast, and mothered me a bit, too, just as Barbara had. She had a frail cat that she loved, that occasionally pattered through the room.

We sat and had a coffee and planned the things we wanted to do that trip. A younger version of me would have wanted

to hit every hot spot in Sicily, but Viola didn't drink, and I had nothing left to prove at the age of forty-seven. Mostly, we wanted to walk and swim and eat. We wanted to take some day trips. We both wanted to write. Courtney had sent me a draft of her new novel, *Friends and Strangers*, and I needed to send her notes on it. There was a bookstore that was having an opening: another night out. I planned also to be entirely healed of my heartbreak by the time the trip was over, but I didn't say that part out loud.

We did all that we desired. We walked through the city down to the water and sat on a beach of rocks and dunked ourselves in the cold Ionian Sea. We ate pizza and gelato and arancini. I drank wine. We visited the new bookstore, then called Libreria Prampolini, which had been open since the late 1800s and was being renovated ever so gently to be a modern bookstore. We took a bus to Ortigia and toured some tunnels that ran beneath the city: always Viola and I would be drawn to beneath the surface. We followed a beautiful voice that day, through the tunnels, until we found a woman singing. She was just a student, she told us. The tunnels had incredible acoustics, and so she was attracted to them. She just came there to practice, to hear how her voice sounded. Of course, Viola and I had felt that we were following a ghost. Were we even a little disappointed that it was a living person?

Later we stood at the edge of the Castello Maniace and the Mediterranean crashed on us and we laughed and took pictures of ourselves, Viola dressed in black, her thick eyeliner smudged slightly at the ends, never smiling, even though I knew she was having a good time anyway. This is how she looks in pictures. This is an accurate representation of my friend. Another day she took a picture of me at night, standing

in front of a fountain, and I am wearing black, too, a cropped black top, black linen pants, my hair is long, I am tan from the sun, my skin is smooth and clear. We were walking back from dinner. It also felt like an accurate representation. I realized how calm and happy I look, and what a relief it is to know my face can look that way still. There I was: happy in Italy.

Near the end of my time in Catania we took a walk in the late afternoon downtown, toward the tourist area. Another nice stroll, two friends walking together, looking for the late-day shade. (Viola, who has pale, pale skin was always directing us to walk in the shade, although she calls it "shadow.") The city was empty; we meandered. Eventually we planned to eat dinner. I had an idea for a bar I wanted to visit, for an Aperol Spritz, which I had been drinking daily since my arrival. We rounded a corner and there were piles of garbage everywhere, spoiled fruit and vegetables, empty cardboard boxes, wrappers, paper, general rubble. The city was so clean otherwise: I was shocked to see it. Viola told me it was where the city street market is held, only all the vendors had cleared out for the day; that was what was left behind. I flashed back to the year before, to my visit to Catania when I had stayed in its center, in that wild apartment rental with the frescoes, when I had walked through that market during the day, as it teemed with life and food and people and colors and all kinds of noises and scents. The same spot, a different angle. All that remained was garbage stinking from the heat of the day.

I said, "It looks like the end of the world." I told her about a trip I took to The End of the World in Portugal, about driving with my ex-boyfriend to the edge of the country, us fighting in the car, only to arrive at our destination, where

we stopped fighting, exited the car, and walked to the water, where I stood looking out at the blue sky and the crashing ocean and the vast landscape all around me, feeling empty and full at the same time.

Viola shook her head at a memory. She told me about a bus trip she took once in London, with a man in her life, one she no longer knew. The destination of the bus read WORLD'S END. They fought on that bus. They fought the whole way. This had happened years earlier, when she was getting her degree there. It was hard for me to imagine there being that kind of a memory already that old for my much-younger friend. But eventually we all have past lives.

The two of us stood there in the dirty, empty marketplace in Sicily and thought about fighting with old lovers for a second. And then we left that particular location behind and moved on to the next.

The final scene of *Singles* is Janet and Cliff standing in the elevator of her apartment building. She's given him a polite, friendly cold shoulder for months, when he realizes that he should have never let her go. He's tried, unsuccessfully, to woo her back, while Janet has gotten her act together, enrolled in architecture school, moved on without him. We are proud of Janet. Janet will be fine without Cliff, the flower deliveryman whose musical performance is reviewed in the Seattle alt weekly as "More pompous, dick-swinging swill from a man who has haunted the local scene for much too long." Janet, stay the course, I find myself saying now while I watch it. Be single. Or find a nice architect to marry. If you must marry. Janet sneezes in the elevator, and Cliff says, "I

bless you," and she rewards him with her entire mouth, and they start making out, and at the time I am sure I thought it was a worthy love story, but now I find myself mildly furious that the grand prize of this film is making out with someone with an actual soul patch.

Two days later, I fly to Naples. During my travel downtime, in airports, at bus stations, I texted with Alex about a house he might buy, a home for him and Dustin, in Vermont. He tells me how hot it is in New York. I told him I'd be there in a week. One night there would be a dinner with Maris and Josh and Jason and Emily and Isaac and Alice, and on the second night I would go with Marisa to see that one-woman show Jacqueline Novak is doing about blow jobs—a plan to pass through the city on my way home from Italy to New Orleans, to say hello to friends and then to see a woman stand in a darkened theater and talk about giving head. Were we ever so free? How?—

Alex told me to walk down to the bay in Naples, so that first night I did. At sunset, I walked down to the water and I sat at a small table on the edge of the Gulf of Naples, and out in the distance was Mount Vesuvius and I had an Aperol Spritz and my bloodstream was a good 30 percent Aperol Spritz by that point in the trip but I felt like I would somehow be betraying something if I did not have just one more Aperol Spritz. I had some salted nuts, too. It was a weekday, and not too busy, people filtered down to the water at the last second for the sunset. And it was hot, and it was summer, and I was alone, and I was somewhere new, and I felt good.

I have to be arriving by now, I thought. I have to get there.

* * *

I am talking to another new therapist in December 2020. This one is my age, and it feels just right. In person for the first time, the two of us masked. I tell her, "When I think about my insides, I see things are held together by like, a paper clip and a piece of chewing gum and a Band-Aid and a small piece of Scotch tape. And that's life, we are held together like that, adhesives of our own choosing and making. And it's a little sturdier now for me. It's grounded in the earth. And it's functional. But still, it's fragile." Her head is still. I don't know if she's smiling or serious. I really have to switch back to Zoom sessions, I think. "Anyway, I love that about people. I love knowing what holds them together, what it looks like in there. All the flaws. I love that."

The next day I walked down back streets in the Quartieri Spagnoli where the laundry hung in lines across the streets. I talked to no one. I was extremely in my head the whole time. I was exhilarated to be there, but I was in my head. I walked miles and miles, I could not stop moving. I was trying to walk him off, and also walk off the version of myself that couldn't let him go. That kind of me, the one that would be stuck on someone. I wanted the other version of me. The one who was always able to do this. Break up with someone and never look back. If I kept walking long enough I would leave that other person behind. I drank spritzes, I ate nuts, I ate pizza, I ate street food. I wandered down a road full of bookstores, and felt the same comfort I always do when I am surrounded

by books, by people who love books, by people who dare to devote their lives to selling them, promoting them, placing them gently on a shelf so that others may admire them. I thought about Ferrante's books—impossible not to think of her in Naples!—how she had dared to define a city so clearly in her writing. I had moved to a city and was just learning how to talk about it, claim even the smallest sense of owner-ship of New Orleans, even though it had such a rich, deep, complicated history I feared I could not even begin to feel in my bones. I owned land, a house, a narrow backyard. Could I claim I owned that? Ferrante didn't blink. She growled. This city was hers. I felt her books all over me as I walked.

The second-to-last night I was in Naples I meandered through some back streets in search of a restaurant I never found. Instead I stumbled right into a memory of walking through Lisbon with my ex the previous fall. Something about the narrow cobblestone streets and the night air and the buzz of a language I couldn't speak and feeling lost in a foreign place—not in any danger—but lost nonetheless. I couldn't snap out of it. Both moments were existing at the same time. I was both here and there. A linear path is a fantasy. Some-thing that you realize in one moment can sit like a bomb in your heart or your mind for years until it goes off.

I found a bench and I sat down and I wrote him an email. I told him a few things. One of them was an apology for the way I had behaved to him one night in Portugal. I never heard back from him. I hadn't expected I would.

There are times we just send out messages into the world and hope they are received with the intention they were sent, but we can't always count on the attitude or the generosity of the recipient. There is a certain benefit of the doubt we must

give to messages transmitted electronically. We cannot read the sender's expression, we cannot hear their voice. We may not be in the mood to fill in those blanks. We may not have the capacity. And also: we don't always deserve the benefit of the doubt.

I thought I would be happy by now. I am, for periods of time. I don't know why I think I deserve to be happy. I've done so many things wrong in my life. I've lied to protect myself, or for my own benefit. I've been mean, said mean things, hurt people's feelings, and felt justified doing it if I felt they hurt me first. I've been selfish, emotionally, physically. I've taken what I've wanted without asking for it. I've been grabby. I've taken the last bite. I've committed crimes, minor ones, and I suppose it depends on how you feel about the laws of the society anyway, but nonetheless I've done these things, knowingly. Stolen things, broken things, vandalized. Consumed illicit substances on both a regular and irregular basis circa 1990 to 2004, and also sometimes still during Carnival season. I've cried to get out of a situation. I've been grouchy. I've yelled at people, lost my temper. I've been unfair. I've had bad days and taken it out on people, strangers, and loved ones alike. One is no worse than the other. No one deserves anyone else's bad day. I've judged people silently and out loud. I've taken things in bad faith. I've been jealous. I've blamed a lot of it on drugs and alcohol, but that's not an excuse. I have to own up to my faults.

Why do I deserve anything good at all? Is this a question I should even be asking? Why do I deserve happiness? I don't— not more than anyone else, anyway.

But still, I want it.

I'm a better person now. I've grown up, I've wizened, I've matured. It is time for me to behave well. I still have to live with my guilt for the rest of my life, but the rest of my life is a long time, and I can use what's left wisely. It is important to me to be of service to my community as best I can.

This doesn't mean I am perfect now. I will never be perfect. This doesn't mean I won't still get things wrong. I have acquired too many scars to be fully healed. I have broken so many bad habits but not all of them. Even the experience of writing a book is just making one mistake after another until you're not anymore. Every day we sit down to work we swim in a sea of our own fuck-ups. On the shore is one good sentence.

But it does mean I am trying, that I have to try every single day. I am obligated by my beliefs and the lessons I have learned to wake up and consistently try to be a good person. Even if it is not inherent within me, it doesn't matter. I can still try. And there is no guarantee of happiness to come from this. I don't have any control over that. I only have control of what kind of person I can be in this world.

Nine months later, when he and I are speaking again, I bring up the email I sent to him in Naples that night. "You wouldn't have wanted me to reply to that," his voice uncharacteristically dark and aggressive. He was right. You don't apologize for things like that, out of the blue. You don't send an email when you're on vacation and think everything is going to be fine. It doesn't work that way.

We had started speaking again because we had run into

each other after a Carnival parade in late February, early in the evening, on a street corner. Together, we walked away from the crowd. I was wearing a bright red silk jumpsuit and glitter on my face and I had my bicycle, the yellow Schwinn with the basket that I've had for a million years, with me, and as we moved through the streets I kept bumping it awkwardly with my leg, and were it another time in our lives I would have asked him to walk it for me, but I had lost those privileges. We were not friends, but we were not enemies either—or were we? At times, it was hard to tell. We would stop and argue every other corner. I could have just bid him goodbye. I could have just hopped on my bike the minute we started fighting. We could have just stayed mad at each other forever.

There are still moments I want to hop on the bike and ride away. But right now, it feels like I will always ride back to him.

My final day in Naples, I walk to the ossuary, Cimitero delle Fontanelle. Originally a pauper's cemetery dating to the 1600s, the carelessly buried skeletal remains were excavated in 1872 and left on the surface in disarray, in boxes, crypts, and on racks. Almost immediately a cult developed around these remains. Devotees adopted the skulls, tending to them, cleaning them, bringing them gifts, asking them for favors, and even giving them names, which came to the followers in their dreams. Eventually the local church tired of this cult, ordering it closed in 1969, and then reopening it as the historical site that I trekked to that hot summer day.

A long walk along winding streets, up steep hills. I left

early in the morning, seeking cooler temperatures, though it didn't matter: the sun licked me like a cat cleaning its fur, persistent and intense. But it was shady and cool inside the cave of the ossuary, with walls made of *tufo* stone and brick; some carved-out windows offer the main source of light, dim, natural. The rooms are lined with displays of bones and skulls, no recognizable rhythm to it, although it all holds together as a piece. Piles and piles of bones and skulls. Some floor crypts are visible through plexiglass. Bones upon bones. The rooms are tidy, the displays are fenced in, contained, but casual, as if they have somehow sprouted forth from the earth rather than have been arranged. A few full raised concrete beds for what must have once been full skeleton forms, encased in glass. Gifts everywhere, small altars forming out of the collection of feelings. Religious figurines, prayer beads, coins and cash, plastic roses, Catholic prayer cards, shells, candles. In one room, there was a persistent drip from the ceiling landing below in a blue bucket. As I walked through, I thought: I came all this way to meet you. Hello, hello. The ossuary felt earthy, organic, and alive.

And then there was a period of time when the ossuary emptied out of other travelers, and I stood alone. Who wanted to see a bunch of old bones in this heat anyway? It grew still. Motor scooters buzzed outside occasionally. The steady drip of water into the blue bucket. But no voices. The rapidly flickering candles. The dim, natural light from the windows. Just me with my thoughts. The first time I had been in a place like this without any other tourists.

A gift of a few minutes. I was alone but not lonely. Surrounded by thousands. If only you can see the ghosts. I closed my eyes to see what I could see. This was the end of the line

for all these bones. Surrounded by the vibration of endless prayers from strangers. And the ping of water.

These skulls, these bones, these ghosts, they offered so much to me. But also, they served as a conduit for my feelings and emotions. I claimed them as my metaphors. This is the thing a writer does, we claim everything around us: the wind, the earth, the collapse of a wave in the ocean, the sting of salt on a wound. We claim it and redefine it and turn it into something new. The bones could be whatever I wanted them to be, whatever I needed them to be. They could be any kind of life I wanted.

I cleared my mind. I'm here, I'm listening. I looked for an answer to the problem of me.

But I saw nothing. Just a circle of darkness behind my eyes. I opened them.

A pile of bones, a ceaseless drip, a blue bucket.

Well, that's enough of that, I thought. Try this instead: How about I'm just happy to be alive? How about I can walk out of here right now and into the fresh air with the blue sky and the big, blazing Italian sun above me and I leave the bones behind? How about I stretch these legs of mine and let them take me wherever I want to go?

It was home, then. To the house, and the yard, and the stacks of books. Enough already, I say to the dog, patting his soft ears. Enough about me.

ACKNOWLEDGMENTS

Portions of this book were previously published in the *New York Times*, the *New York Times Magazine*, *The Atlantic*, the *Wall Street Journal*, the *Sunday Times*, *Away*, Longreads, Lenny Letter, The Rumpus, and Curbed.

I am grateful to the great Morgan Parker and Tin House Books for permission to use selected lines from *There Are More Beautiful Things Than Beyoncé*.

Thank you to Father Carlos A. Martins for permission to use his translation of the poem found at the Capela dos Ossos.

Claire Cameron generously read the first and messiest draft and told me there was a book in all of it. Thank you, friend.

Big thanks also to my other brilliant and supportive readers: Courtney Sullivan, Kristen Arnett, Laura van den Berg,

Priyanka Mattoo, Viola di Grado, Lauren Groff, and Patricia Lockwood. I am a better writer every day because of all of you.

Conversations I had about writing memoirs with Roxane Gay, Cheryl Strayed, Alexander Chee, Samantha Irby, Anne Gisleson, and Melissa Febos were instrumental to the development of this book. I appreciate all of you so much.

Shout-out to the group chat: Maris Kreizman, Jason Diamond, Emily Goldsher-Diamond, Josh Gondelman, and Isaac Fitzgerald. I would not have made it through this year without you.

Thank you, New Orleans: Alison Fensterstock, Caro Clark, Katy Simpson Smith, Brooke Pickett, Brad Benischek, Tamika Jackson, Tia Clark, Ann Glaviano, Zach and Sarah Lazar, Rebecca Diaz, Chrissie Roux, Christopher Dunn, and Ladee Hubbard.

Thank you, New York: Emily Gould, Emily Flake, Alison Dell, Marisa Meltzer, Mary H.K. Choi, Jason Kim, Megan Lynch, Sally J. Kim, Sonya Cheuse, Maria Bell, Szilvia Molnar, Nadxieli Nieto, Laia Garcia-Furtado, Rosie Schaap, Vannesa Shanks, Johnny McCormick, and Stefan Block.

Thank you, West Coast: Esme Wang, Maria Semple, Jasmine Guillory, Amanda Bullock, Drew Zandonella-Stannard, Jade Chang, Cynthia D'Aprix Sweeney, Pat Healy, and Jason Richman.

I am eternally grateful to the #1000wordsofsummer community for your support and good-heartedness.

Much love to the bookstores: Loyalty Bookstores, Books Are Magic, Blue Cypress Books, WORD Bookstores, Octavia Books, Garden District Book Shop, The Book Cellar, Women & Children First, The Booksmith, and too many other wonderful independent bookstores to name.

Thank you to everyone at Ecco Books for taking such care with my work. And thank you to Hannah Westland and Serpent's Tail for their continued support in the UK.

Thank you to my agent, Katherine Fausset, for her kindness and wisdom.

And to my editor, Helen Atsma, extreme gratitude for her clear-mindedness, compassion, and belief in my art. Our ten-year friendship has meant everything to me.

As always, with love to my family.